Publisher's Acknowledgements
We would like to thank **Douglas Crimp**, Rochester, New York; **Fundació Antoni Tàpies**, Barcelona; **Serpentine Gallery**, London. Photographers: **Jon Abbott; Hans Biezen; Liuís Bover; Bild und Tonarchiv Landesmuseum Joanneum, Graz; Ronald Frisch; Angelika Gradwohl; Hans Haacke; Jeremy Hardman-Jones; Paul Katz; Werner Kaligofski, Joel Mallin; Robert Mates; Roman Mensing/artdoc.de; Brian Merrett; André Morin; Stephan Müller; Wolfgang Neeb; PAC Fotostudio; Wolf P. Prange, Udo Reuschling; Adam Rzepka, Bernhard Schaub, Lothar Schnepf; Wilhelm Schürmann, Fred Scruton; Tate Gallery, London; Gyula Zerand; Zindman/Fremont.** Every effort has been made to secure reprint permissions prior to publication. The editors and publisher apologize for any inadvertent errors or omissions. If notified, the publisher will endeavour to correct these at the earliest opportunity.

Artist's Acknowledgements
I would like to acknowledge and thank Gilda Williams, John Stack, Ben Dale, David Hearn and all the others at Phaidon who have helped tirelessly with the realization of this book. I am deeply indebted to Jon Bird, Walter Grasskamp and Molly Nesbit for the texts they generously contributed. I would also like to express my appreciation to the great number of people who have assisted me, directly and indirectly, with the work that is the subject of this publication. And I am grateful to all who have backed me in difficult moments. Above all, without the love, the patience and the endless support of my wife, Linda, none of this would have been possible. Thank you.

All works are in private collections unless otherwise stated.

Texts apperided to captions are written by the artist.

Phaidon Press Limited
Regent's Wharf
All Saints Street
London N1 9PA

Phaidon Press Inc.
180 Varick Street
New York, NY 10014

www.phaidon.com

First published 2004
© 2004 Phaidon Press Limited
All works of Hans Haacke are
© Hans Haacke

ISBN 0 7148 4319 9

A CIP catalogue record of this book is available from the British Library.

Printed in Hong Kong
Designed by Ben Dale (Onespace)

cover, front, **Standort Merry-Go-Round (German Merry-Go-Round)** (detail)
1997
Existing monument, merry-go-round, barbed wire, wood, sound track
h. and ⌀ approx. 6–7 m
Installation, Skulptur Projekte 1997, Münster.

cover, back, **GERMANIA** (detail)
1993
German Pavilion at the XLV Venice Biennale, wood wall, 8 wood letters, plastic reproduction of German 1 mark coin, minted 1990; photograph from 1934, 1,000-watt floodlight
Letters, h. 70 cm; coin, ⌀ 130 cm; photograph, 150 × 150 cm
Installation, German Pavilion, XLV Venice Biennale.

page 4, **Nothing to Declare**
1992
7 picture frames suspended from ceiling, bottle drier
Dimensions variable
Installation, 'The Vision Thing', John Weber Gallery, New York.

page 6, **Hans Haacke**
2003

page 26, **Condensation Cube** (detail)
1963–65
Acrylic plastic, water, climate in area of display
30 × 30 × 30 cm

page 82, **Mixed Messages**
2001
Objects from the collection of the Victoria and Albert Museum, London
Installation, 'Give & Take', Serpentine Gallery, London.
l. to r., mirror, *c.* 1735; meigh vase, 1851, Britain (exhibited at the Great Exhibition) *reflected in mirror*, head of an ox, 17th century, Italy

page 92, **Beton (Concrete)**
1997
Simulacrum of German Autobahn, concrete, in east–west axis of atrium of Martin Gropius-Bau, Berlin
25.5 × 15 m
Installation, 'Deutschlandbilder: Kunst aus einem geteilten Land', Martin Gropius-Bau, Berlin. Although planned before his rise to power, because it was constructed during the Nazi period, the German Autobahn (superhighway) has popularly been credited to Adolf Hitler. It served his preparations for war. During the Second World War the former Ethnological Museum in Berlin and the adjacent Museum of Decorative Arts (located in the immediate neighbourhood of the Gestapo headquarters and Göring's ministry) were both severely damaged. Even though the palatial nineteenth-century buildings could have been saved, they were both slated to be demolished to allow for the construction of a superhighway. Eventually, this plan was abandoned. However, the Ethnological Museum was, in fact, torn down and only the former Decorative Arts Museum was restored. It reopened as an exhibition hall in 1981 and was named after its architect Martin Gropius. Parallel to the building's east–west axis, an insurmountable concrete barrier, the Berlin Wall, which divided the city from 1961 to 1989, loomed less than 100 m from the building. Since the decision of the Bundestag (German Parliament) to return to the old German capital, Berlin has been one of the largest construction sites of the world, using vast quantities of concrete.

page 98, **Wir (Alle) sind das Volk (We [All] Are the People)** (detail)
2003
Proposal for permanent installation at Nikolaikirchhof, Leipzig
Digital simulation by the artist and Geróid Dolan, based on photograph by Peter Franke.

page 144, **Viewing Matters: Upstairs** (during installation)
1996
Exhibition produced with collection of the museum
Installation, Museum Boijmans Van Beuningen, Rotterdam.

Walter Grasskamp Molly Nesbit Jon Bird

Hans Haacke

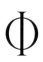

Contents

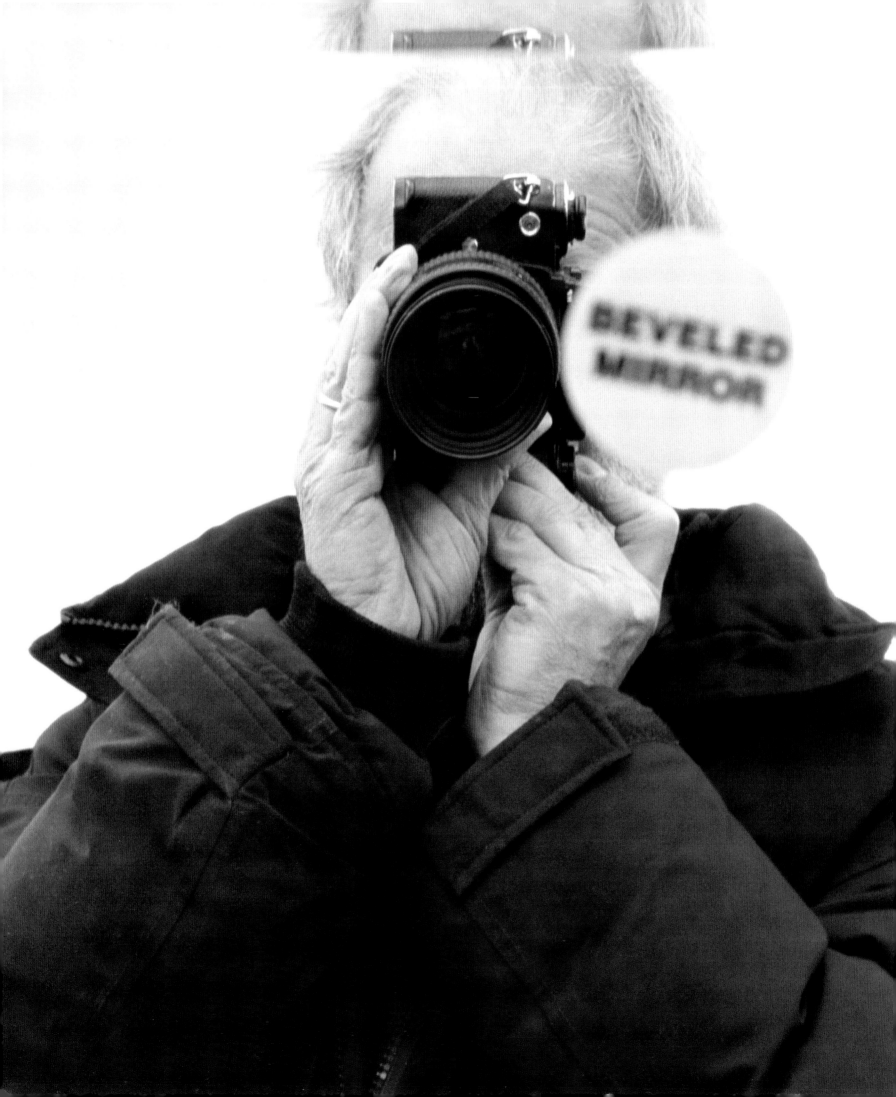

Molly Nesbit All conversations pick up where others have left off, so I thought it would be good to acknowledge right away one of the best you've ever had in print, and which gives any later interviewer real pause. I'm speaking of your dialogue with the great sociologist Pierre Bourdieu. There he said that your work represented an avant-garde for what intellectual work could become. What the two of you began in 1991 (during the same period that Bourdieu was writing *Rules of Art*[1] and you were invited to represent Germany at the Venice Biennale) achieved written form two years later in your book *Free Exchange*.[2] But your own exchange with his work had begun much earlier than this hadn't it?

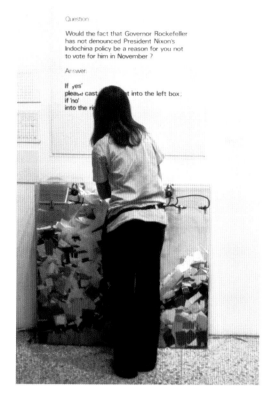

Hans Haacke **Discovering Bourdieu's writings in the early 1970s, and then, some fifteen years later, meeting him in Paris, ranks among the fortunate events in my life. (I've always thought of myself as lucky.) The two volumes of his texts that I read then, in a German translation, had been published by Suhrkamp Verlag, one of the venerable publishing houses in Frankfurt that brought out most of the theory that mattered at that time. They were difficult to read, because they were written in a rather academic style – very different from Bourdieu's later writings. Or is it just that I'm more attuned to it now?**

Nesbit Academic, yes, because he was concerned to prove his points using the very best sociological protocols. I should think, however, that his intensely rational tone would have had a special appeal for you.

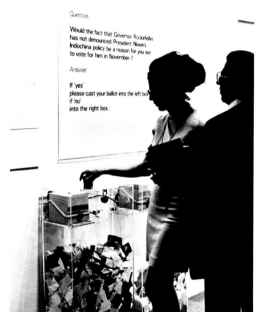

Haacke **Yes, absolutely. He explained in terms of sociological analysis a good deal of what I'd experienced in the art world, in galleries, museums, art talk, etc. The titles of these two books, translated into English, were *Foundations for a Theory of Symbolic Violence*[3] and *On the Sociology of Symbolic Forms*.[4] I read them after I'd been censored by the Guggenheim Museum, around the time I had also been kicked out of the Wallraf-Richartz-Museum in Cologne for my work on the provenance of Edouard Manet's *Bunch of Asparagus* (*Manet-PROJEKT '74*, 1974). Bourdieu's writing seemed to confirm some of what I'd learned from that marvellous sociological trickster Marcel Duchamp. In the other Marcel – I mean Broodthaers – I'd already found a kindred spirit. Bourdieu's texts helped me to understand things in the larger context of the sociology of culture. Then, at the end of a talk I gave at the Centre Georges Pompidou in Paris, when I had a solo show there in 1989, a woman in the audience asked me whether I knew Bourdieu and, if not, whether I'd like to meet him. She'd been working with him and, eventually, arranged for our first encounter.**

Nesbit And this was Inès Champey?

Haacke **Yes. I got the impression that Bourdieu knew some of the stuff I'd done over the years. He may have been particularly intrigued by my polls of the art world from the early 1970s.**

Nesbit Behaving like a sociologist.

Haacke **An amateur sociologist. So there was a certain affinity, as there had been some fifteen years earlier with the American sociologist Howard Becker. Bourdieu and I liked each other, and a little later, we taped a conversation. It**

These questions are and your answers will be part of
Hans Haacke's VISITORS' PROFILE
a work in progress during the Haacke exhibition at the
Guggenheim Museum.

Please fill out the questionnaire and drop it into the box on
the white round table near the windows on the Museum's ground
floor. Do not sign your name.

1) Do you have a professional interest in art,
 e.g. artist, student, critic, historian, etc?
 _____ yes _____ no

2) Is the use of the American flag for the expression
 of political beliefs, e.g. on hard-hats and in
 dissident art exhibitions a legitimate exercise
 of free speech?
 _____ yes _____ no

3) How old are you?
 _____ years

4) Should the use of marijuana be legalized,
 lightly or severely punished?
 legalized lightly severely
 punished

5) What is your marital status?
 married single divorced separated
 widowed

6) Do you sympathize with Womens' Lib?
 _____ yes _____ no

7) Are you male, female?
 _____ male _____ female

8) Do you have children?
 _____ yes _____ no

9) Would you mind busing your child to integrate
 schools?
 _____ yes _____ no

10) What is your ethic background?

11) Assuming you were Indochinese, would you
 sympathize with the present Saigon regime?
 _____ yes _____ no

12) In your opinion is the moral fabric of this
 country strengthened or weakened by the US
 involvement in Indochina?
 strengthened weakened

13) What is your religion?

14) Do you think the interests of profit-
 oriented business usually are compatible
 with the common good of the world?
 _____ yes _____ no

15) What is your annual income (before taxes)?
 $ _____

16) In your opinion are the economic difficulties
 of the US mainly attributable to the Nixon
 Administration's policies?
 _____ yes _____ no

17) Where do you live?
 _____ city _____ county _____ state

18) Do you think the defeat of the SST was a step
 in the right direction?
 _____ yes _____ no

19) Are you enrolled in or have you graduated
 from college?
 _____ yes _____ no

20) In your opinion should the general orientation
 of the country be more or less conservative?
 _____ more _____ less

Your answers will be tabulated later today together with the
answers of all other visitors of the exhibition. Thank you.

took us quite a while to edit it, sending updated versions back and forth, until *Free Exchange* was ready for publication.

Nesbit At what point during this free exchange did you learn that you'd been chosen to represent Germany in Venice?

Haacke I was invited about a year and a half before the opening in 1993. I showed Bourdieu slides of what I'd done in the German Pavilion, and he'd read the text I'd written for my Biennale catalogue. He then wrote an addendum to our joint venture, in which he contrasted my *GERMANIA* with Ernst Jünger's nationalism. What triggered this juxtaposition was that Achille Bonito Oliva, the Italian Artistic Director of the 1993 Biennale, had seen to it that the official Venice Biennale catalogue carried a turgid prologue by Ernst Jünger. In Germany, in France, in Italy and in Spain this German writer is admired for his prose, his esoteric rejection of the Enlightenment, and his lifelong, dandyish disdain for democracy. In the 1920s Jünger had made a name for himself with a celebration of war – where a man shows his mettle (he'd been in the trenches of the First World War). He allied himself with the right-wing enemies of the new democratic Republic and distinguished himself with nationalist and anti-Semitic tracts. It was his habit to send his books, with personal dedications, to Hitler. In 1982, he had Arno Breker, Hitler's favourite sculptor, model a bust of him – as did the collectors Mr and Mrs Ludwig. Oliva managed to make Jünger the recipient of a Golden Lion Prize. I was outraged. To my great delight, a year after the Biennale, choreographer Johann Kresnik asked me to design a stage set for his dance-theatre production about Jünger at the Volksbühne in Berlin. It was not appreciated by the Jünger fan club. I had a facsimile of the golden lion trophy from Venice play a prominent role – as a toy for the warrior to ride.

Nesbit When chains of associations intertwine and extend like this they can take on a life of their own. These chains appear all the time when you talk about your work. Sometimes they come along by coincidence (your luck?) and sometimes because you yourself have returned to an old link, not necessarily to revise some associations but rather because it centred on a good point that bears repeating. These links and chains, however, have a place, and *Free Exchange* describes that place well.

You and Bourdieu speak a great deal about what you call the 'battleground' of public opinion, its nature and its importance. 'Battleground', of course, makes plain the existence of structural adversarial conflicts in the public sphere. It also implies weapons – means for challenging one's opponents, one's adversaries, be they institutional or ideological (those two things now being exactly the same). Bourdieu was fascinated by the way in which you've used the techniques of mainstream publicity to produce your critique of its business (and big business in general). The provocation, then, is produced both by the means and the ends – a double challenge.

The particular provocations being discussed by the two of you are now part of the history of the early 1990s. But as we speak, ten years have passed. Would you see your challenges in the public sphere to be differently defined now? Are different means of provocation, different formal weapons and rhetorics required? Is the rhetoric of the advertising image still useful to you?

Ernst Jünger
1994
The artist's design for the stage set for Johann Kresnik dance theatre's production *Ernst Jünger* at Volksbühne, Berlin.
Officer's cap and epaulettes, framing the stage, are those of a Wehrmacht captain, Jünger's rank in the Second World War.
The statue is a replica of *Bereitschaft* (*Readiness*, 1939) by Arno Breker, Hitler's favourite sculptor. It dominated the German Pavilion of the 1940 Venice Biennale.
The medal, in front of the statue's head, is a replica of the Goethe Prize, which was awarded to Jünger in 1982.
The lion is an enlarged replica of the Golden Lion, the trophy given to visual artists in the Venice Bienniale. In 1993 Jünger received it for a text written for the official Biennale catalogue.
right, third from top, translation of text projection: *To what degree were the National Socialists right, after all? Today, all this is denied, the entire prehistory; and Hitler appears like the devil out of a box.*
[Ernst Jünger, interview in *Der Spiegel*, 16 August 1982, p. 157]

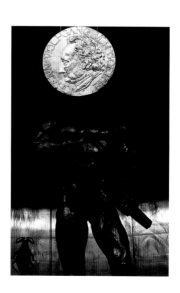
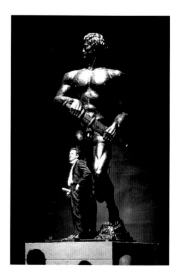

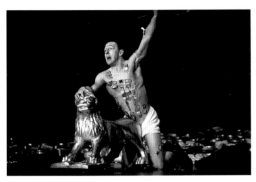

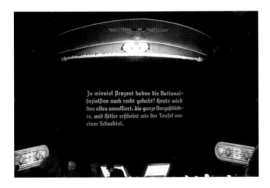

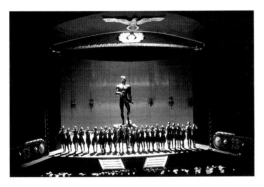

Haacke When Bourdieu and I were talking about cultural politics in the US and how they're connected to 'big-time' politics, things were far from settled. What we saw as a threat then, has since gained incredible force. More and more, every day, the coalition of Christian fundamentalists and neo-conservatives is undermining the public welfare and the American Constitution. Practically all institutions have accepted the domination of the public sphere by corporate interests, many of them without offering much resistance and without embarrassment.

Until the year 2000 the New York art world had reason to believe that assaults on the freedom of expression were foreign to their city. The 'culture wars' were fought elsewhere, not in New York. We seemed to be secure. And the art market was humming. New York's Republican Mayor Rudolph Giuliani taught us not to be so smug. In 1999 he cut the Brooklyn Museum's monthly subsidy of about half a million dollars (a third of its budget); he threatened to replace the Museum's Board of Trustees with people of his choice; and he announced he would evict the Museum from its city-owned premises. All this to punish the Brooklyn Museum for including Chris Ofili's painting *The Holy Virgin Mary* (1996) in its show of the Saatchi collection, 'Sensation' (1999). The subtext was that Catholic voters were to be rallied to prevent the election of Democrat Hillary Clinton to the US Senate! When the New York Mayor's 'sensibilities' are offended, the separation of Church and State, and the right to free speech, as protected in the First Amendment of the Bill of Rights, were no longer considered binding by this former Federal prosecutor! Giuliani believes – like some of his peers in Washington – that he can impose his private or politically expedient views on the country through his hold on public money, i.e. the taxes paid by us. The Brooklyn Museum went to court. Eventually, a Federal judge ruled that His Honour had indeed violated the Constitution. Judge Nina Gershon didn't mince words. Let me read to you what she wrote in her decision: 'There is no federal constitutional issue more grave than the effort by governmental officials to censor works of expression and to threaten the vitality of a major cultural institution as punishment for failing to abide by government demands for orthodoxy.'

In the early 1990s, the Los Angeles County Museum of Art had put together a show commemorating an exhibition that the Nazis had organized in 1937 under the title 'Degenerate Art'. Stephanie Barron, the curator of the show, reported in her catalogue that there was 'an uncomfortable parallel between' the issues raised by the assault on the NEA and those 'raised by the 1937 exhibition, between the enemies of artistic freedom today and those responsible for organizing the "Degenerate Art" exhibition'. Perhaps because I was born in the country with this infamous past, and because I was myself twice the victim of censorship by a museum, I've become allergic to the sort of parallels that Barron saw. In today's media fog, it's easily overlooked that there's something at stake here for all of us. Worrying about freedom of speech is not cool – it doesn't sell.

Nesbit But certainly the revelation of corporate wrong-doing is daily news right now.

Haacke Sure, corporate scandals, Enron, WorldCom, etc. are our daily fare. But we get used to them and merely become cynical. And then a war comes along and we get enthralled by a new spectacle. Rarely can we pay attention

to more than one big item at a time. That may indeed be what the current Bush administration is banking on. They're endowed with an incredible combination of ruthless cunning and arrogant naivety. It's an advanced case of hubris. Except for a few, we're all going to foot the bill.

It boggles the mind that within eighteen months of the attack on the World Trade Center, George W. Bush has squandered the outpouring of sympathy for the US around the world. Instead of sitting on the budget surplus that he had when he took over, with frenetic tax cuts for his wealthy cronies he's piled up an ever-larger mountain of national debt. In 1992 I called a work about his father's version of the redistribution of wealth *Trickle Up*. The son has turned it into a flood. The readers of this exchange between the two of us will know more by the time it's published. I hope that then things will be a bit brighter.

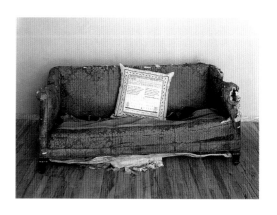

Nesbit So the challenges are still the same. What about the critical weapons you use in your art? Mostly you still use elements found at the site in which you happen to be working.

Haacke I often work with the specific context of the place for which I produce a piece – both the physical as well as the social and political context. They're part of the materials I work with; they're like bronze or paint on canvas. In the place for which a project was conceived, the work has a charge, a performative quality, so to speak. When a work of this nature is shown outside its original context, background information needs to be provided so that the viewers can understand the references and the impact it might have had. Many people think this isn't necessary for other kinds of art. Of course

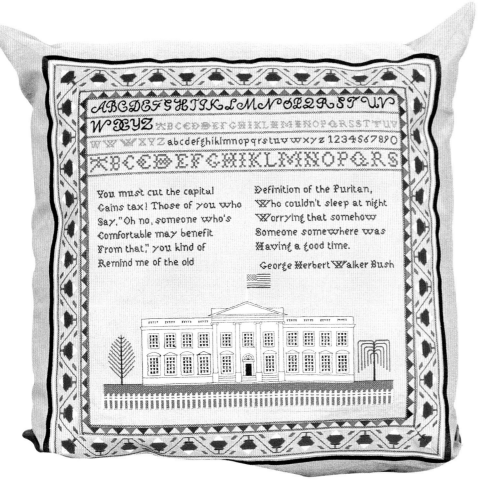

above and left, **Trickle Up**
1992
Decrepit sofa, embroidered
cushion
Sofa, 76 × 183 × 86 cm; cushion,
66 × 66 × 18 cm
Installation, 'The Vision Thing',
John Weber Gallery, New York.

right, **MetroMobiltan**

1985

Fibreglass, photomural, fabric

banners

355.5 × 609.5 × 152.5 cm

Installation, John Weber Gallery,

New York.

Collection, Centre Georges

Pompidou, Paris.

The text on the entablature states

'Many public relations

opportunities are available

through the sponsorship of

programmes, special exhibitions

and services. These can provide a

creative and cost effective answer

to a specific marketing objective,

particularly where international,

governmental or consumer

relations may be a fundamental

concern.' (source: *The Business

Behind Art Knows the Art of Good

Business*, leaflet, Metropolitan

Museum of Art, New York.)

On the blue banners are excerpts

from Mobil's response to a 1981

shareholder resolution by church

groups, calling for the prohibition

of sales to the South African police

and military during the apartheid

regime. With assets of over $400

million, Mobil was one of the

largest US investors in South

Africa, holding 20% of the

petroleum market, a refinery and

more than 1,200 service stations.

It met 20% of the fuel needs of the

South African police and military.

Pension funds, universities and

other large US institutional

investors increasingly divested

themselves of Mobil shares in

protest against Mobil's

collaboration with apartheid; the

US Congress passed sanctions.

Mobil eventually withdrew from

South Africa in 1989.

As a result of international and

domestic pressure, apartheid

ended in 1994. Free elections were

held, and Nelson Mandela was

inaugurated as president of

South Africa.

Mobil ran an advertisement in the

New York Times (10 October 1985)

headlined 'Art, for the sake of

business'. Answering their

question 'What's in it for us?'

Mobil explained the reasons for

sponsoring cultural activities:

'Improving – and ensuring – the

business climate.'

Mobil sponsored numerous

exhibitions at the Metropolitan

Museum, among them a show of

ancient Nigerian art in 1980. It

also contributed $500,000 to the

Museum's Islamic galleries. The

company has major assets in

Nigeria and Saudi Arabia. In 1999

Mobil merged with Exxon (Esso).

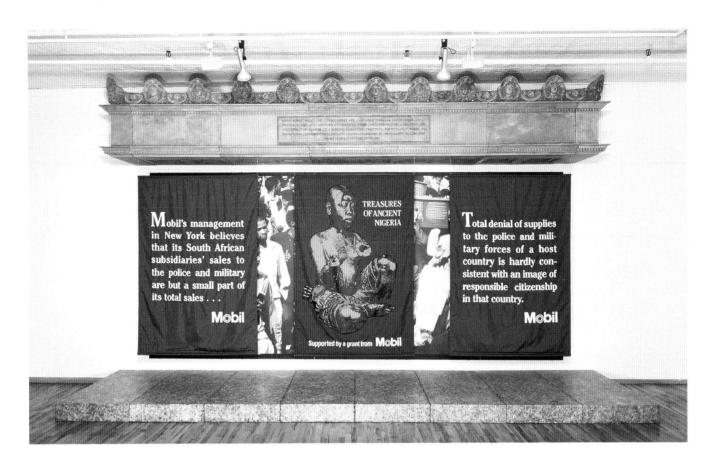

that's a fallacy. We know this from personal experience.

In the 1960s, when Minimalist and Conceptual artists first emerged –
Pop art had already gained a certain market share – their work was hotly
contested. Many people dismissed it as utter nonsense. Do you remember
that Abstract Expressionism was once suspected of being a Communist
conspiracy while, at the same time, the CIA employed it in the Cold War? It's
hard to believe today that a Jackson Pollock painting could have played a role
as a cultural weapon. People who didn't live through that period cannot have
a sense of the significance these works had, what was at stake for those who
made them and for those who supported or dismissed them. It's for
historians to expose the many meanings and often conflicting roles that
artworks have played over the years of their existence. But historians can
only offer the views that are compatible with their own time.

Nesbit We know that the way we think at any given time doesn't, and shouldn't,
frame a work forever. But this allows us to enlarge upon the matter of
communication in the public sphere. Let's look at the different strategies you've
used over the years in your work. Let's compare *GERMANIA* in the German
pavilion in Venice with *MetroMobiltan* (1985) in terms of the way in which your
provocation or exposé is set into motion formally and physically. In Venice, it's
rather like looking at a Cubist picture. You've put various symbolic forms
together and asked us to read them against and through the ripped-up floor.
One sees the violence of the ideological battle physically present in the
disruption, giving us a way to hold it in the mind as a memory. The adversary
becomes a wreck. *MetroMobiltan* is very different. It's more like looking at the
blocks of a well-designed advertisement from the mid-1980s. You've re-
arranged the elements from the display culture of New York's Metropolitan

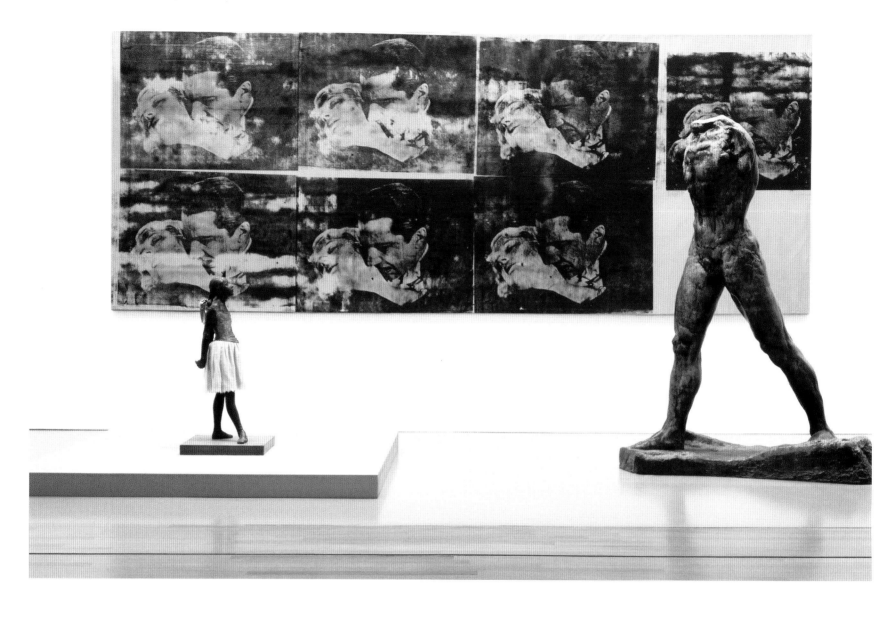

Museum of Art – its banners, its facade – in order to expose the financial interests supporting the museum. The museum reveals its own moral weakness once we examine the parts, but we have to work to pry the elements apart. There's no actual formal violence, just the compression of two opposites into the same facade. The explosion happens conceptually. But in this case you work in the present on the present. In Venice you worked in the present on the past. Is this shift due to a different public being present there? Or is your sense of the work of art's place in time changing?

Haacke **I don't believe that the public of the Biennale and that of the Metropolitan Museum are so different. The Museum is an institution with a very rich past – 'rich' in the multiple meanings of the word. My mock rendition of its facade speaks of that. On its entablature I quote from a leaflet by the Museum with the cute title:** *The Business Behind Art Knows the Art of Good Business.* **In a nutshell, it explains the rationale behind the involvement of corporations in sponsoring culture. Corporations don't have aesthetic desires. They're set up to promote the financial interests of their**

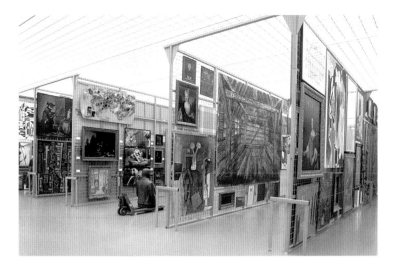

shareholders. And that includes not only promoting the company's image but, as the current crop of executives sees it, making sure institutions that receive their support do not engage in activities that could cast doubt on their 'responsible citizenship'. A Mobil PR-man once said: 'These programmes build enough acceptance to allow us to get tough on substantive issues'; Mobil and Philip Morris have both tried to interfere with shows of mine. Institutions usually don't let it get that far. Self-censorship is a given. *MetroMobiltan* is a collage of disparate elements, put together like the Surrealist's 'exquisite corpse', without smooth transitions. It's the viewers' task to understand the conflicts between these elements and to draw conclusions. It's a technique similar to that of Bertolt Brecht.

Nesbit But the disruption becomes much more physical in the German pavilion.

Haacke **Yes. There's a fundamental difference between how we react to physical reality – in this case the breaking of marble slabs – and mere representations of violence through a photograph. Neither approach is possible or appropriate in every situation.**

Nesbit *Viewing Matters: Upstairs* (1996) at the Museum Boijmans Van Beuningen, Rotterdam, was again very different in approach. Here, you found a way to work with others in a museum setting. It's no surprise to find you working at the Boijmans. Over the years you've often worked on the site of the museum, unmasking what Bourdieu would call its 'invisible structures'. *MetroMobiltan* would also be a good example of that or *Manet-PROJEKT '74* in Cologne in 1974. But the Rotterdam project didn't get you into trouble.

Haacke **Interestingly, some curators and museum directors in The Netherlands were outraged!**

Nesbit Why?

Haacke **I believe they thought I didn't treat the works with the proper respect.**

Nesbit What did they mean by 'proper'?

Haacke **I think they were offended by my bringing the storage racks from the basement upstairs to the *bel étage* and presenting the collection as it is housed downstairs: according to how best to save space, irrespective of medium, period, monetary value and historical or aesthetic significance.**

Nesbit Literally revealing the invisible structure.

Haacke **Yes. Presenting the works they cherish in this seemingly disrespectful fashion they considered insulting both to them and to the works. I meant to demonstrate that every presentation of works from the collection is inevitably a highly selective choice, driven by an ideologically inflected agenda – as was mine. It's often assumed that what we get to see on the walls of museums is a disinterested display of the best works, and represents a reliable account of history. This, of course, is never the case. The**

Viewing Matters: Upstairs
1996
Exhibition produced with the collection of the museum
Installation, Museum Boijmans Van Beuningen, Rotterdam.
opposite, background, Andy Warhol, *The Kiss (Bela Lugosi)*, 1963
foreground, l. to r., Edgar Degas, *Little Dancer Aged Fourteen*, 1880–81
Auguste Rodin, *Man Walking*, 1900–05

canon is an agreement by people with cultural power at a certain time. It has no universal validity.

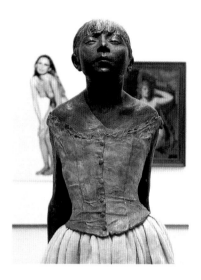

Nesbit They've cleaned it up, as André Malraux told us at great length in his text on the museum without walls, the *Musée imaginaire* (1947). But your Rotterdam project had other elements to it, didn't it?

Haacke **There were a number of other significant components to this show. I called it *Viewing Matters*, both in the sense that it matters to look, and that there are things, or matters, to examine and choose from – like in a department store. For the walls, around the central complex of the storage racks with the indiscriminate display of unrelated works, I selected specific paintings, sculptures, photographs and objects of all sorts, according to five themes: Artists, Reception, Power/Work, Alone/Together/Against Each Other, and Seeing. Throughout the show I provided no explanations. Had I done so, I would have undermined the technique of causing creative friction that has been attributed to the Comte de Lautréamont: juxtaposing normally unrelated objects, such as an umbrella and a sewing machine on an operating table. This was his prescription for producing new and unexpected meanings, adopted by the Surrealists with a similar intent in the parlour game 'the exquisite corpse'.**

Nesbit Then you made a book to accompany and survive the show. Often your books are an important part of the work: they provide another ground with which you, the artist, can communicate with the public.

Haacke **With the book, I tried to do something similar to the exhibition. I emphasized the peculiar nature of a book's physical properties and design:**

above and left, **Viewing Matters: Upstairs**
1996
Exhibition produced with the collection of the museum
Installation, Museum Boijmans Van Beuningen, Rotterdam.
above, l. to r., Edgar Degas, *Little Dancer Aged Fourteen*, 1880–81
Inez van Lamsweerde, *Thank you Thighmaster: Pam*, 1993
Frans Floris, *Death of Lucretia*, 1555–65
far left, background, Adam Willaerts, *Mouth of the River Naas at Den Biel*, 1633
far left, foreground, Bertrand Lavier, *Untitled*, 1986
left, background, l. to r., Marcel Broodthaers, *Museum-Museum*, 1972
Bartholomeus van der Helst, *Portrait of Daniel Bernard*, 1669
Emanuel de Witte, *Courtyard of the Stock Exchange in Amsterdam*, 1653
right, foreground, back to front, Italian Dowry chest, 16th century
Hildo Krop, *Portrait of D.G. van Beuningen*, 1955

above, **Viewing Matters: Upstairs**
1996
Exhibition produced with the
collection of the museum
Installation, Museum Boijmans
Van Beuningen, Rotterdam.
left, background, l. to r., Inez van
Lamsweerde, *Thank you
Thighmaster: Pam,* 1993
Frans Floris, *Death of Lucretia,*
1555–65
Craigie Horsfield, *E. Horsfield.
Well Street, East London,
October 1983, 1995,* 1995
Peter Paul Rubens, *The Bath of
Diana, c.* 1635–40
Richard Prince, *Untitled
(girlfriend),* 1993
left, foreground, Anna (Anna
Verweij-Verschuure), *My Place at
Table 2,* 1972/73
right, l. to r., Maerten van
Heemskerck, *The Virgin Mary,* 1550
Francisco Goya *Not [in this case]
either No. 36,* Los desastres de la
guerra, 1810–20
Belgian dress, 1905–07
Kees van Dongen, *Portrait of
Charles Rapoport, Called the
Red Virgin (French Socialist),* 1913
Richard Lindner, *The F.B.I. in 69th
Street,* 1972
Marcel Duchamp, *Selected Details
After Cranach and 'Relâche',* 1967
Maerten van Heemskerck, *St.
Elizabeth,* 1550

layout, page-sequencing, printing techniques, the qualities and flaws of photographic representation. I was lucky to be able to work on this with Paul Carlos, a very gifted designer in New York who has a rare sense for creative collaboration. The book is not meant to be a documentation of the show. However, like in the exhibition, I positioned images in relation to each other as a motor to create meanings that they wouldn't have had in isolation. We played with varying degrees of photographic resolutions and digital techniques. This highlighted the technically contingent quality of reproductions. We accepted reflections on the surface of paintings and protective glass as they appeared in the photos, and we accepted angled views of planar works. In short, we violated standard design rules. It was a lot of fun.

Nesbit Were you thinking about turning the book into a *musée imaginaire*, or making use of another of Malraux's ideas – that works of art exist in the museum as a confrontation of metamorphoser? The works undergo yet another change of state when photographed. And there the metamorphosis becomes even more dramatic because of the way in which photographs flatten form and distort colour. Was the museum-book as an engine of metamorphosis (and alienation) one of your working concepts?

Haacke **The museum as an institution that shapes our sense of history was certainly on my mind. I have only a vague memory of Malraux's *musée imaginaire*. I believe he spoke about the homogenization to which works are subjected in books, due to the standard size of the printed page and their reproduction in black and white.**

Nesbit Yes, and the strangeness of the close-up also worried him.

Haacke **In many instances in the book, I retained the size of the works relative to each other. Small works were reproduced small next to big works that were reproduced large. But I also played with close-ups and excerpts and collage.**

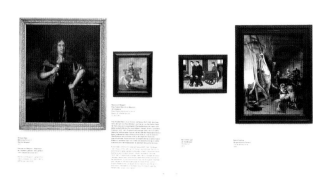 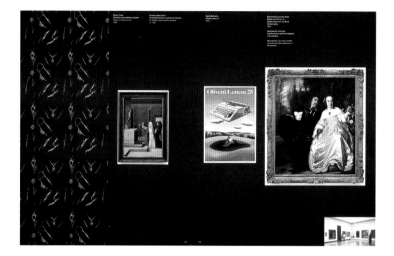

Nesbit And there's the shifting between black and white, and colour.

Haacke **Yes. There are colour pages, pages with black and white, and pages with both – or a monochrome colour.**

Nesbit Your book calls to mind another compendium too, in part because you included so much of his work here, and that's the *Boîte-en-valise* (1935–41) of Marcel Duchamp. Duchamp's *Boîte-en-valise* became a portable museum of his own work, which no museum in the world at that time would have shown. It's very personal. How does the *Boîte* function in the context of your Rotterdam project?

Haacke **Duchamp was, of course, the first artist to think about the aura that surrounds art and artefacts, and the power of context. As we know, they fundamentally affect the way in which we look at objects. The paintings on the storage racks didn't look like much (maybe that was behind the disapproval I encountered). In 1972, Marcel Broodthaers continued Duchamp's project with his fantastic exhibition *Musée d'Art Moderne, Départment des aigles, section des figures* (Kunsthalle Düsseldorf). I was glad the Boijmans had a good number of works by both of these iconoclastic artists. They allowed me to introduce notions of the contingency of meaning and to undermine universalizing assumptions.**

Nesbit Perhaps there's something else involved as well. While Duchamp was an ardent explorer of what he would call the 'non-retinal dimensions', he was also interested in the ways in which retinal matters can be extended. For him these two preoccupations went together. The non-retinal dimension of your own work is probably the one that has been most emphasized over the years, in part because you've asked us to think. Your earlier work using Duchamp's example – I'm thinking of *Broken R.M. ...* (1986) and *Baudrichard's Ecstasy* (1988) – involves more knowing than seeing. Duchamp is there as symbolic form first and foremost. Yet at the same time a retinal dimension is quite evident. In the Rotterdam project it dominates. There you give us more something to look at than something to read.

Haacke **In the section of *Viewing Matters* I called 'Seeing', I included a walk-in camera obscura. Once your eyes had adjusted to the darkness, you could see the street with cars passing by and the church across from the museum.**

above, **Viewing Matters: Upstairs**
1996
Spreads from book,
AnsichtsSachen/ViewingMatters,
Richter Verlag, Dusseldorf, 1999

opposite, left, **Broken R.M. ...**
1986
Gilded snow shovel, broken
handle, enamel plaque
Dimensions variable
First exhibited, 'Hans Haacke:
Unfinished Business', New
Museum of Contemporary Art,
New York.
Collection, Philadelphia Museum
of Art.
The work makes multiple allusions
to readymades by Marcel
Duchamp.
Translation of text on wall:
Art and Silver [Money] on all Floors.

opposite, right, **Baudrichard's
Ecstasy**
1988
Gilded urinal, ironing board, fire
bucket, rubber hoses, circulating
pump
Approx. 110 × 90 × 30 cm
First exhibited, John Weber
Gallery, New York.
Water from the fire bucket is
pumped up and ejected out of the
top of the urinal. It then flows into
the hole at the bottom of the
urinal and back into the bucket.
The work makes multiple
references to Marcel Duchamp's
works, as well as to Jean
Baudrillard's *The Ecstasy of
Communication* (1988).

Of course, they all appeared upside down. During the opening of the exhibition, the head of the installation crew told me with great excitement that he and his kids had just seen lightning in the camera obscura.

Nesbit It's very interesting conceptually to think about this work together with *DER BEVÖLKERUNG* (*TO THE POPULATION*, 1999), in which you brought soil from various different sources into the Reichstag. The seeds and plants that inevitably arrived with it will be allowed to grow there forever. But the historical ground from which museum curators choose their exhibitions is just as charged as the soil that came to the Reichstag. You could even say that it's spiked. It has its toxins and its late bloomers.

This project, like *GERMANIA*, did not spring from museum conditions. At the Reichstag, another kind of communication has been attempted, and another kind of disorder is produced. This time it stems not from violence but from the eruption of natural growth, natural processes, from mother earth. You have a different kind of frame, a different kind of ground. As an American looking at this I say, 'My god, it's incredible! Hans Haacke has the ground of the state on which to make art – and the state itself has given it to him!' Such a thing wouldn't be possible in the United States. As you've spent many decades living in America, what does it mean to you for the German state to give you a space

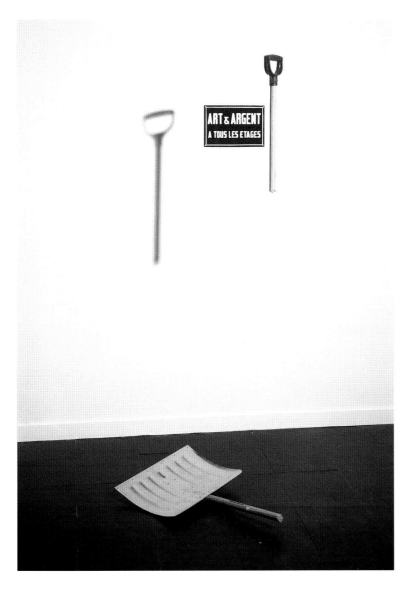

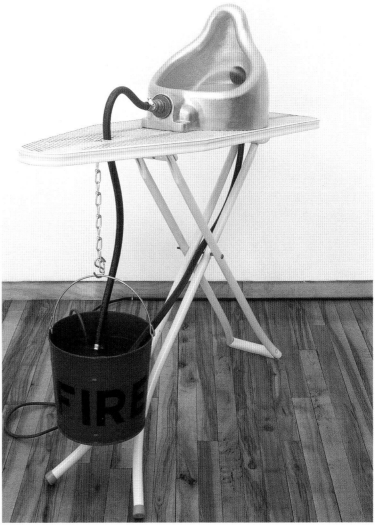

left and below, **Poster project commemorating 9/11**
2001–02
Die-cut white paper
91.5 × 61 cm
Production, Creative Time, New York.
In March 2002 die-cut paper was pasted over posters whose space rental had expired at over 110 locations in Manhattan .

opposite, l. to r., **Storm**
1991
Beat-up shopping cart with only three wheels, American flags, motor, remote control
86 × 95 × 52 cm
Collateral
1991
Shopping cart without wheels filled with badges with the design of the American flag and the caption 'MAY GOD BLESS THE VICTORY OF THE ALLIED TROOP' [*sic*] on them
86 × 95 × 52 cm
Installation,'The Political Arm', John Weber Gallery, New York.

like this for your work? Do you find it extraordinary? Because, you know, you're not exactly a state artist in most people's minds.

Haacke **Some do now think of me as a state artist. As you say, it is indeed uncommon for a parliament or the commissioner of a pavilion at a Biennale to allow national showcases of such symbolic significance to be used as a forum for the discussion of public issues. I give great credit to Klaus Bussman, the German Commissioner in 1993, for inviting Nam June Paik and me to represent Germany at the Venice Biennale. Even though Paik had lived and worked in Germany, he's a resident of New York. He's not a German citizen. And I'd been living outside of Germany for almost three decades and hadn't particularly ingratiated myself with the powers that be.**

Nesbit Did that in any way come into play when the commission for the Reichstag was being decided?

Haacke **It may have played a role. I was the last of nineteen artists to be invited, and, as we know, my proposal did, in fact, cause problems.**

Nesbit And as an artist of conscience working for the state, what changed when you found yourself speaking both for the state and to the state in these different commissions? The Venice pavilion was a temporary installation, a temporary conversation between you and the state and your audience. But the Reichstag is something else again. It has created a conversation that could and should be heard for centuries. As a stage for contemporary art this is extremely unusual. Most contemporary artists couldn't imagine a situation where their work would be shown in a public place for more than six months, much less decades, much less centuries. But when you work for a state that sees itself as having an eternal life, conceivably your work can have an eternal life too.

Haacke **Attitudes towards the state in a liberal society are complex and differ between countries, especially between the US and Europe. Traditionally, Americans – particularly the more conservative ones – are hesitant to cede**

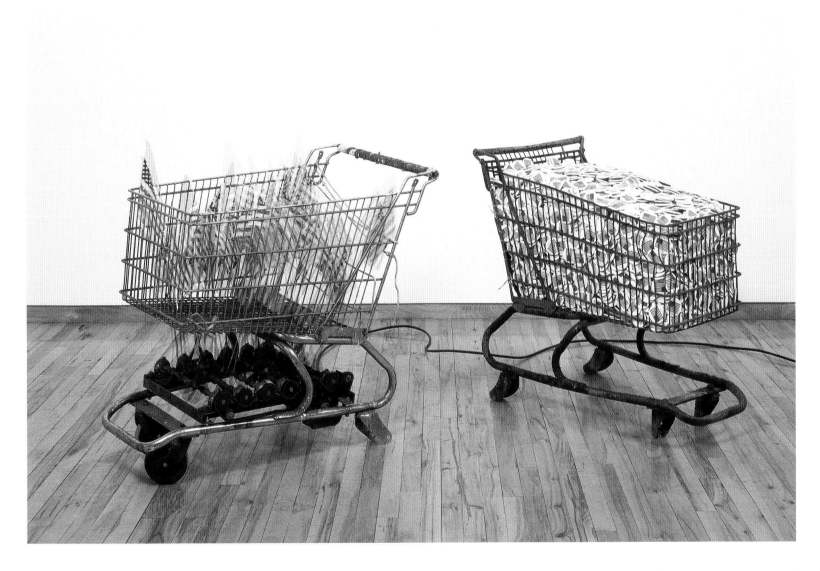

powers and responsibilities to the Federal Government. In the wake of the French Revolution, Europeans, on the other hand, have put the state in charge of practically all matters of public welfare. Public money – which always means taxpayers' money – is used to underwrite the *res publica*, the public cause (Republic). As part of this understanding, culture has been unquestioningly subsidized by the state in Germany and other European countries on a scale that's simply unimaginable in the US. It's a relatively new custom that the organizers of costly exhibitions are emulating the American model and making appeals for corporate sponsorship, even though they know full well that it limits their curatorial independence.

Every artist who exhibits in a public institution is, in a way, a state artist. By accepting the commission from the Bundestag, I allied myself with an

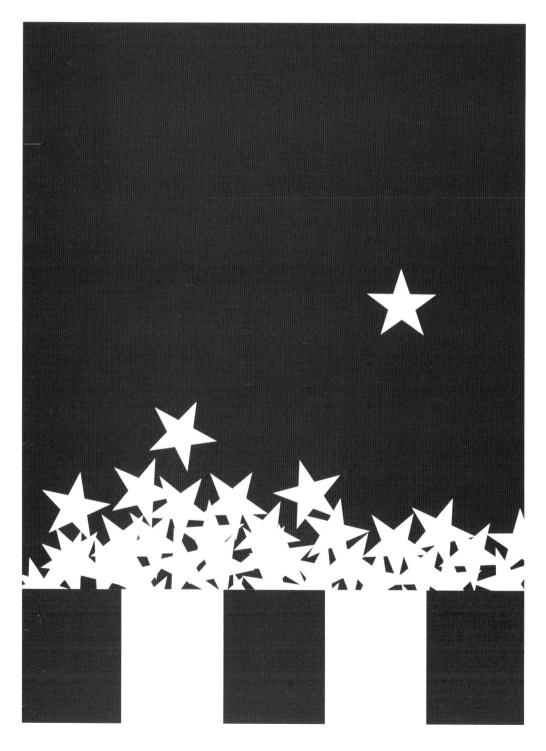

Stuff Happens
2003
Digital print
85 × 61 cm
First exhibited in 192 Books, New York (bookstore affiliated with the Paula Cooper Gallery).
The title is a comment made by Secretary of Defence Donald Rumsfeld on the massive looting and destruction of public buildings – among them the National Library and the National Museum of Art in Baghdad – when US troops occupied the Iraqi capital in April 2003.

institution that constitutes one of the major pillars of German democracy. My work in Berlin obviously wasn't meant to endorse this or that political party. And it wasn't perceived as such. The opposition to it crossed all party lines. The Bundestag Art Committee charged the invited artists to address the history and the political significance of the site. I think I did that. I alluded to the troubled German past and to the present debate over German citizenship, and the responsibility of the Bundestag to all who live on German territory. I wanted the project to be an ongoing participatory process. Taking politicians at their word turned out to be provocative.

Nesbit And there was one word in particular that you picked up on. The controversial component of the piece was to present an alternative to the Reichstag's inscription 'DEM DEUTSCHEN VOLKE' ('TO THE GERMAN PEOPLE') with 'DER BEVÖLKERUNG' ('TO THE POPULATION'), written in neon light.

Haacke **The third article of the German constitution of 1949 speaks about equality: nobody should be discriminated against or favoured because of their gender, origin, race, language, birthplace, their religion, beliefs or political opinions. Obviously, this is based on the Declaration of Human Rights of the French Revolution. Politicians usually claim to have everybody's interests at heart. They invoke the *Bevölkerung* (population) in every speech. But if that inclusive word is played back to them and related to the historically burdened word *Volk* (people), as it was with this project, attitudes change. All of a sudden the population becomes suspect, particularly to conservatives. For non-Germans, 'people' is an innocuous word. However, because Germany became a unified nation only late in the nineteenth century, in the myriad principalities and kingdoms the word *Volk* implied ethnic unity and a common culture. It was this exclusive tradition that the Nazis tapped into. Blood lineage became an issue of life and death.**

Nesbit It does still have a currency, doesn't it? It still has political force behind it of some kind. It's not a dead word.

Haacke **Yes. The revolutionaries of the failed uprising against the German princes and kings in the mid-nineteenth century were inspired by the French Revolution and its emancipatory goals. And in this context it meant, and still means, 'everybody'. Unfortunately, the understanding of *Volk* in the tribal, *völkisch* sense is not yet a thing of the past. As in other countries there are nativists in Germany. Neo-Nazis beat up people who don't look sufficiently German to them. And conservative politicians don't shy away from making veiled appeals to an undercurrent of suspicion regarding people of other ethnic and national backgrounds – not unlike the racist code words with which politicians in other countries try to win elections. The Christian Democrat MP who led the campaign against my project – like so many in his party – is a fervent opponent of the liberalization of the German citizenship laws. He and his supporters want to hold on to the *jus sanguinis*, according to which citizenship depends on parentage rather than place of birth.**

Nesbit You might say that we're not speaking so much now about an artistic strategy of provocation or contradiction as about the promotion of a concept of a people. The weapons we talked about earlier should maybe at this point be

called 'tools'.

Haacke **Yes, I'd rather use the word 'tool' than 'weapon'!**

Nesbit Swords will turn into gardening tools at this point in our interview. With *DER BEVÖLKERUNG* you allowed other people to choose where the soil comes from. Did you do this so it would change form in a way that you couldn't have imagined?

Haacke **It's unpredictable. It's a communal project. Many opponents in the Bundestag accused me of laziness, claiming that I didn't even do my own work. But now, more than 200 Members of the Bundestag have participated, and the project has gained a degree of popularity. Looking back, it's hard to believe that it caused such a bitter national debate and that the Bundestag spent more than an hour, in full session, arguing over it. Eventually, its realization was approved by the slimmest of margins, by a vote of 260 in favour and 258 against. As I imagined, many MPs involved people from their election district in choosing where the soil should be collected from. And so it became a participatory process even at the district level. Wolfgang Thierse, the President of the Bundestag, inaugurated the project with earth from the Jewish cemetery in his district in Berlin. Several Members brought soil from the grounds of former concentration camps. There's earth from a house that had been burned down because Turks had lived there, and from other places that are relevant to the ongoing debate over residents who don't have German citizenship (currently more than nine per cent of the population). Some MPs spiked the soil with seeds. It's fantastic. Nobody knows how it will develop.**

Nesbit Are you going to leave instructions for the kind of garden it will become in the future? Will it ever be trimmed or cut down?

Haacke **No, no gardening whatsoever. No watering, no weeding, no cleaning, no nothing. It's to be left alone. The coming together of earth and plants from all over Germany in a building with the highest security provisions makes this is a unique ecosystem. With the soil, a host of insects, worms and snails arrived. The pigeons in Berlin have also contributed their share.**

1 Pierre Bourdieu, *The Rules of Art: Genesis and Structure of the Literary Field*, Polity Press, Cambridge, 1996.

2 Hans Haacke, Pierre Bourdieu, *Libre-Échange,* Le Seuil/les presses du réel, Paris, 1994. German translation: *Freier Austausch*, S. Fischer Verlag GmbH, Frankfurt am Main, 1995; Portuguese translation: *Livre-Troca*, Editora Bertrand Brasil S.A. Rio de Janeiro, 1995; English translation (American edition): *Free Exchange*, Stanford University Press, 1995; English translation (British edition): *Free Exchange*, Polity Press, London, 1995; Japanese translation: Fujiwara-Shoten, Tokyo, 1996; Chinese translation: San Lian Shu Dian, 1996; Finnish translation: *Ajatusten vapaakauppaa,* Kustannusosakeyktiö Taide, Helsinki, 1997.

3 *Foundations for a Theory of Symbolic Violence,* Les Editions de Minuit, Paris, 1970; Suhrkamp Verlag, Frankfurt, 1973.

4 *On the Sociology of Symbolic Forms*, Suhrkamp Verlag, Frankfurt, 1970.

Calligraphy
1989
Architectural model for competition on the occasion of the 200th anniversary of the French parliament.
Model, 42 × 98 × 149 cm
Installation, National Assembly, Paris, 1989; John Weber Gallery, New York, 1990.
The site of the proposal is the Cour d'Honneur of the Palais Bourbon (part of the French National Assembly's building complex) in Paris.
Members of the French Parliament are to contribute a rock from their election district. The rocks are fitted together and polished to form a perfect cone. Raised gold-leafed calligraphy on its surface spell, in Arabic, the motto of the French Republic: Liberty, Equality, Brotherhood.
A jet of water shoots up from the top of the cone. The water then flows down its surface and continues towards the centre of a balustrade. It rushes through a breach, which its force seems to have broken, onto the main court underneath, which is occupied by a large area in the shape of France, Common French crops are grown in this area in a four-year cycle. The crop are a choice of wheat, corn, rapeseed, cabbage, sunflowers, beans, peas and potatoes. In the fourth year the field lies fallow. The water is carried around the planted area in a shallow, graded trough towards the gate of the court, where it disappears into an opening in the ground. The entire volume of water is recycled.

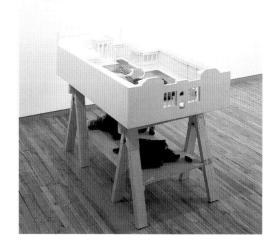

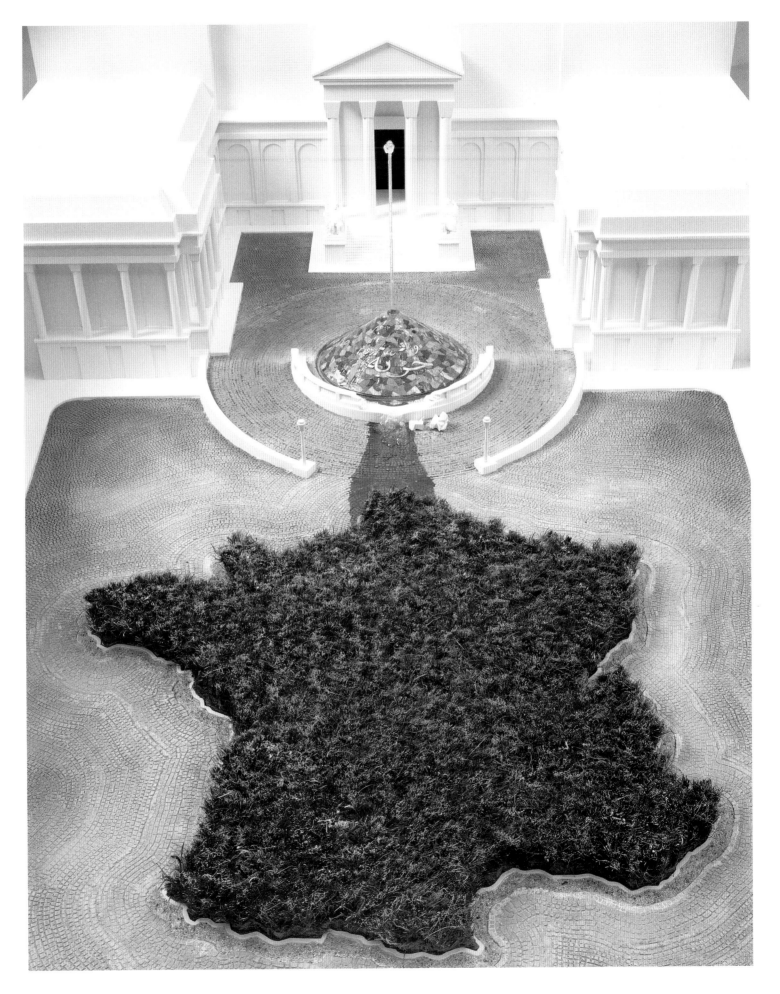

Contents

Fotonotizen, Documenta 2,
1959, Auszug (Photo Notes,
Documenta 2, 1959 [excerpt])
1959
Black and white photographs

In 1956, when Hans Haacke moved, at the age of twenty, from Bad Godesberg, the town where he grew up, to Kassel in order to attend the art academy there, he had good reasons. Several of the school's teachers had made their name at the first documenta (1955), which had taken place in Kassel the year before and was to become the world's major contemporary art exhibition. These included the painter Fritz Winter, whose monumental painting *Komposition vor Blau und Gelb* (*Composition on Blue and Yellow*, 1955) had dominated the great painting gallery, facing small paintings by Pablo Picasso and Henri Matisse. Winter was amongst the generation of modern German artists whose artistic development had been interfered with by Nazism. He had studied at the Bauhaus in Dessau under Wassily Kandinsky, Paul Klee and Oskar Schlemmer, later to emerge as an abstract painter. But abstraction was banned as 'degenerate' by the Nazis, and in the post-war period Winter and Ernst Wilhelm Nay were among the West German abstract artists who tried to reconnect with the period before Nazism. These

artists had started to make their presence felt in the 1950s, influencing considerably the first post-war generation of art students, including Haacke.

After the division of Germany, Kassel had gone from being at the centre of the 'Reich' to occupying a peripheral position. Certainly documenta gave a certain international status to the town, which had been badly damaged in the war, but it was not spared the fate of provincialism. Haacke would soon widen his horizons. Even when still a student, he regularly hitchhiked to Paris, whose painting culture was closely followed by an insecure West Germany. Not only interested in Winter's work and in Tachisme, which was making an impression in Europe, Haacke also admired West German abstract artists like Karl Fred Dahmen and Bernhard Schulze, but above all Emil Schumacher, an Informel artist whom he visited in the Westphalian town of Hagen.

Haacke's own paintings from this period were executed within this abstract pictorial language. While they are remarkable for student work, they inevitably appear somewhat academic in light of the development that he was to undergo at a later stage. For Haacke's work would not be shaped by Winter's painting, and he did not stay with painting for long. In 1960, the year he graduated as an art teacher in Kassel, a painting like *Ce n'est pas la voie lactée* (*This Is Not the Milky Way*, 1960) revealed that he was already concerning himself with completely new questions.

In Düsseldorf in 1959 Haacke had visited Otto Piene, who attracted attention with the Zero

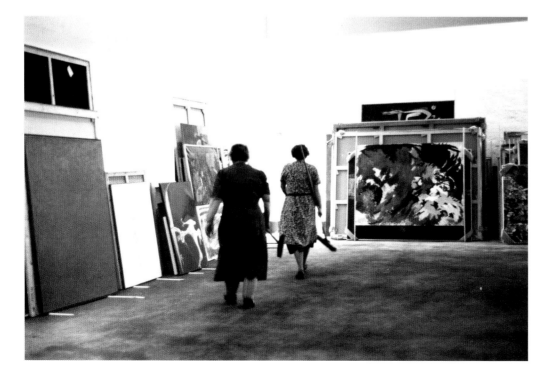

Group. Together with Günter Uecker and Heinz Mack, Piene had moved away from abstraction and Tachisme. They countered the individualistic and romantic expressive qualities of abstract art with anti-subjective pictorial objectives and new materials. Uecker experimented with rows of white nails on white surfaces. Mack used metal, impressing grids on its shiny surfaces. Piene employed fire and smoke as painterly devices so that he could detach himself from the personal handwriting of abstract art, going on to design his pioneering *Mechanical Light Ballet* in 1960, a choreography of projectors and rotating discs.

Though the work of the Zero Group, which was soon to become highly influential, was not shown at documenta 2 in 1959, the second Kassel exhibition confronted visitors with other up-to-date challenges. Cool and elegant studies by Piero Dorazio, Lucio Fontana's disturbing slashed canvases, and Jackson Pollock's monumental all-over painting brought important new international issues to Kassel. In comparison with this, the honourable West German post-war abstraction

movement, which had stood for a fresh start in a democratic culture and had reforged links with classical modernism, began to seem provincial.

Like many of his generation, Haacke now felt challenged to take a new direction in painting. The pictorial concept of *This Is Not the Milky Way* shows clear signs of his encounter with Pollock's work. No longer a composition in the traditional sense, it is dominated by Pollock's characteristic all-over style. Just as Pollock and the Zero Group artists had detached themselves from the expressiveness of abstract brushstrokes, Haacke too avoids any evidence of the artist's hand in this work. Instead he concentrates on the visual stimulus of shimmering colour points. This was no longer Tachisme and not yet in the realm of Op art. Certainly the canvas is still an abstract painting, but is it is about to take the next step, in the direction of the wall object.

However, documenta 2 had aroused other doubts in Haacke's mind. These did not reveal themselves in his paintings, but in pictures that he produced in a medium considered as profoundly

inartistic: photography. Through his student job as a guard at documenta 2, the twenty-three-year-old Haacke had been able to observe life both in front of and behind the scenes at this major exhibition. He captured these observations with a camera that he had recently received as a gift.

Haacke did not count this engaging series of photographs as part of his oeuvre for many years; even experts on his work knew nothing about it until well into the 1980s. The series was first shown about thirty years later at the West Berlin exhibition 'Stationen der Moderne' ('Stations of Modernism', Berlinische Galerie, 1988).[1] But with hindsight it can be regarded as an key early work. The pictures are like diary entries, giving an outstanding insight into the state of upheaval in which Haacke had found himself toward the end of his studies. They offer a revealing glimpse of his future development, though this was not visible to the artist himself at the time, and mark the first turning point in an oeuvre that was to take further and more dramatic turns.

A peek behind the scenes at an ambitious art exhibition must have had a sobering effect on a student for whom the artist's role was profoundly romantic. Here, he was observing for the first time the enormous effort required to isolate a work of art from the everyday world and shift it into the context of an art exhibition from which it draws much of its aura. The anti-art strategies of Marcel Duchamp or Walter Benjamin's theses on the aura of a work of art were still unknown to Haacke; they would preoccupy the next generation a few years later. However, they would quickly have revealed themselves as extremely pertinent to his thinking

against the background of this experience. The process he observed sparked doubts about the dynamics of his chosen profession, and a recognition of the artificiality of art, and what constitutes an artwork. Years before the artist and critic Brian O'Doherty brought this subject to a head with his pioneering analysis of the 'white cube' in 1976, Haacke was becoming aware of the dependency of art on its context, and the fact that it consists of more than mere works.

Having observed the machinations backstage, Haacke looked with amazement at the way in which visitors seeing the show from the front perceived the art. He was interested in the contrast between the distinct modernity of the works and the puzzlement of the lay people looking at them. This was everyday art perception, and Haacke was fascinated by its sociological aspects and contradictions. The photographs explore his burgeoning doubts about the universally communicative power of paints, employing pointed juxtapositions between the visitors' everyday culture and the artificial world of the pictures, which seemed to have less and less to do with this world of ordinary experience the more abstract they became. The artworks appeared like petrified forms, far removed historically, socially and aesthetically from their viewers. Here we see early evidence of the contradictions that Haacke would resolve a few years later with his 'Real-Time System' works. Thirteen years later, in 1972, he would return to this territory, now as a participant in documenta, with a work that would invite visitors to participate in his art (*Documenta-Besucherprofil* (*Documenta Visitors' Profile*, 1972).

**Ce n'est pas la voie lactée (This
Is Not the Milky Way)**
1960
Oil on canvas
120 × 60 cm

The works that followed the student's photographs also reflected Haacke's experience of documenta 2. In 1961 he made *A8 – 61*, a construction made of highly reflective plastic strips that revealed his continuing interest in visual surface effects, but at the same time it reflected the viewer and the exhibition venue in a variety of facets. Although perhaps inspired by the visual experiments contemporary Op artists made with reflective surfaces and mirror reflections, Haacke took a decisive step beyond that. For him, the presence of the spectator in the artistic work was more than an effect of parallel movements or optical illusions. In bringing together the work and the spectator in the moment of viewing, he was interested rather in closing the historical and cultural gap between the work of art and its viewer that had fascinated him in the photos he took at documenta 2. The overlapping of perception and the context of viewing now became the subject of Haacke's work. The development that had taken place in Haacke's thinking became literally visible.

Haacke's inclusion of the viewer and the – literal – reflection on the exhibition context introduce the last phase in which he was to create images to be mounted on walls. He had been challenged by new experiences: a scholarship from the Deutscher Akademischer Austauschdienst (DAAD) had enabled him to spend a year in Stanley William Hayter's internationally renowned printing studio in Paris from 1960 to 1961. He became acquainted with the latest trends in French art, particularly works by Jean Tinguely, Arman and the glamourous Yves Klein, later to be named the *Nouveaux Réalistes*, as well as the kinetic sculptor

Takis. He was particularly impressed by an exhibition of the Groupe de Recherche d'Art Visuel (GRAV), which had formed around Julio Le Parc and François Morellet. Their analytical rationality and geometrical clarity made even the Zero Group's cool art-design seem romantic, still committed to

right, **A8 - 61**
1961
Mirror foil on wood support
65 × 67 × 10.5 cm

opposite, top, **La Bataille de
Reichenfels (The Battle of
Reichenfels)**
1961
Stainless steel rods on reflecting
stainless steel plate, polished
stainless steel
1.5 × 20.3 × 20.3 cm

opposite, bottom, **Les couloirs de
Marienbad (The Corridors of
Marienbad)**
1962
Acrylic plastic, stainless steel
31 × 31 × 10 cm

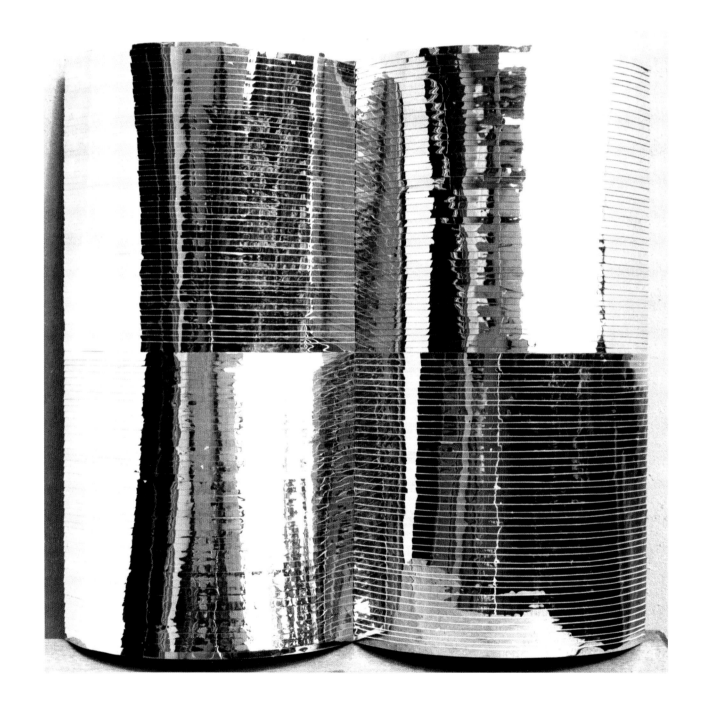

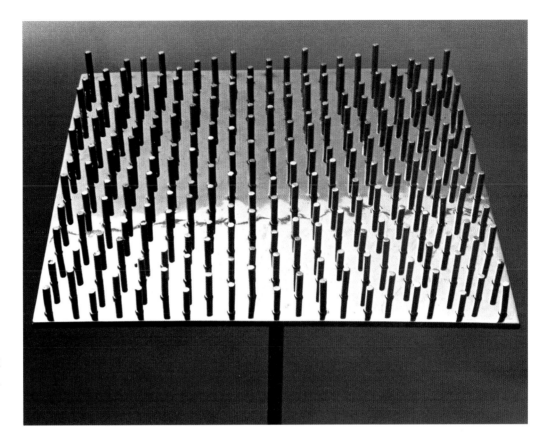

ideals that heroized the artist.

Haacke was fascinated by the way in
which GRAV undermined any sense of artistic
mystification, reducing art to rational and
geometric elements and random procedures, as in
works of François Morellet, or on the laws of visual
perception, like in the works of Julio Le Parc.
Accessible without any art-historical training, this
art was understood as a democratization of art and
liberation from the arrogance of bourgeois culture.
In the period immediately before the international
student unrest that was to draw art into a more
self-critical mode from the mid 1960s onwards,
Haacke identified with GRAV's interest in opening
art up to society and detaching it from its fixation
with rich collectors, museum presentation,
educated classes and official prestige.

In Paris Haacke devised a new repertoire of
forms that prepared the transition from the wall
picture (via the wall object) to the freestanding
object. He produced inkless intaglio prints of
raised dot patterns on paper, later also impressed
on mirror foil. For some he simply drilled holes into
the printing plates. At the same time, he painted
patterns of yellow strokes on white surfaces (*B1 -
61*, 1961) which produced an effect of visual
oscillation. In 1961–62, now living in Philadelphia
on a Fulbright scholarship, Haacke also printed
lithographs with such yellow on white patterns.
As the eye grew tired, they seem to move. These
retinal graphics were Haacke's response to the way
in which both Fontana and Op art had questioned
pictorial illusion.

In 1961 he embarked on three-dimensional
works. It is no coincidence that his *La Bataille de*

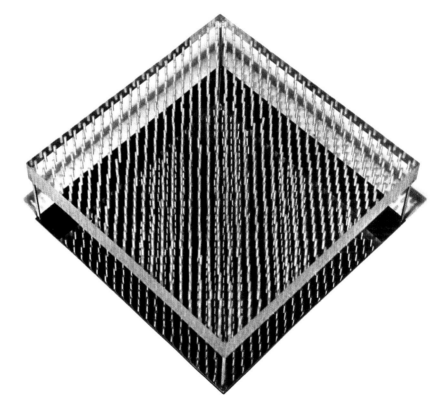

right, **Rain Tower**
1962
Acrylic, water
83 × 10 × 10 cm
Object is to be turned upside
down like an hourglass.

far, right, **Säule mit zwei**
unvermischbaren Flüssigkeiten
(Column with Two Immiscible
Liquids)
1964
Acrylic plastic, two immiscible
liquids
h. 31 cm, ⌀ 6.5 cm
Object is to be turned upside
down like an hourglass.

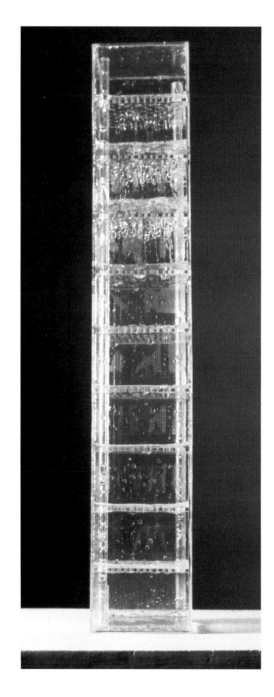

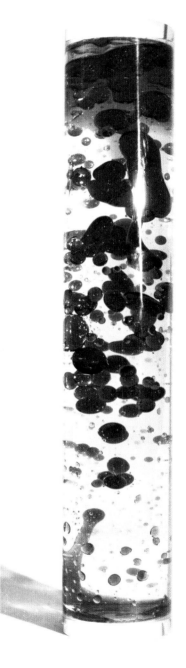

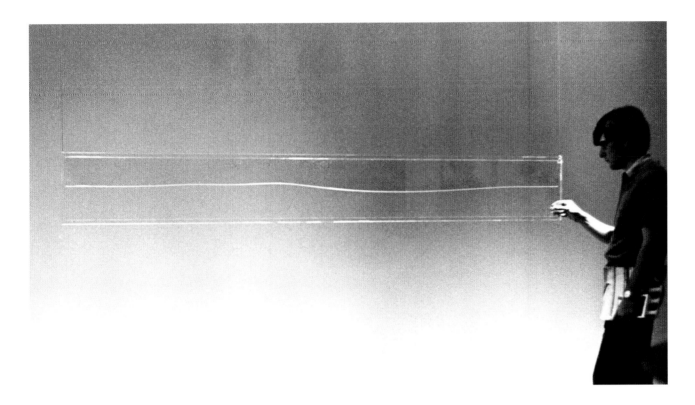

Reichenfels (*The Battle of Reichenfels*, 1961) as well as *Les couloirs de Marienbad* (*The Corridors of Marienbad*, 1962) refer to texts and scripts by Alain Robbe-Grillet:[2] Haacke was picking up on the distanced, anti-subjective and anti-romantic writing methods of the pioneering *nouveau roman*. With their hi-tech appearance and lack of art-historical connotations, acrylic plastic and polished stainless steel appear to be the equivalent of this cool, objective distance. The formula he was working with in his prints, the 'cool grid' (Haacke), is now translated into the third dimension, visible as well in *Revolution-Counter-revolution* (1962).

Haacke's first three-dimensional works may have echoed GRAV's search for objectivity and the role grids had played in the works of Zero artists in the late 1950s, but they were gaining a look that was entirely their own. In New York – where Haacke spent another year in the US after his scholarship to Philadelphia – he constructed *Rain Tower* (1962); then, in Cologne, where he lived from 1963 to 1965, he produced the *Säule mit zwei unvermischbaren Flüssigkeiten* (*Column with Two Immiscible Liquids,* 1964) in different versions and *Welle* (*Wave*, 1964). These three-dimensional works made of acrylic plastic are neither simply pictorial constructs in space nor sculptures: they are

Welle (Wave)
1964
Acrylic plastic, water
142 × 22 × 1.5 cm
Object swings like a pendulum
when pushed.

below, **Kondensationswürfel (Condensation Cube)**
1963–65
Acrylic plastic, water, climate in area of display
30 × 30 × 30 cm
Water evaporates and condenses on the inside walls of the cube in correspondence to environmental conditions in area of display.

right, top, **Kugel in schrägem Luftstrahl (Sphere in Oblique Air Jet)**
1964
Balloon, fan, housing
Balloon, approx. ∅ 50 cm
Installation, Howard Wise Gallery, New York, 1966.

right, bottom, **Ice Stick**
1966
Refrigeration unit, copper tubing, stainless steel
178 × 61 × 61 cm
Installation, Howard Wise Gallery, New York, 1966.
Collection, Art Gallery of Ontario, Toronto.
Environmental moisture condenses and freezes on internally refrigerated copper tube. External temperature regulates thickness and texture of the ice.

transparent 'event-containers', and at the same time objects that have to be handled. *Rain Tower* lets water run through the holes in its subdividing floors, turning their grid from a visual into an operative structure. *Column with Two Immiscible Liquids* and *Rain Tower* are activated when turned over like an hourglass. *Wave*, which is suspended from the ceiling, has to be set in motion like a pendulum. The invitation for the public to handle these works might have been disturbing for insurance companies, but this is precisely what interested Haacke: removing the idea of the untouchable work of art, destroying its aura and actively involving the viewer. The need to handle the objects involved the viewer even more than before in the realization of the artwork. Haacke also developed stationary event containers built

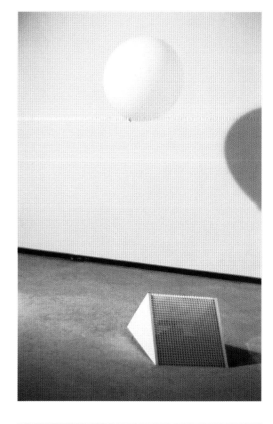

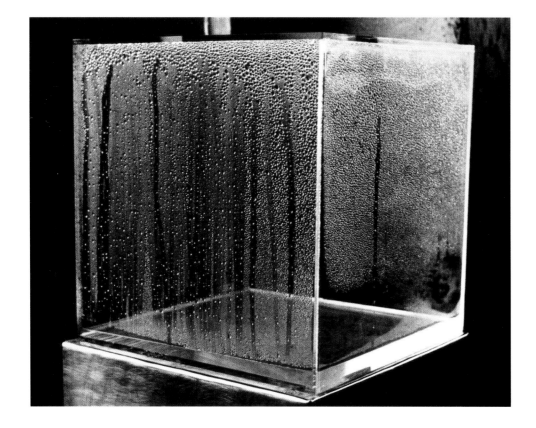

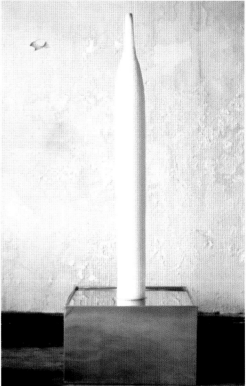

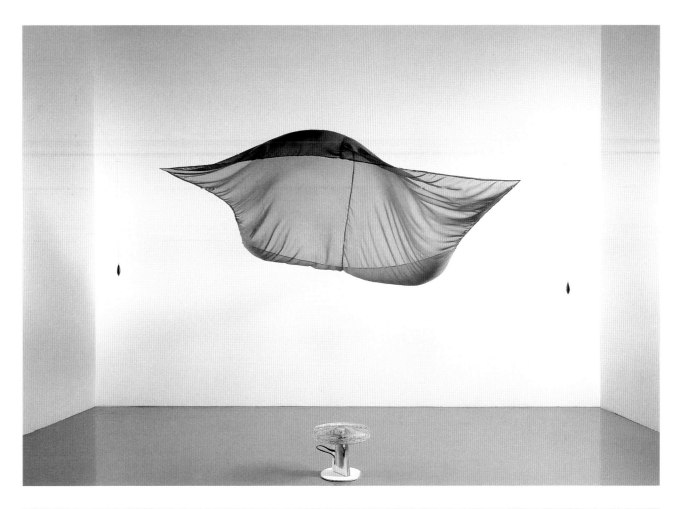

Blue Sail
1964–65
Blue chiffon, oscillating fan,
weights, nylon fishing line
Chiffon approx. 272 × 272 cm
First exhibited, Haus am
Lützowplatz, Berlin, 1965.
Collection, FRAC, Nord-Pas-de-
Calais, Lille.

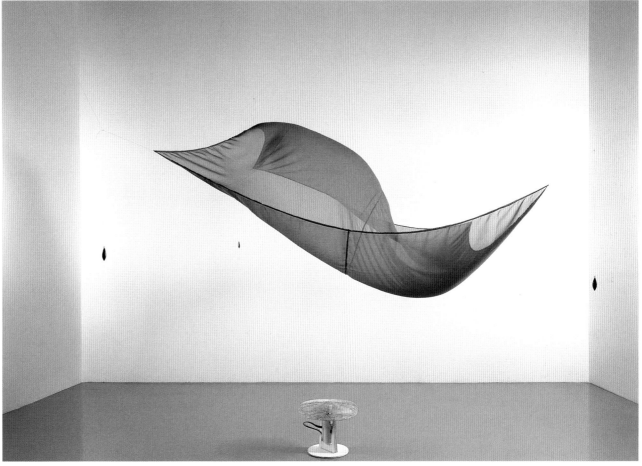

below, top, **Narrow White Flow**
1967–68
White fabric, fan, housing
Dimensions variable
Installation, 'Air Art', Arts Council,
YM/YWHA, Philadelphia, 1968.

below, bottom, **Wind Room**
1968–69
Fans, chainlink fence
Dimensions variable
Installation, Henry Gallery,
University of Washington, Seattle,
1968.

to react to the climate of the exhibition space. In various *Kondensationswürfel* (*Condensation Cubes, 1963–65*) a small quantity of water sealed inside responds to the microclimate of the exhibition venue – to temperature, light and air flow – and is thus context-related in the physical sense. *Ice Stick* (1966) can be seen as a companion piece, its appearance changing from icy to snowy, and the thickness of the ice depending on the temperature of the gallery.

Soon after this, in his works with air (1964–68), Haacke presented physical processes in the gallery: *Kugel in schrägem Luftstrahl* (*Sphere in Oblique Air Jet,* 1964), *Blue Sail* (1964–65), *Narrow White Flow* (1967–68) and *Wind Room* (1968–69) use an artificial, carefully controlled flow of air to create situations that are as technically impressive as they are artistically innovative. Never before had blowers and fans been used in art and, in contrast to other kinetic artworks of the time, there was nothing worth looking at when the electricity was switched off. While a kinetic sculpture of Jean Tinguely, for instance, is conceived to remain an impressive sculpture even when not moving, Haacke's works with air relied totally on the artwork's functioning in time. That was true as well for his first work in a public space, *Sky Line* (1967), a performance staged in New York's Central Park.

Artificial and natural air movements were not the only material Haacke included in this strategy. Water as well as ice – changing continuously instead of vanishing like the wind – remained favourite materials for outdoor pieces, too. One of the sites for Haacke's experiments was his studio's

Sky Line
1967
White balloons, helium, nylon
fishing line
Public events, 'Kinetic
Environment I and II',
Conservatory Pond, Central Park,
New York, 23 July 1967; Sheep
Meadow, Central Park, New York,
29 October 1967.

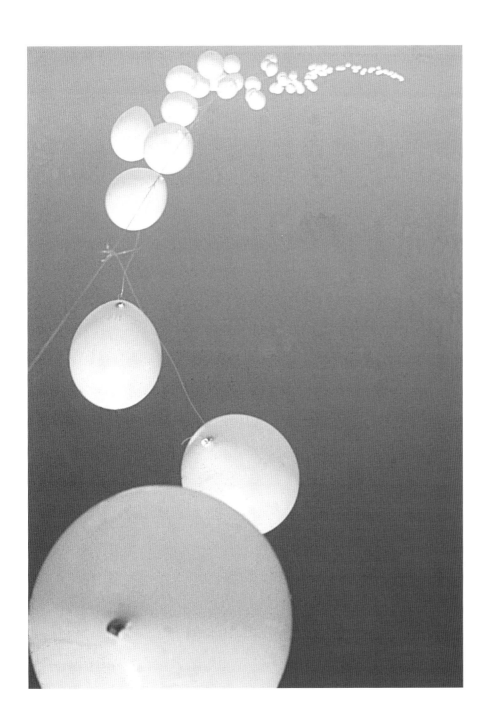

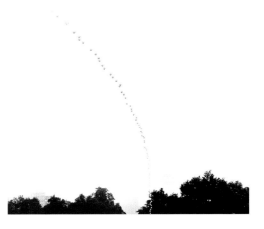

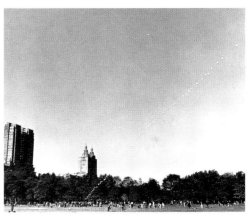

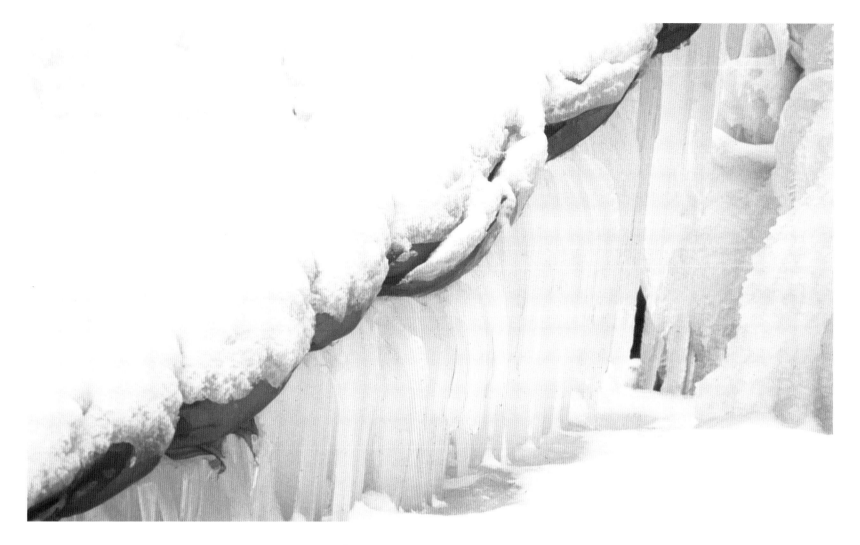

roof at 95 East Houston Street in New York where *Cast Ice Freezing and Melting, January 3,4,5 ... 1969* demonstrated the process of melting and freezing, and the dissolution of the original shape of a large flat sheet of ice. The studio's roof was not the only site for exposing temporary processes with natural materials under changing climatic conditions. *Spray of Ithaca Falls: Freezing and Melting on Rope, February 7,8,9 ... 1969* focussed on a waterfall's fine droplets that collected on a rope to form icicles.

While those pieces functioned without any source of artificial energy, Haacke also used electric pumps for outdoor and indoor versions. One of them in May 1969 consisted of perforated vinyl hoses, running along the edge of the 95 East Houston Street roof and letting water flow to the roof's low centre, from where it was recirculated by a pump (*Cycle*, 1969). *Circulation* (1969) was a gallery piece using PVC hoses and an electric pump to produce a complex closed system – one of the most visually impressive installations in this group of works. Trapped bubbles allowed the viewer to follow the movement of the water within the hoses. *Water in Wind* (1968), another event staged on the studio roof, created rainbow effects in the artificial mist that was produced by pumps and spray nozzles. But this romantic aspect was rather incidental in a sequence of works of nearly scientific stringency. Reducing the work of art to a constellation of prosaic natural materials and technical devices, as well as ephemeral results, Haacke's production had moved far away from what museums, collectors and dominant

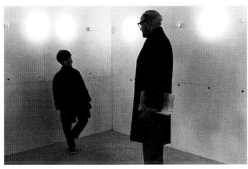

left, **Photoelectric Viewer-Controlled Coordinate System**
Planned 1966, executed 1968
14 infrared projectors, 14 photoelectric sensors, 28 light bulbs
Installation, Howard Wise Gallery, New York, 1968.
People cause light bulbs to go on and off in response to their location within an invisible grid that structures the space through infrared projectors and photoelectric sensors.

below, **Water in Wind**
1968
Spray nozzles, pump, water, wind
Installation, roof, 95 East Houston Street, New York, Summer.

culture had made of art: a heroic mystery.

The works created in the 1960s could be categorized in terms of the physical energy they harnessed or consumed. Haacke himself began to call them 'Real-Time Systems' from around 1966 on. Thus he stressed the fact common to all, that the energies and the materials used for these works of art and their functioning as a system of interrelated elements existed independent of the viewer and the interpretations an audience would bring to them. On the other hand he continued to pursue the theme that he had already addressed in 1961 with *A8 - 61* with the inclusion of the viewer as a constitutive element of the work of art. *Photoelectric Viewer-Controlled Coordinate System* gave this notion a completely new form, new not only in the work of Haacke, but for art in general.

In this work photoelectric sensors registered the visitors' movements and switched light bulbs on and off, thus linking the presence of art with the activity of the viewer in a technical mode. Conceived in 1966 and realized in 1968, it constituted what was later to be called a 'closed circuit' (in reference to the early 1970s video installations of Dan Graham or Peter Campus).

While the idea of 'Real-Time' developed mainly out of art-related considerations – as did Conceptual art in general – it was inspired as well by a new understanding of complex systems: cybernetics. This interest grew out of Haacke's dialogue with critic Jack Burnham, whose first book, published in 1968, was provocatively called *Beyond Modern Sculpture.*[3] Part II of this influential book carried the title 'Sculpture as System' with

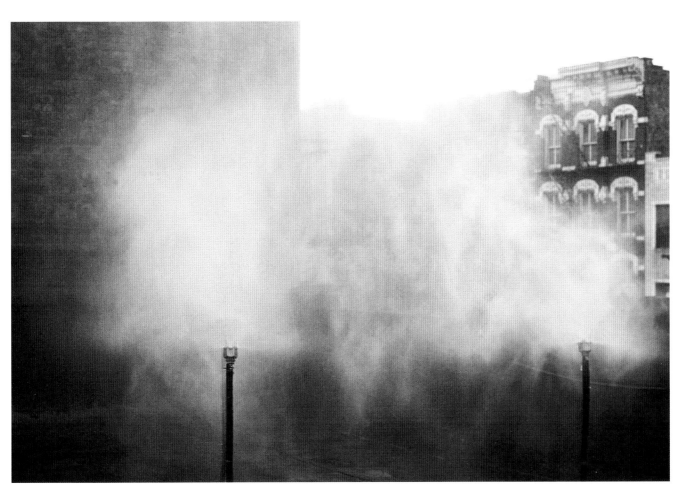

below, top to bottom,

Norbert: 'All Systems Go'
1970–71
Mynah bird
A mynah bird was taught to say:
'All systems go.'

Bowery Seeds
1970
Earth, airborne seeds
Installation, roof, 95 East
Houston Street, New York.
Sprouting of airborne seeds.

Ten Turtles Set Free
1970
Turtles
'L'art Vivant aux États-Unis',
Fondation Maeght, St.-Paul-de-
Vence, 20 July 1970.

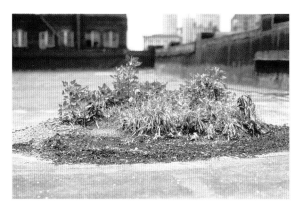

subheadings such as 'The Cybernetic Changeover', 'The Cybernetic Organism as an Art Form' and 'The Future of Responsive Systems in Art'. With a subsequent book of 1971, *The Structure of Art*,[4] Burnham was probably also the first author to introduce structuralism into the discourse on art. Next to the dream of revolution, cybernetics was the second intellectual model that shaped the thinking of the late 1960s. It represented an enormous challenge for architecture, music, fine art and literature; exhibitions like 'The Machine at the End of the Mechanical Age' (The Museum of Modern Art, New York, 1968), 'Information' (The Museum of Modern Art, New York, 1970), 'New Alchemy: Elements, Systems and Forces' (Art Gallery of Ontario, Toronto, 1969), 'Software' (Jewish Museum, New York, 1970, curated by Jack Burnham) and 'Arte de Sistemas' (Museo de Arte Moderno, Buenos Aires, 1971) proved the impact of cybernetics on contemporary art.

It is scarcely possible to understand the development of Haacke's work in the late 1960s without being aware of the growing influence of the two failed Utopias of this decade, one political, one technological, both of which promised to bring the bourgeois religion of art to an end. Haacke reflected the influence of cybernetics on his work in an essentially parodic work *Norbert: 'All Systems Go'* (1970–71), which involved training a mynah bird to say 'All systems go.' The bird was named after the mathematician Norbert Wiener, a pioneer of cybernetics, which at the time stood for an optimism about the future that Haacke no longer shared. The principles of control and com-munication in the operation of complex machines

and the functions of organisms were for him increasingly associated with the Vietnam War. It became clear to Haacke that the use to which they are put is always determined by ideology.

Norbert: 'All Systems Go' was one of Haacke's many 'Real-Time Systems' produced with living natural materials, plants and animals. His works with plants included a number of works using grass seeds and beans – *Grass Cube* (1967), *Grass Grows* (1969), *Gerichtetes Wachstum* (*Directed Growth*, 1970–72) – which he let germinate in a variety of exhibition venues. They appeared between 1968 and 1972, around the time of his works with animals; ants, seagulls, chicks, tortoises, the mynah bird and a goat were the protagonists. Haacke playfully calls them his 'Franciscan' works (in reference to Saint Francis, patron saint of animals), referring for instance to *Ten Turtles Set Free* (1970). Different from Jannis Kounellis, who in 1967 exhibited plants in a group show of Arte Povera and in 1970 his famous horses in the L'Attico Gallery, Rome (*Senza titolo [12 cavalli]* [*Untitled (12 Horses)*]), Haacke concentrated not on the living things themselves, but on the growth process. The metaphoric use of the word 'growth' as used before in describing condensation was now given a literal meaning. Animals as such were not of interest but their role within a system, either constructed by the artist or found, as in *Chickens Hatching* (1969).

Monument to Beach Pollution (1970) indicates that these works with plants and animals anticipated evolving ecological concerns. This is the first of Haacke's many projects relating to the notion of monuments, but above all it is one of the

first artworks of the twentieth century to articulate an awareness of the environment that goes beyond the merely aesthetic. As if a parody of Arte Povera's use of 'poor' materials, Haacke collected the flotsam and jetsam along a Spanish beach and piled it up in a heap of trash. The ephemeral but ubiquitous leftovers became the material for a transitory monument on a non-art site, quoting Haacke's own heaps like *Grass Grows* (1969).

While working with plants Haacke was often occupied by the idea of unregulated growth. The idea stayed with him for more than thirty years, extending to his project for the Berlin Reichstag, *DER BEVÖLKERUNG* (*TO THE POPULATION*, 1999), a wild plant reserve inside the former and recent German parliament building. The first example of this idea of naturally growing an artwork was to have been the *Topographic Contour Project, Proposal for Fort Greene Park Brooklyn* (1968). It involved leaving a topographically defined area running around a hilly site to be left free of horticultural intervention. *Niemandsland* (*No Man's Land*), which Haacke proposed in 1973–74 for a complex of new ministry buildings in Bonn, was to have gone further. The site was to have been off-limits not just to horticulturists but also to any political or police intervention. Neither of these projects was realized. However, with *Bowery Seeds* (1970) he created a zone of free plant growth on a small scale on the studio roof of 95 East Houston Street. With *DER BEVÖLKERUNG*, the

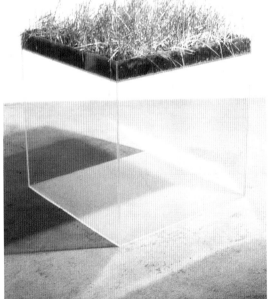

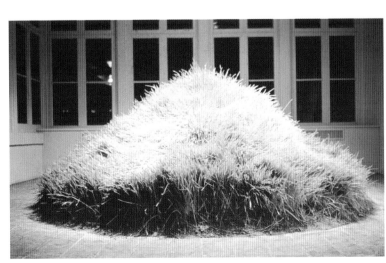

above, **Topographic Contour Project, Proposal for Fort Greene Park Brooklyn**
1968
Drawing for unrealized project
The area between two topographic contour lines marking a difference in height of 10 feet (305 cm) is to remain untended.

right, **Monument to Beach Pollution**
1970
Rubbish
Installation, Carboneras, Spain, August
Rubbish on a 200 × 50 m stretch of beach in Carboneras, Spain, was collected and piled in a heap.

idea was finally implemented in a symbolically significant public space.

Since the beginning of the 1970s, after his works with wind and water, and with plants and animals, Haacke's entire production could be characterized as 'works with people'. From then on the 'Real-Time Systems', relating to physics and nature, were gradually replaced by pieces triggering social processes or referring to institutions. The first projects to move in this direction related to the institutional frame of the exhibition itself, aiming to open it up to the outside world and placing it in a broader social context.

Recording of Climate in Art Exhibition (1969–70), Haacke's contribution to the exhibition 'Conceptual Art and Conceptual Aspects' curated by Joseph Kosuth at the New York Cultural Center (1970), represented a step towards this new departure. By exhibiting the thermograph, barograph and hydrograph commonly used in museums to conserve works of art, Haacke employed a highly reduced, nearly anonymous form. Like the mynah bird, this climate-recording

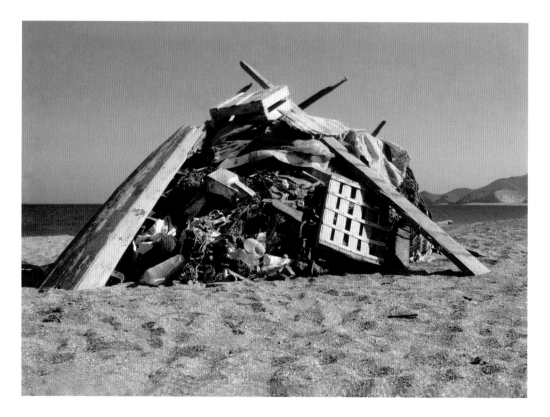

**Recording of Climate in Art
Exhibition**
1969–70
Thermograph, barograph,
hydrograph
Installation, 'Conceptual Art and
Conceptual Aspects', New York
Cultural Center, 1970.

device could be seen as a kind of readymade. As Edward F. Fry wrote in 1972 in the first monograph on Haacke's oeuvre, 'Although Haacke saw Duchamp's work in Philadelphia in 1961, he did not recognize how his own systems related to readymades until 1966–67.' Having made this discovery, however, Haacke seems to have rapidly moved beyond the object-bound – and by now somewhat fetishistic – character of the readymade, in order to make it operational.

Like the documenta 2 photographic series ten years earlier, this work anticipated an approach that would come to define and typify Haacke's production: it ranks among his first explicitly institution-related pieces. The climate-recording device recalled his earlier *Condensation Cubes* and their response to the microclimate of the exhibition space, but represented as well the museum's reaction to the value of an artwork. It was a precursor of his later critique of art institutions, their economic entanglements and their ideological and political role.

In *News* (1969), at the Howard Wise Gallery, New York (also in the group exhibitions 'Prospect', Kunsthalle Düsseldorf, 1969, and 'Software', Jewish Museum, New York, 1970), Haacke opened up art institutions commonly sealed off from the everyday world by transmitting political and economic news via a teleprinter. This both prevented the art world from isolating itself from political reality, and made the news as relevant as the artworks of the other participants. It was not a formal gesture; at that time the Vietnam War was escalating, and international resistance was being organized against it. Protesting students at Kent State University, Ohio, had been shot by members of the National Guard on 4 May 1970. In 1969 Haacke had joined together with other artists in New York to form the Art Workers Coalition, which carried the protest into cultural institutions.

While viewers of *News* were merely presented with the political present in an unusual place, at 'Information', a group exhibition held at New York's Museum of Modern Art in 1970, they were

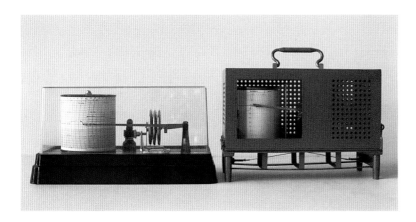

able to state their own opinions about political events. In *MOMA-Poll* Haacke invited visitors to cast ballots in response to the question, 'Would the fact that Governor Rockefeller has not denounced President Nixon's Indochina Policy be a reason for you not to vote for him in November?' By referring to the Governor of New York, who was running for re-election and considering a race for the presidency, Haacke was implicating the Rockefeller family, a key influence on New York's cultural life, not least on life at The Museum of Modern Art. Haacke was not invited back to exhibit for several decades.

With his *Gallery-Goers' Birthplace and*

Residence Profile, shown at the Howard Wise Gallery in 1969, Haacke began a sociological examination of the venue in which his art was shown. He asked gallery visitors to mark with pins on maps where they were born and where they now lived. In the gallery of Paul Maenz in Cologne he then exhibited in 1971 the photographs he had taken of the gallery visitors' houses in New York as a visual social and urban profile.

This piece represented a completely new departure in the work of the thirty-three-year-old artist. His research into New York gallery visitors took him to the 'Real-Time System' of living conditions in that city, and ultimately on the trail of the real-estate industry that is a key feature of that system. His confrontation with the urban world led to two thoroughly researched documents – *Shapolsky et al. Manhattan Real Estate Holdings, a Real-Time Social System, as of May 1, 1971* and *Sol Goldman & Alex DiLorenzo, Manhattan Real Estate Holdings, a Real-Time Social System as of May 1, 1971* – about two New York real estate groups. These works caused a sensation, and not just among estate agents.

In 1971, they were the reason for Haacke's first major international solo show to be cancelled six weeks before it was due to open. Haacke was to have been the young star of a prestigious exhibition at the Solomon R. Guggenheim Museum, New York, curated by Edward F. Fry. It was to have followed his journey from painting to object-making to Conceptual art, the 'Real-Time Systems' and operational readymades, and would have given him a special status amongst his generation of Conceptual artists.

When Haacke was faced with direct interference in the exhibition's content by the Director of the Guggenheim, Thomas M. Messer, a dramatic conflict ensued. Messer insisted that Haacke omit three works: the two real estate pieces and a visitor's poll, which, along with ten demographic questions, sought viewers' political opinions. Haacke offered to compromise by replacing the names of the real estate owners by fictitious names, but refused to withdraw the three works. Messer responded by cancelling the entire show, for which Haacke had already planted beans and wheat inside the museum. Fry, who had demonstrated solidarity with the artist to the end, lost his job.

This blatant censorship and the violation of both the freedom of art and the right to express political opinions were so flagrant that protest was unanimous across all artistic camps, with numerous internationally known artists joining a boycott of the museum.[5] No cultural, educational and political institution in a democratic country has ever been so rightly pilloried as the Guggenheim Museum and its Director after the cancellation of the show. It is difficult to exaggerate the financial and personal damage incurred as a result of this censorship, in the lives of both curator and artist. Fry worked as co-curator on documenta 6 and documenta 8 in 1977 and 1987, but was never again employed by a US museum, and Haacke's work was not bought or shown in US museums for twelve years. The first purchases were made by the Allen Memorial Art Museum at Oberlin College, Ohio, which acquired *The Right to Life* (1979) in 1983, and the

Gallery-Goers' Residence Profile,
Part 2
1970
732 black and white photographs,
189 typewritten cards
Photographs, 12.5 × 18 cm each;
cards, 12.5 × 18 cm each
Installation, Galerie Paul Maenz,
Cologne, 1971.

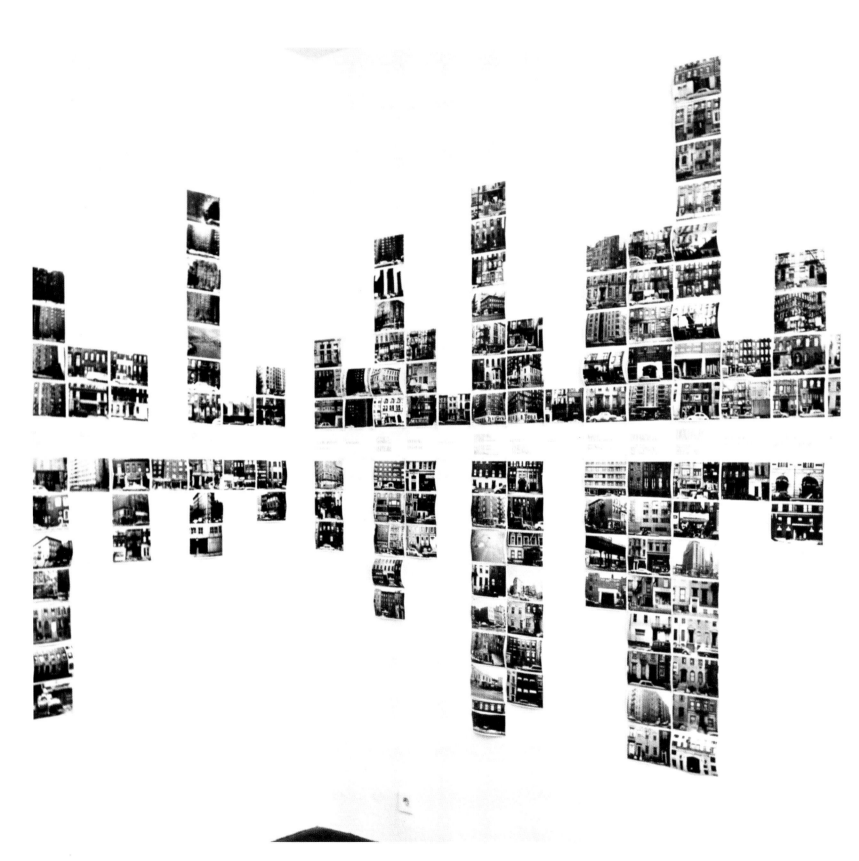

Gallery-Goers' Birthplace and Residence Profile, Part 1

1969

Maps, red and blue pins

Maps, 111.5 × 86 cm, 111.5 × 162.5 cm, 111.5 × 162.5 cm

Installation, Howard Wise Gallery, New York, 1969.

During a solo exhibition at the Howard Wise Gallery, visitors were asked to mark their birthplace with red pins and their current residence with blue pins on maps of Manhattan, the five boroughs of New York, the New York Metropolitan area, the United States, and the world. By the end of the exhibition (1–30 November 1969) 2,312 locations were marked as birthplaces and 2,018 as residences. In the 1960s, the Howard Wise Gallery on New York's 57th Street (between 5th and 6th Avenues) was one of the important galleries for what was considered to be the avant-garde art of the time.

Where?	Birthplace	Residence
Manhattan	257	732
Brooklyn	91	78
Queens	42	81
Bronx	62	43
Staten Island	5	6
New York City	457	940
New York State (excl. New York City)	184	265
New Jersey	162	164
Connecticut	66	52
Tri-State area	869	1,421
United States (excl. NY, NJ and CT)	920	402
United States	1,789	1,823
Canada	52	43
South and Central America	50	22
Europe	213	63
Asia	105	27
Africa	22	15
Australia	9	6
Isolated Islands, oceans, map edge	72	19
Total	2,312	2,018

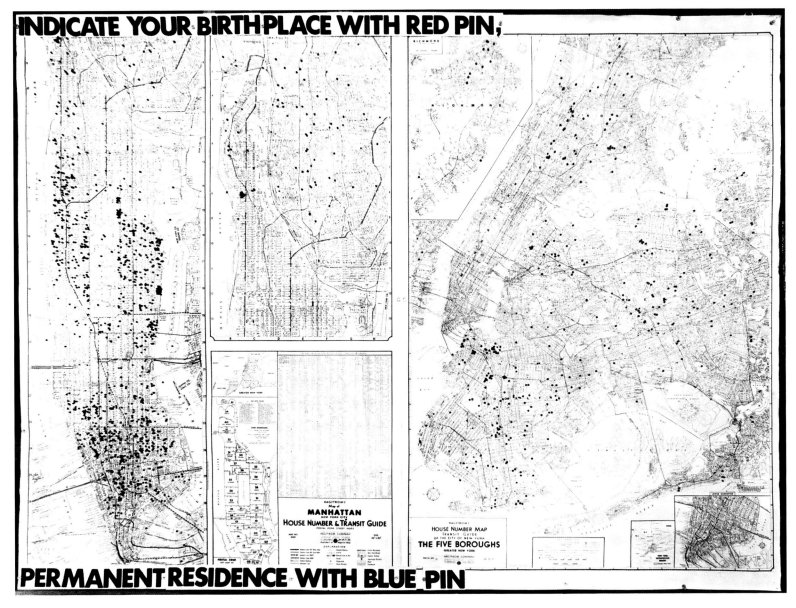

INDICATE YOUR BIRTHPLACE WITH RED PIN,

PERMANENT RESIDENCE WITH BLUE PIN

Shapolsky et al. Manhattan Real Estate Holdings, a Real-Time Social System, as of May 1, 1971
1971
Photographs, data sheets, charts
First installed, 'Art Without Limits', Memorial Art Gallery, University of Rochester, New York, 1972.
Collection, Centre Georges Pompidou, Paris.
opposite, bottom, installation 38th Venice Biennale, 1978.

In 1971 the Shapolsky real estate group, headed by Harry Shapolsky and nominally owned by about seventy different corporations, frequently bought, sold and mortgaged properties within the group. What amounted to self-dealing had tax advantages (interest on mortgage payments are tax-deductible) and obscured the actual ownership of the properties. The boards of these seventy odd corporations included at least one member of the Shapolsky family or someone with close ties. The 142 known properties were located predominantly on the Lower East Side and in Harlem – in 1971 both slum areas of New York City – where they constituted the largest concentration of real estate under the control of a single group. The information for the work was culled from public records at the New York County Clerk's Office. Thomas Messer, then the director of the Solomon R. Guggenheim Museum, rejected this work and two other works which had been made for a solo exhibition at the Museum. He cancelled the exhibition six weeks before the opening when the artist refused to withdraw the disputed works. Messer called them 'inappropriate' for exhibition at the museum and stated he had to 'fend off an alien substance that had entered the art museum organism'. Edward F. Fry, the curator of the exhibition, was fired when he defended the works. Artists held a protest demonstration in the Museum. Over one hundred pledged not to exhibit at the Guggenheim 'until the policy of art censorship and its advocates are changed'. Many commentators assumed that the trustees of the Guggenheim Museum had links to the Shapolsky real estate group. There is no evidence to support such suspicions.

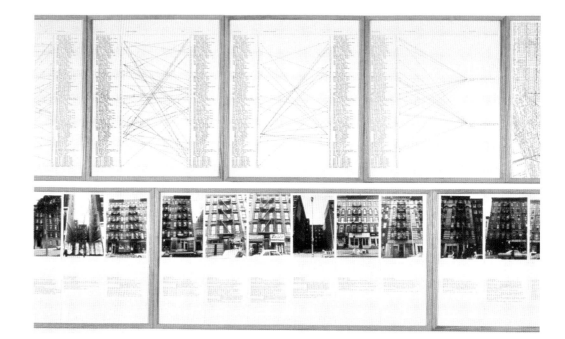

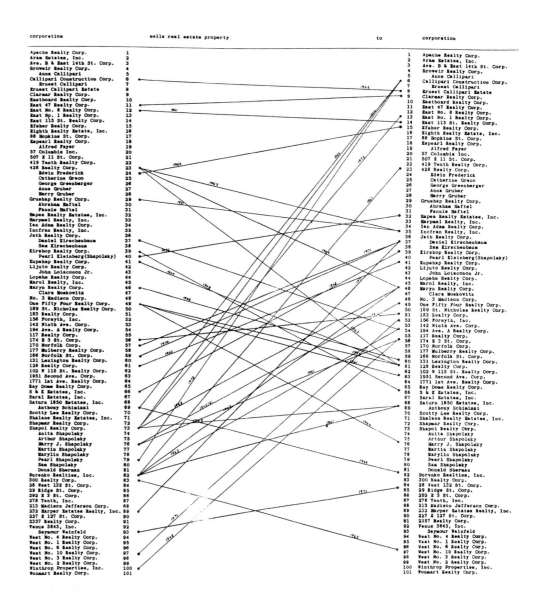

Philadelphia Museum of Art, which contrasted Haacke's dialectical homage *Broken R.M. …* (1986) with its extensive Duchamp collection. The first solo show in a museum in the US was not held until fifteen years later, at New York's Museum of Contemporary Art in 1986.

These facts must be borne in mind if Haacke's resistance to censorship is not to be misunderstood retrospectively. In the early 1970s the art world was not dominated by the avant-garde scandal aesthetic which was redesigned in the 1980s with the provocative stunts deployed by artists like Jeff Koons. These strategies suited the art market, and have done so ever since. Seen in this light, Haacke could be regarded as a pioneer of this type of provocative art. But during the 1960s and 1970s art was still taken seriously as engine of aesthetic and social change, thus placing strong moral demands on its exponents.

It was against the background of this morality that Haacke relinquished his one-person show. The esteem and recognition that he garnered at the time did in no way boost his market value. On the contrary, Haacke had nothing to fall back on at the time, since Howard Wise had closed his gallery in 1970 to devote himself exclusively to the promotion of video art.

If Haacke enjoyed a relative independence at the time it was only due to his teaching position in the Art School of The Cooper Union in New York. Beginning in 1967 as a part-time instructor, he was appointed to a full-time position in 1971 and was granted tenure in 1975. Apart from that he enjoyed his exchange with students, this position provided Haacke and his family with an economic base, important also for the years to come, because it allowed him to produce works he might otherwise not have dared considering.

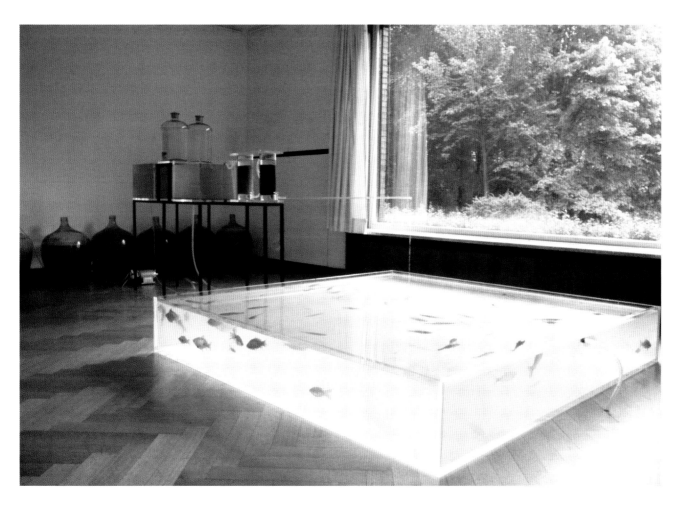

Fortunately, in 1972 Haacke was among the participants in documenta 5, curated by Harald Szeemann. Three years before, Szeemann had shown Haacke's work in 1969 in his pioneering show 'When Attitudes Become Form' (Kunsthalle Berne, and tour), one of the first European shows of contemporary art to be sponsored by a multi-national company, in this case Philip Morris Europe; corporate sponsorship of art exhibitions became a challenge artists had to deal with in the years that followed. Haacke was also taken up in 1973 by the New York dealer John Weber, on the recommendation of Carl Andre, even though Weber could have feared that his relations with museums might be damaged as a result.

The material that had been planned for the catalogue to Haacke's Guggenheim exhibition was published with the title *Werkmonografie* in German by the Cologne publisher DuMont Verlag, in 1972. Twenty-five years later, the high esteem that Haacke had gained from these censored works was expressed again when Catherine David, in 1997, showed *Shapolsky et al. Manhattan Real Estate Holdings, a Real-Time Social System, as of May 1, 1971* at Documenta X as one of the key artworks of the post-war generation.

Haacke was rather surprised by the potential for conflict in his very first works of social criticism. This blow to his career led to another turning point in his artistic development. The freedom of art now became a central theme in his work, with which he once more gained an outstanding international reputation.

His first solo exhibition after the Guggenheim

episode was held in 1972 at the renowned Museum Haus Lange in Krefeld, Germany. In addition to other works he showed *Rheinwasseraufbereitungsanlage* (*Rhine Water Purification Plant*, 1972), which developed Haacke's ecological concerns of the late 1960s. Highly polluted water taken from the Rhine river was pumped through a system of filters to fill a large basin where the presence of living goldfish proved that it was clean. The idyllic, 'Franciscan' direction of his work with plants and animals almost inevitably led him to its political implications. The work drew attention to environmental pollution in the Rhineland, where the region's dominant river, once praised and painted by the Romantics, had long since become a stinking chemical sewer for the industries on its banks.

From this time onwards Haacke was seen as a political artist. One could say, however, that this categorization is, at least in the traditional sense, misleading. He is not a political artist who would enlist art to support a party or a particular ideological programme; quite to the contrary, his work addresses the way in which managers and politicians instrumentalize art. He examines what is required for art to be free, and he makes this the subject of his work whenever he sees this freedom endangered. The general perception of the 'political' Haacke tends to conceal the artist Haacke – even in the art world – for two main reasons. Firstly, the early work of the 1960s and early 1970s is largely ignored, and rarely included in exhibitions. Secondly, studies of his work seldom foreground the specific formal decisions that he has made.

In 1974 Haacke devised – not without motives of vengeance – *Solomon R. Guggenheim Museum Board of Trustees*, a work that implicitly demonstrated that the statutes of the Guggenheim Museum were at odds with the interests of its trustees. With the same painstaking research that he had previously devoted to the corruption of the New York real estate world, he now traced the political and economic entanglements of an art institution that could only commit itself to the support of art to the extent that the business relations of the museum's promoters and friends remained untouched. In particular, relations with Chile, where Guggenheim-related copper mining interests had played an important part in the overthrow of Salvador Allende's elected social-democratic government, were a case in point.

In the same year, Haacke created a work for the exhibition 'PROJEKT '74. Kunst bleibt Kunst' ('PROJECT '74. Art Remains Art'), planned in Cologne by the Wallraf-Richartz-Museum for its 150th anniversary, in conjunction with the local Kunsthalle and the Kölnischer Kunstverein. Entitled *Manet-PROJEKT '74*, it marked the start of a new phase in Haacke's work, and has become a classic of twentieth-century art.

Haacke subtly picked up on and subverted the title of the exhibition with a ten-panel work about the turbulent and surprising fate of a painting by Edouard Manet, *Bunch of Asparagus* (1880), as it passed through the hands of its various owners before being bought for the Wallraf-Richartz-Museum by an acquisition committee of the museum's friends. Every temporary owner of the painting was presented, along with their

Rheinwasseraufbereitungsanlage (Rhine Water Purification Plant)
1972
Glass and acrylic containers, pump, polluted Rhine water, tubing, filters, chemicals, goldfish, drainage to garden
Dimensions variable
Installation, Museum Haus Lange, Krefeld.
Highly-polluted Rhine water was treated through a system of chemical agents and filters. After having gone through this process, it was a fit habitat for the survival of goldfish. A hose carried the overflow out to the garden of the museum where it seeped into the ground.
At the time of the exhibition, the City of Krefeld annually discharged 42 million cubic metres of untreated household and industrial waste water into the Rhine.
The Museum Haus Lange in Krefeld, like its parent, the Kaiser-Wilhelm-Museum is a municipal institution. The director is a civil servant.

SOLOMON R. GUGGENHEIM MUSEUM

CORPORATE AFFILIATION OF TRUSTEES

Kennecott Copper Corporation

FRANK R. MILLIKEN, President, Chief Exec. Officer & Member Board of Directors

PETER O. LAWSON-JOHNSTON, Member Board of Directors

ALBERT E. THIELE, past Member Board of Directors

Multinational company mining, smelting, refining copper, molybdenum, gold, zinc and coal. Copper based mill products.

Operates in the U.S., Australia, Brazil, Canada, Colombia, Costa Rica, England, Indonesia, Italy, Netherlands Antilles, Nigeria, Peru, South Africa.

El Teniente, Kennecott's Chilean copper mine, was nationalized July, 1971 through Constitutional Reform Law, passed unanimously by Chilean Congress. Chilean Comptroller General ruled profits over 12% a year since 1955 to be considered excess and deducted from compensation. His figures, disputed by Kennecott, in effect, eliminated any payments.

Kennecott tried to have Chilean copper shipments confiscated or customers' payments attached. Although without ultimate success in European courts, legal harassment threatened Chilean economy (copper 70% of export).

President Salvador Allende addressed United Nations December 4, 1972. The New York Times reported:

The Chilean President had still harsher words for two U.S. companies, the International Telephone & Telegraph Corp. and the Kennecott Corp., which he said, had "dug their claws into my country", and which proposed "to manage our political life."

Dr. Allende said that from 1955 to 1970 the Kennecott Copper Corp. had made an average profit of 52.8% on its investments.

He said that huge "transnational" corporations were waging war against sovereign states and that they were "not accountable to or representing the collective interest."

In a statement issued in reply to Dr. Allende's charges, Frank R. Milliken, president of Kennecott, referred to legal actions now being taken by his company in courts overseas to prevent the Chilean Government from selling copper from the nationalized mines:

"No amount of rhetoric can alter the fact that Kennecott has been a responsible corporate citizen of Chile for more than 50 years and has made substantial contributions to both the economic and social well-being of the Chilean people."

"Chile's expropriation of Kennecott's property without compensation violates established principles of international law. We will continue to pursue any legal remedies that may protect our shareholders' equity."

President Allende died in a military coup Sept. 11, 1973. The Junta committed itself to compensate Kennecott for nationalized property.

1973 Net sales : $1,425,613,531 Net after taxes : $159,363,059 Earn. per com. share : $4.81

29,100 employees

Office: 161 E. 42 St., New York, N.Y.

biographical data, including that of the Chairman of the committee, the German banker Hermann J. Abs, who had played a key role in the economic design and stabilization of Nazism. Such biographical details had tended to be suppressed in the post-war period, but Haacke had only to go to the Bonn university library to dig them up. Given that most of the previous owners of the Manet, including the artist Max Liebermann, had been Jewish, the revelation of Abs' past provided a cultural-historical twist with a considerable impact. Under pressure from the Director of the museum (presumably in the interest of Abs, who, as the post-war chairman of the Deutsche Bank for many years, was still extraordinarily influential), the curators were forced not to admit Haacke's work to the exhibition.

As a protest against this scandalous decision, the artist Daniel Buren made small photocopies of Haacke's panels and pasted them onto his exhibit. Buren was then censored in turn. The photocopies were pasted over with white paper or torn off. Marcel Broodthaers also showed solidarity with Haacke by adding a second palm tree to his

These questions and your answers are part of

Hans Haacke's **DOCUMENTA–VISITORS' PROFILE**

a work in progress during documenta 5.

Please fill out this questionnaire
and drop it into the box
provided for this. Don't sign.

Example. () ■
Use a pencil. (←) ■
Only horizontal lines! () ■

1 Do you have a professional interest in art, e.g. artist, critic, dealer, etc. ?
yes () ■
no () ■

2 Do you think an artist who exhibits a painting depicting Franz Josef Strauß with a swastika, should be prosecuted?
yes () ■
no () ■

3 What school do you or did you attend last?
Grade/Primary School () ■
Secondary/High School () ■
Junior College () ■
Professional/Trade School () ■
Undergraduate/Graduate School () ■

4 The Ostpolitik of which party do you prefer?
the Ostpolitik of the SPD-FDP () ■
of the CDU/CSU () ■
don't know () ■

5 Do you think members of communist organizations should not be appointed to positions in the civil service?
yes () ■
no () ■
don't know () ■

6 Where do you live?
in Kassel () ■
within 40 km of Kassel () ■
elsewhere in Hesse () ■
elsewhere in the Federal Republic () ■
abroad () ■

7 Are you for the legalization of abortions?
yes, generally () ■
only during the first 3 months generally () ■
only in case of mental/social hardship,& rape () ■
only if health of mother/child is in danger () ■
no, under no circumstances () ■

8 Sex?
male () ■
female () ■

9 What is your religion?
Protestant () ■
Catholic () ■
other () ■
none () ■

10 What do you think about the influence of the churches in the Federal Republic?
it is too little () ■
too great () ■
just right () ■
don't know () ■

11 What do you think about the influence of the unions in the Federal Republic?
it is too little () ■
too great () ■
just right () ■
don't know () ■

12 If elections were held today, which party would you vote for?
SPD () ■
CDU/CSU () ■
FDP () ■
NPD () ■
DKP () ■
other () ■
none, don't know () ■

13 Have you ever taken one of the following drugs (without prescription)?
hashish, marihuana () ■
opium () ■
morphium, heroin () ■
codein () ■
LSD, mescaline , () ■
other hallucinogenic drugs () ■
amphetamines () ■
barbiturates () ■
none () ■

14 How old are you?
under 20 years () ■
20 - 25 years () ■
25 - 30 years () ■
30 - 35 years () ■
35 - 45 years () ■
45 - 55 years () ■
over 55 years () ■

15 Do you think the interests of big industry are generally compatible with the common good?
yes () ■
no () ■
don't know () ■

16 Would you be willing to pay higher taxes and/or prices for the rehabilitation of the environments?
yes () ■
no () ■
don't know () ■

17 What is your net income per month?
under DM 700 () ■
DM 700 - 1000 () ■
DM 1000 - 1400 () ■
DM 1400 - 1800 () ■
DM 1800 - 2500 () ■
DM 2500 - 3500 () ■
over DM 3500 () ■

18 Do you think the tax rate for an annual income of more than DM 200.000 should be raised to 60%?
yes () ■
no () ■
don't know () ■

19 What is or was your profession?
unskilled worker () ■
skilled worker () ■
employee(lower echelon) () ■
employee(qualified supervisor) () ■
senior executive () ■
civil servant(lower echelon) () ■
civil servant(middle echelon) () ■
civil servant(upper echelon) () ■
professional () ■
selfemployed(other) () ■
farmer () ■
housewife () ■
armed forces () ■
grade/highschool student () ■
apprentice () ■
university student () ■

20 Are you in favor of the City of Kassel, the State of Hesse and the Federal Republic financing documenta 5 with your tax money?
yes () ■
no () ■
don't know () ■

Thank you for your cooperation. Your answers will be processed by computer. The results will be posted in the exhibition.

Documenta-Besucherprofil (Documenta Visitors' Profile)
1972
Machine-readable multiple-choice questionnaires, print-out of results
Installation, documenta 5, Kassel.
The visitors of documenta 5 (30 June–8 October 1972) were asked, in German, English and French, to complete a machine-readable multiple-choice questionnaire, comprised of ten demographic questions and ten questions on topical sociopolitical issues. The answers were processed by the computer centre of the Kassel region. Periodically updated printouts of the results of the poll were posted in the exhibition. 19.8% (41,810) of the visitors participated.

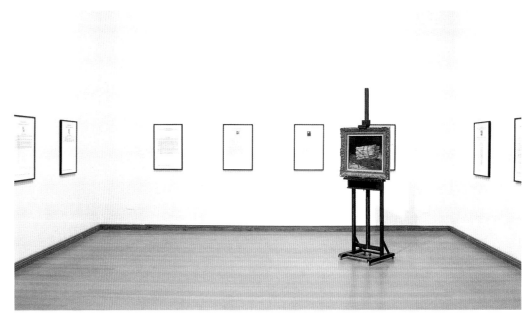

Daniel Buren
Art Remains Politics (detail)
Daniel Buren incorporated
facsimiles of the censored panels
of *Manet-PROJEKT '74* into his
work in the Wallraf-Richartz-
Museum's anniversary exhibition.
The General Director of Cologne
Museums, Prof. von der Osten,
had them pasted over with paper.

installation as an ironic gesture. The art dealer Paul Maenz, who had been committed to Conceptual art since the 1970s, immediately offered to show Haacke's censored work in his Cologne gallery for the duration of the 'PROJEKT '74' exhibition, which put the finishing touches to the scandal, since its object had not been censored effectively. West Germany's post-war discretion about the former economic functionaries of Nazism had been introduced as a topic in the art world for the first time.

Manet-PROJEKT '74 suggested – as did the writings of the art philosopher Walter Benjamin, who was being rediscovered at the time – that the way in which a work is received, its afterlife and changes in its interpretation, are a valid subject for art history. Above all it disputed, through the prosaic facts of purchases, sales and inheritances, the ideology of art's timelessness and autonomy. One of the work's most powerful qualities was its simplicity; all Haacke had to do was research the facts and put them in the right context. They spoke for themselves. As with *Recording of Climate in Art Exhibition*, Haacke seemed again to marginalize a personal artistic 'handwriting'.

This work attracted a powerful collector who had not previously shown much interest in Conceptual art: the Aachen chocolate manufacturer and Pop art fan Peter Ludwig. However, the sale of this work fell through because Ludwig was not prepared to sign the sales contract with which Haacke had sealed all his transactions since 1971. Devised by the art agent Seth Siegelaub in collaboration with a New York lawyer, it is a model contract, reserving certain rights to the artists, such as an entitlement to fifteen per cent of the profits of subsequent sales, and the right to borrow the work for exhibitions at certain intervals and to veto loans to exhibitions in which the artist did not want it to be shown. Ludwig, who was much praised as an art patron at that time, felt that this artist-friendly contract made unreasonable demands. But the relations between the two protagonists of this failed transaction would not end here.

Experiences like the Cologne exhibition served only to reinforce Haacke's mistrust regarding the alleged independence of cultural institutions and contingent guarantees of artistic freedom. The next year he produced *On Social Grease* (1975), a much-cited classic of his institutional critique. Over the years, Haacke had collected quotations in

Das Spargel-Stilleben
erworben mit Stiftungen von

Hermann J. Abs, Frankfurt
Viktor Achter, Mönchengladbach
Agrippina Rückversicherungs AG., Köln
Allianz Versicherung AG., Köln
Heinrich Auer Mühlenwerke, Köln
Bankhaus Heinz Ansmann, Köln
Bankhaus Delbrück von der Heydt & Co., Köln
Bankhaus Sal. Oppenheim jr. & Cie., Köln
Bankhaus C. G. Trinkaus, Düsseldorf
Dr. Walter Berndorff, Köln
Firma Felix Böttcher, Köln
Robert Bosch GmbH, Köln
Central Krankenversicherungs AG., Köln
Colonia Versicherungs-Gruppe, Köln
Commerzbank AG., Düsseldorf
Concordia Lebensversicherungs AG., Köln
Daimler Benz AG., Stuttgart-Untertürkheim
Demag AG., Duisburg
Deutsch-Atlantische Telegraphenges., Köln
Deutsche Bank AG., Frankfurt
Deutsche Centralbodenkredit AG., Köln
Deutsche Continental-Gas-Ges., Düsseldorf
Deutsche Krankenversicherungs AG., Köln
Deutsche Libby-Owens-Ges. AG., Gelsenkirchen
Deutsche Solvay-Werke GmbH, Solingen-Ohligs
Dortmunder Union-Brauerei, Dortmund
Dresdner Bank AG., Düsseldorf
Farbenfabriken Bayer AG., Leverkusen
Gisela Fitting, Köln
Autohaus Jacob Fleischhauer K. G., Köln
Glanzstoff AG., Wuppertal
Graf Rüdiger von der Goltz, Düsseldorf
Dr. Paul Gülker, Köln
Gottfried Hagen AG., Köln
Hein. Lehmann & Co. AG., Düsseldorf
Hilgers AG., Rheinbrohl
Hoesch AG., Dortmund
Helmut Horten GmbH, Düsseldorf
Hubertus Brauerei GmbH, Köln
Karstadt-Peters GmbH, Köln
Kaufhalle GmbH, Köln
Kaufhof AG, Köln
Kleinwanzlebener Saatzucht AG., Einbeck

Klöckner Werke AG., Duisburg
Kölnische Lebens- und Sachvers. AG., Köln
Viktor Langen, Düsseldorf-Meerbusch
Margarine Union AG., Hamburg
Mauser-Werke GmbH, Köln
Josef Mayr K. G., Hagen
Michel Brennstoffhandel GmbH, Düsseldorf
Gert von der Osten, Köln
Kurt Pauli, Lövenich
Pfeifer & Langen, Köln
Preussag AG., Hannover
William Prym Werke AG., Stolberg
Karl-Gustav Ratjen, Königstein (Taunus)
Dr. Hans Reuter, Duisburg
Rheinisch-Westf. Bodenkreditbank, Köln
Rhein.-Westf. Isolatorenwerke GmbH, Siegburg
Rhein.-Westf. Kalkwerke AG., Dornap
Sachtleben AG., Köln
Servais-Werke AG., Witterschlick
Siemag Siegener Maschinenbau GmbH, Dahlbruch
Dr. F. E. Shinnar, Tel-Ganim (Israel)
Sparkasse der Stadt Köln, Köln
Schlesische Feuervers.-Ges., Köln
Ewald Schneider, Köln
Schoellersche Kammgarnspinnerei AG., Eitorf
Stahlwerke Bochum AG., Bochum
Dr. Josef Steegmann, Köln-Zürich
Strabag Bau AG., Köln
Dr. Nikolaus Graf Strasoldo, Burg Gudenau
Cornelius Stüssgen AG., Köln
August Thyssen-Hütte AG., Düsseldorf
Union Rhein. Braunkohlen AG., Wesseling
Vereinigte Aluminium-Werke AG., Bonn
Vereinigte Glaswerke, Aachen
Volkshilfe Lebensversicherungs AG., Köln
Jos. Voss GmbH & Co. KG., Brühl
Walther & Cie. AG., Köln
Wessel-Werk GmbH, Bonn
Westdeutsche Bodenkreditanstalt, Köln
Westd. Landesbank Girozentrale, Düsseldorf
Westfalenbank AG., Bochum
Rud. Siedersleben'sche O. Wolff-Stiftg., Köln

opposite, top and following pages,
Manet-PROJEKT '74
1974
10 panels in black frames under glass;
1 colour photo reproduction of
Manet's *La botte d'asperges* (*Bunch of
Asparagus*) in its museum frame,
photographed by Rolf Lillig
Panels, 80 × 52 cm each; Manet
reproduction, 83 × 94 cm
First installed, Galerie Paul Maenz,
Cologne
opposite, top, installation,
'DeutschlandBilder: Kunst aus einem
geteilten Land', Martin-Gropius-Bau,
Berlin.

In 1974, to celebrate its 150th
anniversary, the Wallraf-Richartz-
Museum, Cologne, organized the
exhibition 'PROJEKT '74'. The show
was to present 'aspects of
international art at the beginning of
the 1970s'.
Invited to participate, Haacke
submitted an outline for a new work:
Manet's *Bunch of Asparagus* of 1880,
collection Wallraf-Richartz-Museum,
is on a studio easel in an approx. 6 ×
8 m room of 'PROJEKT '74'. Panels on
the walls present the social and
economic position of the persons who
have owned the painting, and the
prices paid for it.
The Museum's curator of modern art
responded that even though this was
'one of the best projects submitted',
it could neither be realized in the
exhibition nor presented in the
catalogue.
The director of the Museum, Dr Keller,
objected to the listing of Hermann J.
Abs' nineteen positions on boards of
directors (Abs had been instrumental
in acquiring the painting for the
Museum). Dr Keller explained: ' ... a
grateful museum and an appreciative
city ... must protect initiatives of such
an extraordinary nature from any
interpretation that might later throw
even the slightest shadow on it ... '
And he remarked: 'A museum knows
nothing about economic power;
however, it does, indeed, know
something about spiritual power.'
On the day of the Museum's press
opening, the excluded work went on
exhibition at Galerie Paul Maenz in
Cologne. Standing in for the original
Bunch of Asparagus was a full-size
colour reproduction.
Daniel Buren incorporated facsimiles
of the censored panels into his work
in the Museum's anniversary show.
The General Director of Cologne
Museums, Prof. von der Osten, had
them pasted over with paper.
Until his death in 1994, Hermann J.
Abs was barred from entering the US
because of his role at the Deutsche
Bank, during the Nazi period, in the
'Aryanization' of Jewish property.
Translation of text, left, *Bunch of
Asparagus acquired with donations
from* [...]

Translation of text,
Hermann J. Abs
Born 1901 in Bonn. Descendent of well-to-do Catholic family. Father, Dr Josef Abs, attorney and judge, co-owner of Hubertus Braunkohlen AG Brüggen, Erft (brown coal mining company). Mother, Katharina Lückerath.

1919, graduates from Realgymnasium Bonn. Studies one semester law, University of Bonn. Trains as banker at Bankhaus Delbrück von der Heydt & Co., Cologne. Gains experience in international banking in Amsterdam, London, Paris, the United States.

1928, marries Inez Schnitzler. Her father related to Georg von Schnitzler, member of executive committee of I.G. Farben group. Aunt married to Baron Alfred Neven du Mont. Sister married to Georg Graf von der Goltz. Birth of two children, Thomas and Marion Abs. Member of Zentrumspartei (Catholic Party). 1929 on staff at Bankhaus Delbrück, Schickler & Co., Berlin, with power of attorney. 1935–37, one of five partners of the bank.

1937 on board of directors and member of executive committee of Deutsche Bank in Berlin. Chief of its foreign division. 1939, appointed member of advisory council of Deutsche Reichsbank by Walther Funk, Minister of Economic Affairs of the Reich. Member of committees of the Reichsbank, Reichsgruppe Industrie, Reichsgruppe Banken, Reichswirtschaftskammer, and Arbeitskreis of the Minister of Economic Affairs. 1944 on more than fifty boards of directors. Membership in associations for the advancement of German economic interests abroad.

1946 imprisoned by British. Cleared by Allied denazification board and placed in category five (exonerated of active support of Nazi regime).

1948 participated in foundation of Kreditanstalt für Wiederaufbau (Credit Agency for Reconstruction). Extensive involvement in economic planning by West German government. Economic advisor to Chancellor Konrad Adenauer. 1951–53, head of German delegation to London conference negotiating German war debts. Advisory role during negotiations with Israel at Conference on Jewish Material Claims in The Hague. 1954 member of CDU (Christian Democratic Party).

1952 on board of directors of Süddeutsche Bank AG. 1957–67, president of Deutsche Bank AG. Since 1967 chairman of the board.

Honorary chairman of board of directors:
Deutsche Überseeische Bank, Hamburg; Pittler Maschinenfabrik AG, Langen (Hesse).
Chairman of the board of directors: Dahlbusch Verwaltungs-AG, Gelsenkirchen; Daimler Benz AG, Stuttgart-Untertürkheim; Deutsche Bank AG, Frankfurt; Deutsche Lufthansa AG, Köln, Philipp Holzmann AG, Frankfurt; Phoenix Gummiwerke AG, Hamburg-Harburg; RWE Elektrizitätswerk AG, Essen; Vereinigte Glanzstoff AG, Wuppertal-Elberfeld; Zellstoff-Fabrik Waldhof AG, Mannheim.
Honorary chairman: Salamander AG, Kornwestheim; Gebr. Stumm GmbH, Brambauer (Westphalia); Süddeutsche Zucker-AG, Mannheim.
Vice-chairman of the board of directors: Badische Anilin- und Sodafabrik AG, Ludwigshafen; Siemens AG, Berlin-München.
Member of the board of directors: Metallgesellschaft AG, Frankfurt.
President of supervisory board: Kreditanstalt für Wiederaufbau; Deutsche Bundesbahn.
Great Cross of the Order of Merit with Star of the Federal Republic of Germany, Papal Star with Cross of the Commander, Great Cross of Isabella the Catholic of Spain, Cruzeiro do Sul of Brazil, Knight of the Order of the Holy Sepulcher. Honorary doctorate degrees from universities of Göttingen, Sofia, Tokyo, and Wirtschaftshochschule Mannheim.
Lives in Kronberg (Taunus) and Bentgerhof near Remagen.
Photo from Current Biography Yearbook 1970, New York.

Das Spargel-Stilleben
erworben durch die Initiative des Vorsitzenden des Wallraf-Richartz-Kuratoriums

Hermann J. Abs

Geboren 1901 in Bonn. – Entstammt wohlhabender katholischer Familie. Vater Dr. Josef Abs, Rechtsanwalt und Justizrat, Mitinhaber der Hubertus Braunkohlen AG. Brüggen, Erft. Mutter Katharina Lückerath.

Abitur 1919 Realgymnasium Bonn. – Ein Sem. Jurastudium Universität Bonn. – Banklehre im Kölner Bankhaus Delbrück von der Heydt & Co. Erwirbt internationale Bankerfahrung in Amsterdam, London, Paris, USA.

Heiratet 1928 Inez Schnitzler. Ihr Vater mit Georg von Schnitzler vom Vorstand des IG. Farben-Konzerns verwandt. Tante verheiratet mit Baron Alfred Neven du Mont. Schwester verheiratet mit Georg Graf von der Goltz. – Geburt der Kinder Thomas und Marion Abs.

Mitglied der Zentrumspartei. – 1929 Prokura im Bankhaus Delbrück, Schickler & Co., Berlin. 1935-37 einer der 5 Teilhaber der Bank.

1937 im Vorstand und Aufsichtsrat der Deutschen Bank, Berlin. Leiter der Auslandsabteilung. – 1939 von Reichswirtschaftsminister Funk in den Beirat der Deutschen Reichsbank berufen. – Mitglied in Ausschüssen der Reichsbank, Reichsgruppe Industrie, Reichsgruppe Banken, Reichswirtschafts-kammer und einem Arbeitskreis im Reichswirtschaftsministerium. – 1944 in über 50 Aufsichts- und Verwaltungsräten großer Unternehmen. Mitgliedschaft in Gesellschaften zur Wahrnehmung deutscher Wirtschaftsinteressen im Ausland.

1946 für 6 Wochen in britischer Haft. – Von der Alliierten Entnazifizierungsbehörde als entlastet (5) eingestuft.

1948 bei der Gründung der Kreditanstalt für Wiederaufbau. Maßgeblich an der Wirtschafts-planung der Bundesregierung beteiligt. Wirtschaftsberater Konrad Adenauers. – Leiter der deutschen Delegation bei der Londoner Schuldenkonferenz 1951-53. Berater bei den Wiedergutmachungsver-handlungen mit Israel in Den Haag. 1954 Mitglied der CDU.

1952 im Aufsichtsrat der Süddeutschen Bank AG. – 1957-67 Vorstandssprecher der Deutschen Bank AG. Seit 1967 Vorsitzender des Aufsichtsrats.

Ehrenvorsitzender des Aufsichtsrats:
Deutsche Überseeische Bank, Hamburg – Pittler Maschinenfabrik AG, Langen (Hessen)
Vorsitzender des Aufsichtsrats:
Dahlbusch Verwaltungs-AG, Gelsenkirchen – Daimler Benz AG, Stuttgart-Untertürkheim –
Deutsche Bank AG, Frankfurt – Deutsche Lufthansa AG, Köln – Philipp Holzmann AG, Frankfurt –
Phoenix Gummiwerke AG, Hamburg-Harburg – RWE Elektrizitätswerk AG, Essen –
Vereinigte Glanzstoff AG, Wuppertal-Elberfeld – Zellstoff-Fabrik Waldhof AG, Mannheim

Ehrenvorsitzender:
Salamander AG, Kornwestheim – Gebr. Stumm GmbH, Brambauer (Westf.) –
Süddeutsche Zucker-AG, Mannheim
Stellvertr. Vors. des Aufsichtsrats:
Badische Anilin- und Sodafabrik AG, Ludwigshafen – Siemens AG, Berlin-München
Mitglied des Aufsichtsrats:
Metallgesellschaft AG, Frankfurt
Präsident des Verwaltungsrats:
Kreditanstalt für Wiederaufbau – Deutsche Bundesbahn

Großes Bundesverdienstkreuz mit Stern, Päpstl. Stern zum Komturkreuz, Großkreuz Isabella die Katholische von Spanien, Cruzeiro do Sul von Brasilien. – Ritter des Ordens vom Heiligen Grabe. – Dr. h.c. der Univ. Göttingen, Sofia, Tokio und der Wirtschaftshochschule Mannheim.

Lebt in Kronberg (Taunus) und auf dem Bentgerhof bei Remagen.

Photo aus Current Biography Yearbook 1970 New York

Translation of text,
*1968, Bunch of Asparagus
through Mrs Marianne Feilchenfeldt
of Zurich
acquired for 1,360,000
Deutschmark by the
Wallraf-Richartz-Kuratorium
(Friends of the Museum)
and the City of Cologne
Presented to the Wallraf Richartz
Museum as a permanent loan
by Hermann J. Abs, chairman of
the Kuratorium on 18 April 1968,
in memory of Konrad Adenauer.
Wallraf-Richartz-Kuratorium und
Förderer Gesellschaft e.V.
Executive Committee and trustees:
Hermann J. Abs, Prof. D. Kurt
Hansen, Dr Günter Henle, Prof. Dr
Ernst Schneider, Prof. Dr Otto H.
Förster, Prof. Dr Gert von der Osten
(managing director).
Trustees: Prof. Dr Victor Achter, Dr
Max Adenauer, Fritz Berg, Dr
Walther Berndorff, Theo Burauen,
Prof. Dr Fritz Burgbacher, D. Fritz
Butschkau, Dr Felix Eckhardt, Mrs
Gisela Fitting, Prof. Dr Kurt
Forberg, Walter Franz, Dr Hans
Gerling, Dr Herbert Girardet, Dr
Paul Gülker, Iwan D. Herstatt,
Raymund Jörg, Eugen Gottlieb van
Langen, Viktor Langen, Dr Peter
Ludwig, Prof. Dr Heinz Mohnen
Cai Graf zu Rantzau, Karl Gustav
Ratjen, Dr Hans Reuter, Dr Hans-
Günther Sohl, Dr Werner Schulz, Dr
Nikolaus Graf Strasoldo, Christoph
Vowinckel, Otto Wolff von
Amerongen.
Hermann J. Abs presenting the
painting.*

On Social Grease

1975

6 photo-engraved magnesium plates, mounted on aluminium 76 × 76 cm each

Installation, John Weber Gallery, New York.

Authors and sources of quotes:

Frank Stanton. Media executive. CBS Inc., President and CEO 1946–71, Vice-chairman 1971–73, Director 1948–78. Business Committee for the Arts, Director 1967–77, Chairman 1972–74; Chairman Lincoln Center; member New York State Council on the Arts, 1965–70. Quoted from speech 'The Arts – A Challenge to Business', 25th Anniversary Public Relations Conference of American and Canadian Public Relations Society, Detroit, 12 November 1972.

David Rockefeller. Banker. Chase Manhattan Bank Corp., Chairman 1969–81. Co-founder Trilateral Commission 1973. Council on Foreign Relations, Vice-president 1950–70, Chairman 1970–85. The Museum of Modern Art, New York, Trustee since 1948, Chairman 1962–72 and 1987–93; Business Committee for the Arts, co-founder and Director. Quote from speech 'Culture and the Corporation's Support of the Arts', National Conference Board, 20 September 1966.

Robert Kingsley. Manager of Urban Affairs, Department of Public Affairs, Exxon Corp., New York, 1969–77. Founder, Chairman of Arts and Business Council, New York. Quote in Marylin Bender, 'Business Aids the Arts … and Itself', *New York Times*, 20 October 1974. Died 1980.

C. Douglas Dillon. Investment banker. Dillon, Read & Co., Chairman 1946–53, Chairman Executive Committee 1971–81; US & Foreign Securities Corp. Chairman 1969–84; Metropolitan Museum of Art, New York, President 1970–78, Chairman 1878–93; Business Committee for the Arts, co-founder, first Chairman. Quote from C. Douglas Dillon, 'Cross-Cultural Communication Through the Arts', *Columbia Journal of World Business*, September–October 1971. Died 2003.

Nelson Rockefeller. Governor of New York State 1958–73. US Vice-president 1974–77; The Museum of Modern Art, New York, Trustee 1932–79, President 1939–41, Chairman 1957–58. Quote from report by Grace Glueck, *New York Times*, 1 May 1969. Died 1979.

Richard M. Nixon. President of United States 1968–74. Resigned under pressure from Congress. Quote from address to Congress, *Wall Street Journal*, 2 January 1970. Died 1994.

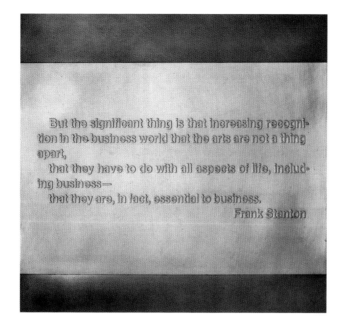

But the significant thing is that increasing recognition in the business world that the arts are not a thing apart,

that they have to do with all aspects of life, including business—

that they are, in fact, essential to business.

Frank Stanton

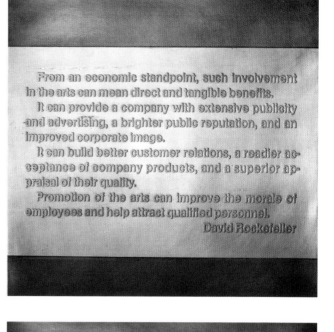

From an economic standpoint, such involvement in the arts can mean direct and tangible benefits.

It can provide a company with extensive publicity and advertising, a brighter public reputation, and an improved corporate image.

It can build better customer relations, a readier acceptance of company products, and a superior appraisal of their quality.

Promotion of the arts can improve the morale of employees and help attract qualified personnel.

David Rockefeller

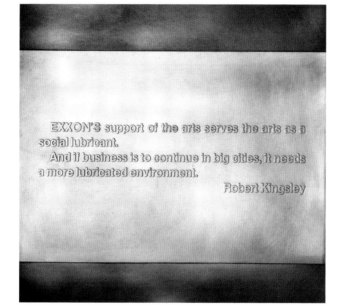

EXXON'S support of the arts serves the arts as a social lubricant.

And if business is to continue in big cities, it needs a more lubricated environment.

Robert Kingsley

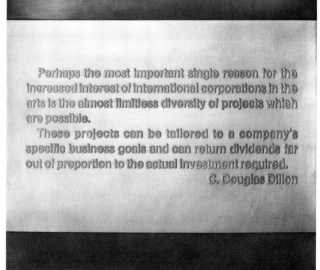

Perhaps the most important single reason for the increased interest of international corporations in the arts is the almost limitless diversity of projects which are possible.

These projects can be tailored to a company's specific business goals and can return dividends far out of proportion to the actual investment required.

C. Douglas Dillon

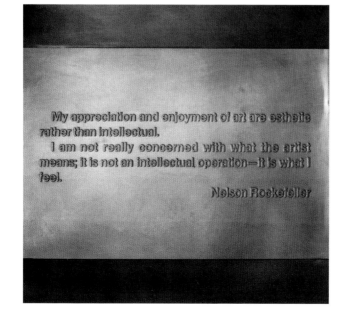

My appreciation and enjoyment of art are esthetic rather than intellectual.

I am not really concerned with what the artist means; it is not an intellectual operation—it is what I feel.

Nelson Rockefeller

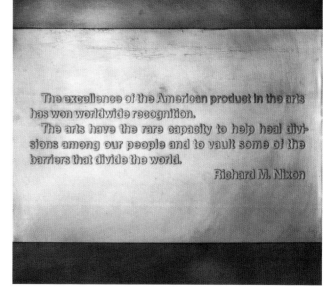

The excellence of the American product in the arts has won worldwide recognition.

The arts have the rare capacity to help heal divisions among our people and to vault some of the barriers that divide the world.

Richard M. Nixon

which politicians and leading business figures describe the relationship between art and commerce. Immortalized on uniform aluminium panels in the powerful, cool aesthetic of Minimalist art and hung in neat rows at the John Weber Gallery, these comments betray a cynicism, coldness and insensitivity towards the aesthetic status and freedom of art. *On Social Grease* became a treasure trove for all opponents of the idea of corporate sponsorship and the neo-liberal traffic between art and commerce.

The next major work in which Haacke addressed the problematic relationship between art and commerce also caused a stir. This time he took on the art collector and chocolate manufacturer, Peter Ludwig. Since their first contact in 1974, Ludwig had become more important in Europe than any other collector of contemporary art. *Der Pralinenmeiser* (*The Chocolate Master*, 1981), was one of the early works in which Haacke used a style other than that of Conceptual or Minimal art. As on many subsequent occasions he drew his inspiration from Pop art. While he had reservations about Pop as a movement, it seemed the appropriate form with which to tackle this manufacturer of consumer goods for a mass market who specialized in collecting works by Pop's leading exponents.

Haacke based this work, which comprised fourteen text-and-image panels, on one of Ludwig's products, a pseudo-stylish brand of chocolate whose packaging exuded petit-bourgeois values. Thus the text was set on a beige ground framed with gold and brown stripes. He included unofficial photographs from the inside of Ludwig's factory in Aachen, taken by the Aachen photographer and art collector Wilhelm Schürmann, showing the everyday life of the workers – mainly seasonally employed immigrant women, who were notoriously badly paid and were housed in dingy hostels on the fringe of Aachen's industrial district.

The fourteen panels were conceived as seven diptychs, alternately showing Ludwig's roles as factory owner and collector of contemporary art. This was bound to tarnish his reputation as a philanthropic patron. Haacke was implying that an art collection can help its owner not only to detach himself from the less pleasant elements of his business but also serve as a smokescreen and an instrument for cultural and political manoeuvres. *The Chocolate Master* was shown for the first time in 1981 at Maenz's gallery in Cologne. A year later, in 1982, it was at documenta 7. Ludwig attempted to buy the work, but this time it was Haacke who refused to sell, afraid that Ludwig would purchase it in order to take it out of circulation.

Ludwig was not the only art collector whose position of power and involvement in commerce Haacke addressed. Concerned about the growing importance of major collectors for the development of art and its market, he also used several works to expose the dual role in art and politics played by the British collector and advertising tycoon Charles Saatchi. *Taking Stock (Unfinished)*, presented in 1984 at Haacke's solo show at the Tate Gallery, London, was a portrait of the Conservative Prime Minister Margaret Thatcher, for whom the advertising agency Saatchi & Saatchi had organized several successful election

Der Pralinenmeister (The Chocolate Master)

1981

Multi-coloured silkscreen prints, collage of photographs and packaging of assorted chocolates and chocolate bars, brown wood frame, glass, arranged as diptychs 100 × 70 cm each

Installation, Galerie Paul Maenz, Cologne.

The German chocolate manufacturer and art collector Peter Ludwig once said, 'The market for Pop Art has been determined by the activities of Mr and Mrs Ludwig'.

Through donations of art works, promised gifts and loans, he also tried to determine the programming and professional appointments in public museums. His contract with the City of Cologne provided 'Appointments for the position of Director as well as the professional staff of the Museum Ludwig are made in consultation with Mr and Mrs Ludwig or the surviving spouse. Prof. Dr Ludwig and his wife are fully apprised of the museum's ongoing work (eg. exhibitions, acquisitions and publications).' The construction of the Museum, a condition for Ludwig's contributions, cost the City DM 273 million. At the Museum's opening in 1986 yearly maintenance was estimated at DM 40 million.

In 1983, Peter Ludwig sold 144 illuminated manuscripts to the Getty Museum (since 1977 the City of Cologne had paid two curators for research on the manuscripts and the publication of a four-volume catalogue). A Ludwig Foundation for Art was endowed with DM 30 million from the sale. It invested its capital in Ludwig's ailing chocolate enterprise. Nevertheless, licensing agreements and factories eventually had to be sold or closed. After the Getty sale, the collector was charged with non-payment of DM 1.5 million in property taxes.

Shortly before his death in 1996, Peter Ludwig asked the 1,400 unionized workers in his German factories to agree to an increase of their work week by two hours, the reduction of vacation days by three, and the elimination of overtime pay – all without wage adjustments. If his demands were not accepted, Ludwig threatened to move his production to Poland and Turkey. Two years after his death his widow sold the company.

Translation of texts,

Art Objects on Permanent Loan Are
Exempt from Property Taxes
Peter Ludwig was born in Koblenz in
1925, the son of the industrialist
Fritz Ludwig (Ludwig Cement
Factory) and Mrs Helene Ludwig
(née Klöckner).
After his military service (1943–45),
he studied law and art history. In
1950, he received a doctorate degree
with a dissertation on Picasso's
Image of Man as an Expression of
his Generation's Outlook on Life.
The dissertation focuses on relations
between contemporary literature and
the work of Picasso. Historical events
get little attention.
In 1951, Peter Ludwig married a
fellow student, Irene Monheim, and
joined Leonard Monheim KG,
Aachen, his father-in-law's business.
In 1952, he became managing
partner; in 1969, president; and in
1978, chairman of Leonard Monheim
AG, Aachen.
Peter Ludwig is represented on the
boards of directors of Agrippina
Versicherungs-Gesellschaft
(insurence) and Waggonfabrik
Uerdingen (freight cars). He is the
chairman of the regional council of
the Deutsche Bank AG for the district
of Cologne-Aachen-Siegen.
Peter and Irene Ludwig have been
collecting art since the beginning of
the 1950s. At first they collected
primarily ancient, medieval, and Pre-
Columbian art. Since 1966, they
have been concentrating on modern
art: Pop Art, Photorealism, Pattern
Painting, art from East Germany,
and the 'New Expressionists'. Since
1972 Peter Ludwig has been adjunct
professor at Cologne University and
holds seminars in art history at the

Museum Ludwig.
Permanent loans of modern art are
located at the Museum Ludwig,
Cologne, the Neue Galerie-Sammlung
Ludwig and the Suermondt-Ludwig-
Museum in Aachen, the National
Galleries in West and East Berlin, the
Kunstmuseum Basel, the Centre
Georges Pompidou in Paris, and the
state museums in Saarbrücken and
Mainz. Medieval works are housed at
the Schnütgen Museum in Cologne,
the Couven Museum in Aachen, and
the Bavarian State Gallery. The
Rautenstrauch-Joest Museum in
Cologne has Pre-Columbian and
African objects, as well as works from
Oceania.
In 1976, the Wallraf-Richartz-
Museum of Cologne (now Museum
Ludwig) received a donation of Pop
Art. The Suermondt-Museum of
Aachen (now Suermondt-Ludwig-
Museum) was given a collection of
medieval art in 1977. A collection of
Greek and Roman art which includes
permanent loans located in Kassel,
Aachen, and Würzburg, was donated
to the Antikenmuseum Basel (now
Antikenmuseum Basel and Museum
Ludwig). In 1981, a collection of
modern art became part of the
Austrian Ludwig Foundation for Art
and Science.
Peter Ludwig is a member of the
Acquisitions Committee of the state
gallery of Düsseldorf, the
International Council of The Museum
of Modern Art, New York, and the
Advisory Council of the Museum
of Contemporary Art, Los Angeles.

Regent
Under the Regent label, the
Monheim Group distributes milk
chocolate and assorted chocolates,
mainly through the low-priced Aldi
chain and vending machines.
The production takes place in
Aachen, where the company employs
2,500 people in two factories. Its
administrative headquarters are
also located there. About 1,300
employees work in the Saarlouis
plant, some 400 in Quickborn, and
approximately 800 in West Berlin.
As it did ten years earlier, in 1981
Monheim had a total of about 7,000
employees (sales tripled over the
same period); 5,000 of these are
women. The blue collar work force
numbers 5,400, of which two-thirds
are unskilled. In addition, the
company employs approximately 900
unskilled seasonal workers.
The labour union Nahrung-Genuss-
Gaststätten negotiated wages
ranging from DM 6.02 (scale E =
assembly line work, under eighteen
years) per hour to DM 12.30 (scale S
= highly skilled work). According to
the union contract, the lowest salary
amounts to DM 1,097 per month,
and the highest salary a minimum of
DM 3,214.
The overwhelming majority of the
2,500 foreign workers are women.
They come predominantly from
Turkey and Yugoslavia. However,
foreign workers are hired by agents
in Morocco, Tunisia, Spain and
Greece, as well (price 'per head': DM
1,000 in 1973). Another contingent
of foreign workers crosses the border
daily from Belgium and Holland.
The company maintains hostels for
its female foreign workers on its
fenced-in factory compound in

Aachen, as well as at other
locations. Three or four women share
a room (the building of hostels for
foreign workers is subsidized by the
Bundesanstalt für Arbeit [Federal
Labour Agency]). The rent is
automatically withheld from the
worker's wage.
The company keeps a check on
visitors to these hostels and, in fact,
turns some away. The press office of
the Aachen Diocese and the
(Catholic) Caritas Association
judged the living conditions as
follows: 'Since most of the women
and girls can have social contacts
only at the workplace and in the
hostels, they are practically living
in a ghetto.'
They also report that female foreign
workers who give birth are obliged
to leave the hostel because Monheim
does not have a daycare centre; or
they must find a foster home for the
child at a price they can hardly
afford. Another option would be
to offer their child for adoption. 'It
should be no problem for a big
company which employs so many
girls and women to set up a daycare
centre.'
The personnel department retorted
that Monheim is 'a chocolate factory
and not a kindergarten'. They added
that it would be impossible to hire
kindergarten teachers; the company
is not a welfare agency.

right and opposite, top,
The Saatchi Collection
(Simulations)
1987
Wood, Formica, artificial roses,
cardboard boxes, bucket, paint
roller, paper, plastic mirror-coated
fibreglass
255 × 193 × 38 cm
Installation, Victoria Miro Gallery,
London, 1987.
Collection, Fonds National d'Art
Contemporain, Paris.
The 1985 annual report of Saatchi
& Saatchi Company PLC quoted
Lenin: 'Everything is connected to
everything else'.
KMP-Compton, a major affiliate of
Saatchi & Saatchi in South Africa,
counted the apartheid regime
among its clients. In 1983, it
promoted the adoption of a new
constitution, which, like its
predecessor, reserved power to the
white minority (16% of the
population) and left the 21 million
blacks (72% of the population)
disenfranchised and confined to
'homelands', arid stretches of
land, scattered around the
country. Blacks were treated as
foreigners in their native land.
In 1986 KMP-Compton designed
a campaign for the government
tourist agency SATOUR in the US
and European press. In each case,
the full-page ads offered a
package travel deal and, after
speaking about 'big game fever',
announced: 'But best of all, let
yourself be pleasantly surprised by
the difference between the South
Africa on your evening news ... and
the real South Africa, that's living,
breathing, and changing for the
better every day.'
When Barclays Bank, the most
important British Bank in South
Africa, withdrew from the country
in 1987, Siegel & Gale, then a
wholly-owned New York subsidiary
of Saatchi & Saatchi, developed
the new corporate identity
programme for its successor, the
First National Bank, including the
bank's logo, the silhouette of a
thorn tree against the sun.
Under the title 'NY Art Now: The
Saatchi Collection', an exhibition
of Charles Saatchi's latest bulk
purchases from nine New York
artists opened in 1987 in his
private museum in north London.
Jean Baudrillard's booklet
Simulations of 1983, is said to have
had a strong impact on several of
the artists.

campaigns. This parodic prestige portrait was
accompanied by references to Saatchi's
involvement with important London institutions,
such as the Tate and the Whitechapel Art Gallery.
It also listed his advertising campaigns for over
thirty international corporations and British state
institutions, as well as for the South African
National Party, who stood for apartheid.

The second work on this theme, *The Saatchi
Collection (Simulations)*, was presented in
September 1987 at the Victoria Miro Gallery,
London, at a time when Saatchi was presenting
an exhibition of newly acquired art from New York
('New York Art Today. The Saatchi Collection').
Saatchi had opened an impressive museum of his

own, and had gained a reputation for his massive
influence on the art market, and indeed for
manipulating it. But this was not the only aspect
that interested Haacke. He was concerned as much
with the role Saatchi & Saatchi played in political
advertisement and their effect on public opinion.
This ironic installation – imitating the agency's
image and typography – took aim at its campaigns
in support of the apartheid regime in South Africa.

South Africa was a key theme in several of
Haacke's works. Since 1978 he had been trying
to expose companies and brands with clandestine
dealings and connections to the racist regime. His
attention was often focused on cases of product
advertising where patrons and sponsors employ art
to blur economic or political conflicts of interest.
Even if art did not play a direct role in their
strategies, Haacke exposed many corporations in
Europe and North America who had links with the
South African government, for example Mercedes
and the Deutsche Bank in Germany, Mobil Oil in the
United States, Bührle (Switzerland), Cartier
(France), Alcan (Canada), Fabrique Nationale
Herstal S.A. (FN) (Belgium) and British Leyland.

These works should not be seen as a thematic
travelling circus, unpacking and displaying its
posters at any old stopping place. On the contrary,
they were site-specific interventions, reacting to
suppressed information, to connections that the
media had marginalized, or to explosive
combinations of culture and politics. Haacke had
thus become a pioneer of a kind of site-specificity
that understands and comments upon the location
in which it is performed, not abstractly and
decoratively, but historically and politically.

bottom, top, **Jeff Koons**
Rabbit
1986
Stainless steel
104 × 48 × 30 cm

bottom, **Haim Steinbach**
Country Weave
1985
Wood, formica, straw baskets,
drift wood
111.5 × 143.5 × 48 cm

Instead of a utopian striving for a union between work and observer, we now see an examination of the multiple forms in which venues and their visitors, images and their viewers, media and their consumers miss each other – accidentally or by design.

For every exhibition Haacke devises a work whose aesthetic and thematic co-ordinates derive directly from its local context. This could relate to companies that are based in the area, or to the influence that questionable sponsors might have on the exhibition venue itself. Thus, inviting Haacke to exhibit can become an acid test of an institution's independence and integrity. Once he has found a rewarding subject, he must then establish how far he wants and can afford to become involved. In 1984 the Mobil Oil company, for example, whose business practice has been the subject of several works, took legal steps to prevent him from displaying their logo. Even though their attempt ultimately came to nothing, this led to a year-long delay in the distribution of a catalogue published by the Tate Gallery and the Stedelijk Van Abbemuseum, Eindhoven.

Haacke is all too pleased to turn the publicity material of companies with questionable activities against them, especially if it already carries an unintended aspect of self-parody. In 1978 he took British Leyland's motto 'A Breed Apart', used in the UK to advertise its prestigious Jaguar, and turned

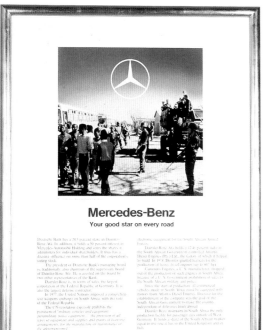

Mercedes-Benz

Your good star on every road

REPUBLIC OF SOUTH AFRICA

DM 200,000,000
8½% Deutsche Mark Bonds of 1983/1991

The investigation of Deutsche Bank revealed that it represented an unusual concentration of economic power, and that it participated in carrying out the criminal policies of the Nazi regime, in the economic sector.

Office of Military Government for Germany, United States Finance Division, Financial Investigation Section, 1946/47

Die Untersuchung der Deutschen Bank hat ergeben, daß sie eine ungewöhnliche Konzentration wirtschaftlicher Macht darstellte und an der Durchführung der verbrecherischen Politik des Naziregimes auf wirtschaftlichem Gebiet teilgenommen hat.

Militärregierung der Vereinigten Staaten für Deutschland Finanzabteilung, Sektion für finanzielle Nachforschungen 1946/47

Wir sind nicht willens und nicht in der Lage, politische Forderungen zu stellen, weil, wenn wir diese gegenüber Südafrika stellen würden, wir sie gegenüber vielen, vielen anderen Ländern und Geschäftspartnern auch stellen müssten. Und das kann und darf nicht unsere Aufgabe sein.

Werner Blessing, Vorstandsmitglied

We are not willing and not in a position to make political demands, because if we were to do so in the case of South Africa, we would have to do so with many, many other countries and business partners as well. This cannot and must not be our job.

Werner Blessing,
Member Managing Board of Directors Deutsche Bank

Kontinuität (Continuity)
1987
3-dimensional adaptation of Deutsche Bank logo, rotating Mercedes neon star, light box, colour transparency (source photo Mark Peters, Black Star), neon tubing, 8 panels, text and photographs, 6 live laurel trees
500 × 350 × 350 cm overall
Installation, documenta 8, Kassel.

Deutsche Bank, the largest German bank, holds a major stake in Daimler-Benz.
In 1986, it installed *Continuity*, a monumental granite sculpture of a double Möbius-strip by Max Bill, in front of its headquarters in Frankfurt. The hallways and rooms of the bank's twin towers are decorated with works by contemporary artists. Each of the fifty-six floors is dedicated to one artist, whose name is listed in the elevator, identifying the floor. In 1997 the bank opened Deutsche Guggenheim in the centre of Berlin, a joint venture with the Solomon R. Guggenheim Museum.
In the 1980s Deutsche Bank led a consortium for a bond issue of the South African government, while Mercedes-Benz supplied the military and police of the apartheid regime with vehicles, and produced heavy diesel engines in a joint venture with a government company. Jürgen E. Schrempp was head of the South African subsidiary of Mercedes. In 1987 he faced a bitter nine-week walkout of its black workers. 2,800 strikers were fired. Schrempp became president of Daimler-Benz in 1995, and in 1998 also of DaimlerChrysler. He resigned from his seat on the board of the New York Stock Exchange in 2003 over a compensation scandal. The corporation maintains an art exhibition space at Potsdamer Platz in Berlin.
Walter Dahn, one of the artists in the bank's Frankfurt collection, denounced it in an open letter (1987) for supporting the apartheid regime, 'I will no longer provide, with my work, a cover of cultural liberalism to an enterprise, which continues to support that ruthless butcher Botha and his corrupt regime'.
Hilmar Kopper, since 1997 the Deutsche Bank chairman, declared in 1995, 'When culture is the instrument with which to distinguish oneself, it has to be held in respect and has to be kept under control.'
The photos of the Deutsche Bank window displays were taken in 1987 at the main branch in Düsseldorf. Translation of the texts in the window displays:
Individuality. Customers expect more from a bank than a friendly smile.
Individuality. We help you fulfill even extraordinary wishes.

No British Leyland military display could be complete without the world-famous Land-Rover. In 28 years of production the Land-Rover has become one of the United Kingdom's greatest export winners, opening up areas of the world previously inaccessible to ordinary vehicles and playing a major role in the development of many overseas territories.

British Leyland. Press Release. Aldershot 1976

Leyland Vehicles. Nothing can stop us now.

Leyland advertising slogan

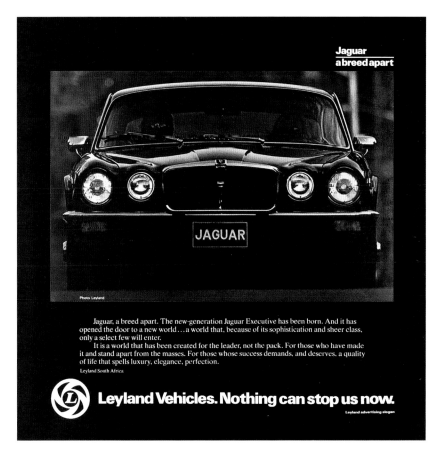

Jaguar, a breed apart. The new-generation Jaguar Executive has been born. And it has opened the door to a new world…a world that, because of its sophistication and sheer class, only a select few will enter.

It is a world that has been created for the leader, not the pack. For those who have made it and stand apart from the masses. For those whose success demands, and deserves, a quality of life that spells luxury, elegance, perfection.

Leyland South Africa

Leyland Vehicles. Nothing can stop us now.

Leyland advertising slogan

The Security Council decides that all States shall cease forthwith any provision to South Africa of arms and related matériel of all types, including the sale or transfer of weapons and ammunition, military vehicles and equipment, paramilitary police equipment, and spare parts of the aforementioned, and shall cease as well the provision of all types of equipment and supplies, and grants of licensing arrangements, for the manufacture or maintenance of the aforementioned.

United Nations Security Council Resolution 418. 1977

Leyland Vehicles. Nothing can stop us now.

Leyland advertising slogan

A Breed Apart (details)
1978
7 panels, photographs on masonite, framed, under glass
91.5 × 91.5 cm each
Installation, Museum of Modern Art, Oxford.
Collection, Tate Gallery, London.
In 1978, the British Anti-Apartheid Movement and the Museum of Modern Art, Oxford sponsored a poster made of the first panel of A Breed Apart, which shows a black man lying prone, surrounded by white South Africa soldiers, against the backdrop of a Land Rover.
Land Rover and Jaguar – in 1978 part of British Government held British Leyland (BL) – are now owned by the Ford Motor Company.

it into a slogan representing the company's co-operation with the South African regime. In a gesture as polished as it was scornful, Haacke perfectly mimicked the advertising campaign's typography, juxtaposing the slogan with photographs showing how blacks were treated in South Africa, against the background of the British Leyland Land Rovers used by the military authorities in South Africa.

Thus the debacle of the Guggenheim censorship became another impetus for developing an artistically complex art of enlightenment that has given Haacke an unmistakable profile. Though he has always wished to avoid a recognizable signature style, subtle, revealing mimicry and a skilful use of ironic quotation, have become his trademark. The artistic quality of his work is perhaps not always immediately perceptible; the artistry appears so plausible that it is easy to forget all the choices and refinement that have gone into it. But once one has gained an insight into Haacke's flexible, job-related language, and understood its sometimes bitter irony, even apparently dry works like *Recording of Climate in Art Exhibition* lose their innocence: was that perhaps a parody too, of the self-referential quality of Conceptual art, which was increasingly tending to sail off into the blue?

Even his return to painting is ambiguous: the three pictures that he executed alongside *Taking Stock (Unfinished)* employ painting merely as an historical medium for official representation. In *Oelgemaelde, Hommage à Marcel Broodthaers (Oil Painting: Homage to Marcel Broodthaers)*, shown at documenta 7 in 1982, he confronted a pompously

Voici Alcan
1983
2 sepia and 1 colour photographs;
aluminium windows; acrylic
plastic; silver foil
3 parts, 220 × 104 cm each
Installation, Galerie France Morin,
Montreal.
Collection, National Gallery of
Canada, Ottawa.
The multinational corporation
Alcan is among the largest
aluminium producers of the world,
with subsidiaries and affiliates
around the globe. During the
apartheid regime it had major
investments in South Africa.
Stephen Biko was the co-founder
and central figure in the Black
People's Convention, the South
African black consciousness
movement. He was arrested,
without charges, by the Special
Branch of the South African police
on 8 August 1977, and detained in
Port Elisabeth. The police
admitted having forced Biko to
spend nineteen days naked in a
cell before he was interrogated
around the clock for fifty hours,
while shackled in handcuffs and
leg irons. During his detention he
suffered severe head injuries. In a
semiconscious state he was taken
in a Land Rover to a hospital in
Pretoria, about fourteen hours
away from Port Elizabeth. He died
from his injuries on 12 September.
Alcan, with headquarters in
Montreal, sponsors cultural
events in the Canadian province
of Quebec, where it is the largest
manufacturing employer.
Translation of text on panels:
left, *LUCIA DI LAMMERMOOR,
produced by the Montreal Opera
Company with funding from Alcan.
Alcan's South African affiliate is
the most important producer of
aluminium and the only fabricator
of aluminium sheet in South
Africa. From a non-white work force
of 2,300 the company has trained
eight skilled workers.*
centre, *STEPHEN BIKO, black
leader. Died from head wounds
received during his detention by
the South African police.
Alcan's South African affiliate sells
to the South African government
semi-finished products which can
be used in police and military
equipment. The company does not
recognize the trade union of its
black workers.*
right, *NORMA, produced by the
Montreal Opera Company.
Alcan's South African affiliate has
been designated a 'key point'
industry by the South African
government. The company's black
workers went on strike in 1981.*

monarchical portrait of a self-satisfied President Reagan with the photograph of a mass protest in Bonn against Reagan's intention to deploy a new generation of medium-range nuclear missiles in West Germany, an event that took place a week before documenta opened. A year later, Haacke delivered an unsolicited *Alcan: Tableau pour la salle du conseil d'administration* (*Alcan: Painting for the Boardroom*) to Alcan, in which he listed the Canadian group's ecological sins.

In 1984, Haacke – the painter – again turned his attention to Ludwig, who was penetrating markets with his chocolate products in the 'Warsaw Pact' countries – East Germany, Bulgaria, Poland, Hungary and the Soviet Union – and was simultaneously collecting officially sanctioned art from these communist states on a grand scale. Ludwig's preferences in the field of art had initially been Anglo-Saxon Pop art and German painters like Georg Baselitz, Gerhard Richter or A.R. Penck. Now these former dissidents and refugees from East Germany saw Ludwig's new acquisitions as an

indication that he was all-too prepared to also enhance the value of art from the communist East. This double game of art imports and chocolate exports provided the theme for *Weite und Vielfalt der Brigade Ludwig* (*Broadness and Diversity of the Ludwig Brigade,* 1984), which brought together two different but ironically complementary pictorial worlds from either side of the wall. Standing for the West, a current poster for a Ludwig chocolate product functioned as a readymade, and for the former German Democratic Republic the 'Chocolate Master' was stirring the cocoa mass himself like a traditional confectioner. Haacke painted him in the manner of the East German painter Willi Sitte, building in layers of varied pictorial quotations: August Sander's photograph of a master confectioner was juxtaposed with the portrait of a officially celebrated female workers' leader by the East German artist Walter Womacka, as well as Jean Olivier Hucleux's double portrait of Ludwig and his wife.

Weite und Vielfalt der Brigade Ludwig (Broadness and Diversity of the Ludwig Brigade)
1984
Oil painting on canvas, billboard with poster, wall
Painting, 225 × 170 cm; poster wall, 267 × 371 cm; wall variable
Installation, 'Nach allen Regeln der Kunst', Neue Gesellschaft für Bildende Kunst, Künstlerhaus Bethanien, Berlin.

The exhibition took place about a hundred yards west of the wall that divided Germany from 1961 to 1989 and where more than 150 people were killed by East German border guards during their attempts to escape to the West. The pose of the German chocolate manufacturer and art collector Peter Ludwig in the centre of the painting is modeled after August Sander's 1928 photograph of a Cologne confectioner. The portrait of his wife (left) is derived from a painting the Ludwigs had commissioned from Jean-Olivier Hucleux. On the right, the officially celebrated East German worker Erika Steinführer, is quoted from a 1981 painting by Walter Womacka (in the Ludwig collection). The painting style of the triple portrait imitates that of Willi Sitti, a member of the East German parliament and head of the state-controlled Artists Association. Only politically vetted artists who belonged to the Association and adhered to established art norms were able to exhibit publicly. Sales were managed by a state agency. Not more than 15% of the sales income accrued to the artists.

Closely co-operating with state authorities, Ludwig amassed a large collection of East German art as well as collections of officially sanctioned art from the Soviet Union and Bulgaria. In return for acting as their cultural emissary, the governments entered into lucrative business deals with Ludwig.

Beginning in the early 1970s, Peter Ludwig had licensing, joint venture and other business agreements with East Germany. A key role was played by his Trumpf-Schokolade- and Kakaofabrik GmbH in West Berlin. Its factory was built with public subsidies and enjoyed preferential tax rates. The majority of Trumpf employees in Berlin, as in Ludwig's other chocolate factories, were low-wage workers and women. Over 60% were foreigners, mostly from Turkey. The majority were women.

Art-historical quotations like these run throughout Haacke's work. He has employed the organizational form of the medieval altarpiece on several occasions, for example in the polyptych *Wij geloven aan de macht van de creative verbeeldingskracht* (*We Believe in the Power of Creative Imagination*, 1980). But direct pictorial quotations also frequently occur, from the Mannerist sculptor Franz Xaver Messerschmidt (*We Bring Good Things to Life*, 1983) to the photographer Walker Evans (*Photo Opportunity [After the Storm/Walker Evans]*, 1992), from Victor Vasarely (*The Chase Advantage*, 1976) to Haim Steinbach and Jeff Koons (*The Saatchi Collection*, 1987). Sometimes these links are like tributes; at others they are more or less ironic sideswipes at colleagues.

In *Cowboy with Cigarette* and the Pop art satire *Helmsboro Country*, both of which were produced for a solo exhibition at John Weber's New York

Translations of texts in painting:
left placard, *Solidarity with our fellow workers in the capitalist part of Berlin*
right placard, *9 DM/hour is not enough. Stop the job cuts at Trumpf*
on the bowl, *Sweet Factory of Dresden, Florence on the Elbe, People's Owned Enterprise*
on the crate, left, *State Art Trading Agency of the GDR Ludwig Foundation for Art and International Understanding. c/o Trumpf Chocolate and Cocoa Factory, Inc., 1 Berlin 44, Grenzallee 4*
on the cartons, right, *People's Owned Enterprise*

gallery in 1990, Haacke's quotations become caricatures. *Helmsboro Country* was an allusion to the ultra right-wing US Senator Jesse Helms, who made himself a name as an art censor when he became the leader of an onslaught against the National Endowment for the Arts. The Philip Morris company – which presented itself as a promoter of contemporary art and had recently run an advertising campaign around the Bill of Rights – tried to stop the exhibition of this work, since it also addressed the political sponsorship that Philip Morris extended to Jesse Helms.

Since the late 1980s Haacke has been increasingly occupied with unconventional monuments and historically troubled memorial sites. These range from the German Pavilion at the Venice Biennale to the commemoration of the democratic revolt that occurred around the Nikolaikirche in Leipzig in 1989. They also include

his 'museum mix-ups' at the Museum Boijmans Van Beuningen in Rotterdam and the Serpentine Gallery, London, where Haacke worked with existing artworks as readymades.[6] In a sense, Haacke's interest in memorials and monuments whose historical messages or formal languages need some contemporary correction is a particular form of site-specificity.

It began in 1988 with a work in a public space when Haacke was invited to participate in 'Styrian Autumn', an annual culture festival in the Austrian city of Graz. While examining local history, Haacke came across photographs showing a column topped by a statue of the Virgin Mary that had been converted into a triumphant obelisk for the Nazis after they had marched into Austria in 1938. Haacke picked up on the Nazi's re-dedication of the column, which had long been forgotten by the people of Graz, and recreated it, although with a

Wij geloven aan de macht van de creative verbeeldingskracht (We Believe in the Power of Creative Imagination)
1980
11 silkscreen panels, blued brass frames, black velvet flag
left and right boards, 100.5 × 38 cm; centre boards, 100.5 × 83.5 cm; top and bottom boards, 27.5. × 83.5 cm; flag, l. 180 cm
Installation. 'Kunst in Europa na 68', Museum van Hedendaagse Kunst, Ghent.
Collection, Stedelijk Museum voor Actuele Kunst, Ghent.
Fabrique Nationale Herstal S.A. (FN), with headquarters in Herstal, near Liège, Belgium, is one of the major manufacturers of small arms and ammunition in the world. According to *Armies and Weapons* (No. 5, 1974), an international military journal, the light automatic rifle F.A.L. 7.62 mm of FN 'has been used on a large scale in all the more recent wars and guerilla actions (the last Arab–Israeli conflict, the Indo–Pakistan war of 1971, the Congo, Northern Ireland, South America and so on).' The F.A.L. was produced under license from FN in about a dozen countries, among them Argentina, Brazil, Canada, Great Britain, Israel and South Africa. The South African army under apartheid was equipped with the FN automatic rifle.
A facsimile of a portion of the FN posters, announcing the competition for the 'FN-Browning Prize for Creativity', is reproduced under the photos from South Africa. Translations of texts: top panels, *It goes to countries, which are not in a state of war (laughs). Well, in principle ... But it can happen that the Belgian Army takes it over and it is delivered through an intermediate country.* – Mr Reynvoet, Christian Labour Union at FN (Interview on Belgian TV, 1975).
The Société Générale de Belgique owns 29.35 % of FN. It is believed that the Belgian Royal Family, the Vatican, Prince Amaury de Merode, Count Lippens, and the families of Solvay, Boël and Janssen are the controlling shareholders of the Société Générale de Belgique. – (The Economist, 18 March 1978)
We sell arms to responsible governments. As soon as they have taken possession of their arms, it is they who use them. We have nothing to do with the use to which they are finally put. – Mr Fons Ni, Director of FN (Interview on Belgian TV, 1975) centre panels, *In Soweto [black township] (Johannesburg) 1976 In the South African Army 1977 FN-Browning Prize for Creativity created on the occasion of the millennium of the prince-bishopric of Liège.*

Mia san mia (We Are Who We Are)

2001

Inkjet prints of digital montages, mounted on the six sides and two faces of 2 rectangular pillars

350 × 143 cm; 134 × 75 cm

Installation, Generali Foundation, Vienna.

The title quotes a defiant Austrian Member of Parliament. Austria faced sanctions by fourteen European nations in 2000, when the Freedom Party (FPÖ), led by Jörg Haider (with 27.7% of the votes in a federal election), joined the People's Party (ÖVP), as junior partner in a governing coalition. Deftly exploiting dissatisfaction with uninterrupted coalitions of the two largest Austrian parties, Haider had campaigned on an 'Austria First' populist platform of anti-Semitism, sympathies with National Socialist ideology, hostility towards refugees and immigrants, and opposition to the inclusion of Eastern European countries in the EU. He also vilified artists and intellectuals. In 2002, Haider paid a visit to Saddam Hussein.

Haider announced in 2001 on large roadside billboards, that with him as governor of the province 'Carinthia is blooming!' Against the background of a misty blue mountain chain (Karawanken), this message was emblazoned on a ribbon tying together two red roses on the left of the poster, while on the right, the qiant head of a pensive looking Governor Haider loomed into the picture. The Karawanken mountains in the backdrop are the border between Carinthia and Slovenia, the northern-most Balkan country.

Black is the colour of Chancellor Wolfgang Schüssel's Conservative ÖFP; blue is the colour of Haider's far right-wing FPÖ, represented in the first ÖVP/FPÖ coalition by Vice-Chancellor Susanne Riess-Passer and seven ministers. In the renewed coalition of 2003, Haider's older sister serves as state secretary.

In 1941, the German film *Heimaterde* (*Native Soil*) was distributed in Nazi-ruled Austrian provinces with a poster featuring a blond, Ayrian-looking couple resolutely looking to the left (reproduced on the right in *Mia san mia*). According to the summary of the film's plot 'the unmasking of a border-crossing smuggler leads to a happy ending.'

Und Ihr habt doch gesiegt (And You Were Victorious After All)
1988
Existing monument, wood, fabric, fibreglass
Obelisk, 1,600 × 600 × 600 cm; billboard, 300 × 950 cm
Installation, Bezugspunkte 38/88, Steirischer Herbst, Graz, Austria.
Poster, collection, Generali Foundation, Graz.
top, photograph from 1938 rally
bottom, left, after attack

Since 1968 a publicly funded culture festival, the Steirischer Herbst (Styrian Autumn), has been held annually in Graz. The festival's 20th anniversary in 1988 coincided with the 50th anniversary of the Anschluss, Hitlers annexation of Austria in 1938.

For the Steirischer Herbst of 1988, artists were invited to produce temporary installations in public places that had played a significant role during the Nazi regime. One of the sites in the centre of the city was the Mariensäule, a column crowned by a 17th-century gilded statue of the Virgin Mary, celebrating the Austrian victory over the Turks. When Hitler conferred the title Stadt der Volkserhebung ('City of the People's Insurrection') on Graz in 1938, the ceremony on 25 July was held at the foot of the Mariensäule. For the occasion, it was hidden under a red obelisk, emblazoned with the Nazi insignia and the inscription UND IHR HABT DOCH GESIEGT ('And You Were Victorious after All'). This claim referred to the failed Nazi putsch in Vienna on 25 July 1934. Graz had been an early Nazi stronghold in Austria.

The obelisk was reconstructed for the 1988 Steirischer Herbst as a memorial to Nazi victims with a tally: 'The Vanquished of Styria: 300 Gypsies killed, 2,500 Jews killed, 8,000 political prisoners killed or died in detention, 9,000 civilians killed in the war, 12,000 missing, 27,900 soldiers killed.' During the night, a week before the closing of the exhibition, the memorial was firebombed. The bronze statue of the virgin was severely damaged. Within a week, the arsonist and the instigator of the firebombing, a well-known sixty-seven-year-old Nazi, were arrested. They were convicted in a jury trial and sentenced to serve two-and-a-half and one-and-a-half-year prison terms respectively.

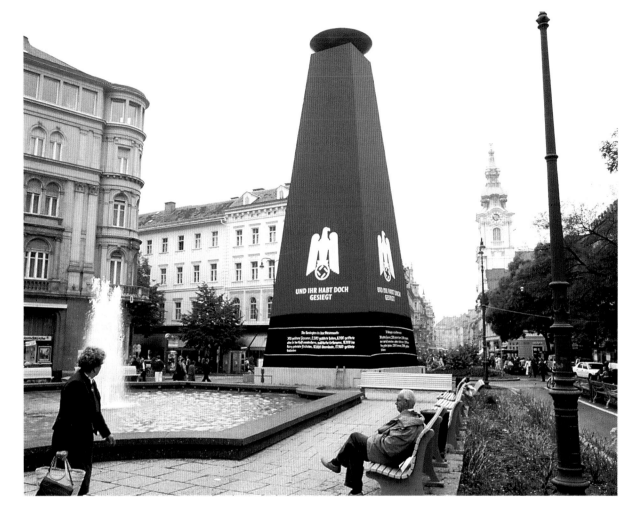

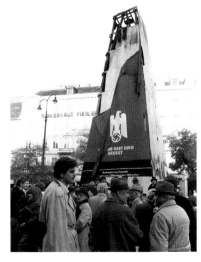

The Chase Advantage

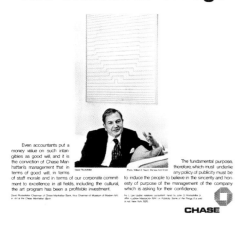

The Chase Advantage
1976
Silkscreen on acrylic plastic
122 × 122 cm
First exhibited, John Weber
Gallery, New York, 1977.
The hexagonal frame is the logo
of the Chase Bank (former Chase
Manhattan Bank), one of the
largest banks in the US, with
extensive international interests.
In the 1970s its advertising
slogan was 'Give Yourself The
Chase Advantage'. David
Rockefeller is seen sitting in front
of a painting by Victor Vasarely.
David Rockefeller was the Bank's
chairman from 1969 until 1981.
He and his family were major
shareholders. Ivy L. Lee (quoted
on the right) was hired by David
Rockefeller's father as public
relations consultant after the
'Ludlow Massacre' in 1914, the
break-up of a strike of coal miners
in which forty strikers including
women and children were killed.
John D. Rockefeller, David's
grandfather, had a 40% share in
the mining company.
David Rockefeller was chairman
of the board of The Museum of
Modern Art in New York from 1962
to 1972 and from 1987 to 1993.

different slant. He reconstructed the obelisk, including the original Nazi inscription *Und Ihr habt doch gesiegt* (*And You Were Victorious After All*), an allusion to the failed Nazi coup d'état of 1923 in Munich during which several of Hitler's followers died. Like a book-keeper he then added the numbers of those who had been murdered by the Nazis: 'The Vanquished of Styria: 300 Gypsies killed; 2,500 Jews killed; 8,000 political prisoners killed or died in detention; 9,000 civilians killed in the war; 12,000 missing; 27,900 soldiers killed.' In this sense, the travestied Nazi statement was apposite: these people were irrevocably dead, which meant that a central Nazi goal – the systematic extinction of Jews, gypsies and political opponents – had been successfully accomplished.

Haacke's new re-dedication of the column stirred up the conservative tabloid *Die Krone*, along with some members of the community who obviously found this reappraisal of Austria's collaboration with the Nazi German Reich unwelcome. As contemporary photographs show, a large number of the citizens of Graz had enthusiastically welcomed the Nazis' arrival. A heated local debate ensued. It culminated in an arson attack in the middle of the night on Haacke's critical reconstruction of the obelisk, at the instigation of an old Nazi. It was severely damaged. The statue of Mary melted in the heat.

Three years later, in 1991, Werner Fenz, the curator who was responsible for the intervention in Graz, invited Haacke to exhibit in another public space, this time on the Königsplatz in Munich. This central square contains the Glyptothek, the Museum of Antiquities and the Propylaeum, and is

a neo-classical monument to the building activities of the Bavarian King Ludwig I in the nineteenth century. In the 1930s, its east side was rounded off, on Hitler's orders, with a *Haus der Partei* (House of the Party) and a *Haus des Führers* (House of the Leader) along with a Temple of Honour for Nazis who had been killed in the failed putsch of 1923.

Haacke's work created an oppressive link between the Nazi past and very recent German history. He installed it in the Propylaeum, which dominates this square once used by the Nazis for spectacular military parades, and called it *Die Fahne hoch* (*Raise the Flag*, 1991) after a once-popular Nazi marching song. Three black flags hung from the building. Two of these listed in Gothic lettering the German companies who had supplied Iraq with materials that could be used for military purposes in the late 1980s. A third, hanging in the middle, summoned 'German Industry in Iraq' to 'fall in for inspection' under the SS skull and crossbones cockade. Since Saddam Hussein's Iraq was one of the states most firmly opposed to Israel's right to exist, and numbered Israel among its targets in cases of conflict, this support for the arming of the regime showed an unfortunate continuity in German history, to say nothing of the dictator's poison-gas attacks on the Kurds and repression of the Shiites.

In summer 1993, Haacke – along with Nam June Paik – represented Germany at the XLV Venice Biennale. The German Pavilion there owes its present form to a major rebuilding programme ordered by Hitler in 1938. The exterior was restyled in the heavy, neo-classical style favoured by the

Nazis, and an apse was added to the central gallery, equipping it for semi-religious presentations. Haacke's installation *GERMANIA* reflected this historical dimension of the site. On entering the pavilion, the visitor was greeted by a poster-size photograph of Hitler visiting the Biennale in 1934. But Haacke was also thinking about the building in regard to German reunification, which had been concluded by treaty in 1990. A large plastic replica of a Deutschmark symbolized this new Germany, hanging on the same hook from which the German eagle with swastika had been removed in 1945. The coin's mint date was 1990, which referred to the first year of a common currency. Thus a friction occurred between the murderous and pompous imperial ideas of Nazism and the seemingly neutral economic power of a country now unified in part through a common currency. The larger-than-life-size coin also symbolized the fact that German reunification represented the triumph of capitalism over communism.

Inside the building, Haacke created a metaphor for German history. The building's floor slabs had been taken up, some of them badly damaged in the process, and left lying as a field of rubble. This produced a distressing terrain that evoked a large number of associations. Those familiar with Minimalist art might see it as a skewed work by Carl Andre, while medieval iconographers could imagine it as a site for the resurrection of the dead, and thus the victims of the Holocaust. It reminded others of Caspar David Friedrich's famous image *Das Eismeer (Die Gescheiterte 'Hoffnung') (The Sea of Ice*

above, **Franz Xaver Messerschmidt**
Ein Schalksnarr (The Buffoon)
c. 1770

left, **We Bring Good Things to Life**
1983
Wood, plaster, gold leaf, neon
279 × 90 cm overall; bust, h. 68.5 cm
Installation, John Weber Gallery, New York.
Collection, Jerusalem Museum.
In the 1950s, Ronald Reagan appeared in TV commercials as spokesman for the products and political views of General Electric. The company is widely known for its consumer goods, but it is also a major US military contractor. Among its arms contracts was the production of 300 Mark 12A nuclear warheads.
When he was President Ronald Reagan promoted a space-based defence system popularly known as 'star wars'. At that time General Electric advertised its household appliances with the slogan 'We bring good things to life'. The company controls NBC, one of the three largest US television networks.

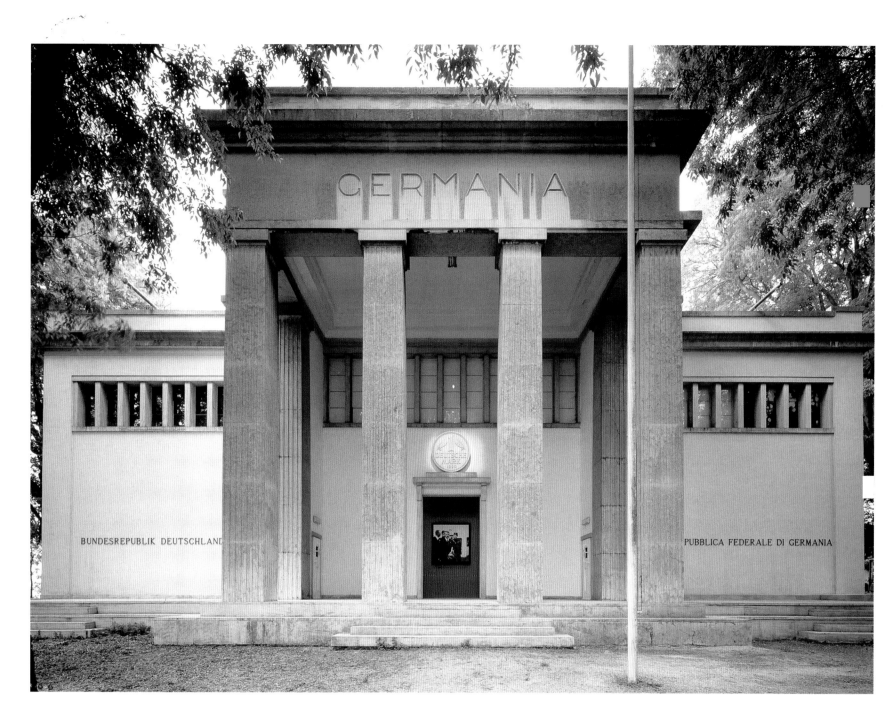

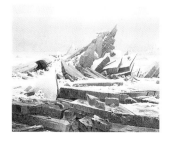

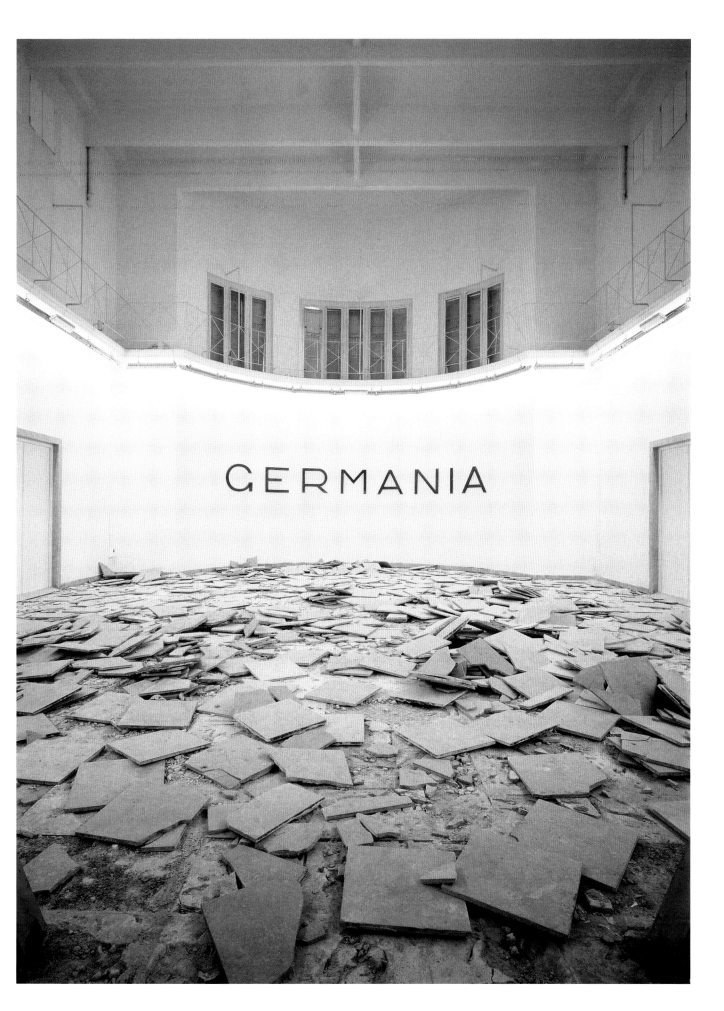

GERMANIA

1993

German Pavilion at the XLV Venice
Biennale, wood wall, 8 wood
letters, plastic reproduction of
German 1 Mark coin, minted 1990,
photograph of 1934, 1,000 watt
floodlight

Letters, h: 70 cm; coin, ⌀ 130 cm;
photograph, 150 × 150 cm
Installation, German Pavilion, XLV
Venice Biennale.

After seizing power in 1933,
Hitler's first trip abroad was to
meet Benito Mussolini in Venice –
and to visit the German Pavilion of
the Biennale. He ordered a face-
lift of the building following the
martial variant of neo-classicism
that had been introduced by the
new Haus der Deutschen Kunst in
Munich. The parquet floor of the
building was replaced by marble
slabs. And on a hook above the
entrance, the Nazi version of the
German eagle was installed, with
a wreath surrounding the
swastika.

During the 1993 Biennale the
same hook held an enlarged
replica of a 1 Deutsche Mark coin
with a mint date of 1990, the year
of the reunification of East and
West Germany and the adoption of
the West German currency as
common legal tender. From the
entrance the view into the
interior was blocked by a red wall
with a black and white
photograph of Hitler's visit of the
pavilion in 1934. Once visitors had
passed it to the left or right, they
found the entire floor broken up.
The word GERMANIA (Italian for
Germany) on the pavilion's facade
was quoted in the apse.
GERMANIA had been the name
Hitler had envisioned for Berlin
after his expected victory in the
Second World War and the
imperial redesign of the German
capital by Albert Speer.

opposite, bottom right, top,
Carl Andre
Equivalent VIII
1966
Bricks
12.5 × 229 × 68.5 cm

opposite, bottom right, bottom,
Caspar David Friedrich
The Sea of Ice (Shipwrecked
'Hope')
1823–24
Oil on canvas
96.5 × 127 cm

[Shipwrecked 'Hope'], 1823–24), which has been read as a political image, expressing Friedrich's despair over the failure of a democratic revolution in Germany. Ultimately, this graphically effective, grandiose stage set could either stand for a fresh start or for complete collapse.

As with a floor work by Carl Andre, many of the disconcerted visitors were hesitant to complete the work by walking on it and creating their own disturbing, echoing noise in the coolly lit white cube. The field of rubble was dominated by the word 'GERMANIA' emblazoned on the gallery apse, which quoted the exterior inscription. It too elicited various associations. The ancient Germanic tribes constituted such an important reference for the racial delusions of the Nazis that Hitler had wanted to rename Berlin 'Germania' when his monumental building project for the city was concluded.

The German pavilion with Haacke's *GERMANIA* and Nam June Paik's media art, curated by Klaus Bussmann and Florian Matzner, won a Golden Lion Prize at the Biennale. The effect of *GERMANIA* was so striking that the dance theatre director Johann Kresnik invited Haacke to design a stage set for his dance theatre production at the Berlin Volksbühne about Ernst Jünger. Klauss Bussmann was also among those who introduced the idea that Haacke – along with Gerhard Richter, Sigmar Polke, Anselm Kiefer, Georg Baselitz and others – was invited in 1998 to submit a proposal for a project in the Reichstag building in Berlin, into which the Bundestag, or German parliament, intended to move.

As early as 1984, Haacke had been struck during a visit to West Berlin by a significant contradiction: in front of the Reichstag, with its motto 'DEM DEUTSCHEN VOLKE' ('TO THE GERMAN PEOPLE'), the Tiergarten's vast lawns were being used extensively on Sundays for leisure and relaxation by Turkish families. Even though post-war West Germany never saw itself as a country of immigrants, it recruited generations of workers from Italy, Spain and Portugal, from the Balkans and from Turkey, thus contradicting the sense of a homogeneous people suggested by the historical inscription. The traditions surrounding the inscription are also problematic. On the one hand its wording reveals the condescension of Kaiser Wilhelm II who, after the German parliamentary system had been wrested from the imperial Reich and its conservative elites, had thought of democracy as a generous gift. Additionally, the concept of *Volk* in German history is a romantic political notion, which was exploited by the disastrous symbiosis of the term *völkisch* and the Nazis' thinking. Unlike the French Revolution, which gave *le peuple* a neutral authority for political sovereignty, *das Volk* in German usually suggests a biologically, historically and culturally sanctioned community from which people not deemed to belong could be barred on the most primitive criteria and with drastic consequences, as the Nazis' racial policies were not the first to demonstrate. Against this background, it seemed remarkable to Haacke that the new parliament of the reunited Germanies should meet under a motto that was as questionable historically as it was now inappropriate. He suggested juxtaposing the building's old dedication with the neutral and

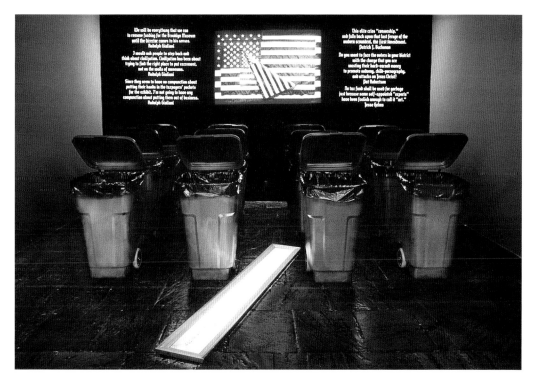

more suitable motto 'DER BEVÖLKERUNG' ('TO THE POPULATION') in one of the Reichstag's inner courtyards. Members of parliament were invited to contribute a sack of soil from their district and spread it around the letters of the new dedication. Any plants that grew out of this soil were welcome. A day-by-day video-documentation was to be accessible via the internet.[7]

Overwhelming approval of the proposal by the Bundestag's art committee was followed by a broad public campaign by opponents of the installation. Although Haacke had not suggested removing the old inscription from its place above the main entrance, but simply planned an installation with the new dedication in one of the inner courtyards, the arguments turned into a conflict that lasted for months, provoking resistance even among art-lovers, as if he were assaulting one of the most sacred insignia of the German nation. The debate achieved a degree of intensity and longevity unparalleled for a discussion about a work of art in post-war Germany, with the possible exception of Christo's wrapping of the Reichstag in 1995. Finally the Bundestag legislature held a full-house debate and

voted by a small majority in favour of the realization of the project.

At the same time, Haacke was in the midst of a controversy in the US, which had flared up around his work *Sanitation* (2000) at the Whitney Museum in New York. *Sanitation* was directed against the interference with the freedom of art by US politicians and particularly against New York's Mayor Rudolph Giuliani. The mayor had cancelled the Brooklyn Museum's monthly subsidy of about $500,000 in September 1999 because it refused to remove Chris Ofili's controversial *The Holy Virgin Mary* (1996) from the Saatchi collection's 'Sensation' exhibition. Haacke responded to this campaign by Giuliani, which had been declared unconstitutional by a federal judge in the same year, by setting quotations from the statements of the Mayor and likeminded politicians against the guarantee of freedom of expression in the Bill of Rights. Twelve open trash cans metaphorically referred to the censors' claim that the work in 'Sensation' was 'garbage'. Loudspeakers in the garbage cans emitted the sound of marching. This element, along with the fact that the quotations appeared on the wall in Gothic script, caused

Sanitation
2000
Grey garbage containers with open lids, speakers, gold-framed facsimile of First Amendment of American Constitution, newspaper clippings, American flags, silk-screened quotes
Dimensions variable
Installation, Whitney Biennial 2000, Whitney Museum of American Art, New York.
Since the late 1980s conservative Republicans, Christian fundamentalists and neo-conservatives have waged a 'culture war'. Spearheaded by Senator Jesse Helms (NC), the US Congress passed a law stipulating that, in awarding grants, the National Endowment for the Arts (US Government agency) must be 'sensitive to the standards of decency and respect and diverse beliefs of the American public'. The budget of the NEA has since been practically frozen. It discontinued grants to artists and critics, and museums have become cautious in their programming. The curator of a 1992 show at the Los Angeles County Museum, commemorating the infamous 'Degenerate Art' exhibition staged by the Nazis in 1937, alluded in her catalogue to parallels with the American present. In 2000, Rudolph Giuliani, then the Mayor of New York, demanded that the Brooklyn Museum remove Chris Ofili's painting *The Holy Virgin Mary* from its 'Sensation' exhibition, a show culled from the collection of Charles Saatchi. He threatened to cut the city's subsidy (one third of the Museum's annual operating budget), to replace its Board and to evict the Museum from its city-owned premises. He attacked the artist and the Museum in language matching that of Senator Helms, Pat Robertson (a politically influential televangelist) and Patrick J. Buchanan, a well-known right-wing journalist and presidential candidate.
The Brooklyn Museum went to court. A federal judge ruled that Rudolph Giuliani had violated the First Amendment of the American Constitution. He was ordered to resume the city's subsidies and not carry out his threats. The judge stated: 'There is no federal constitutional issue more grave than the effort by government officials to censor works of expression and to threaten the vitality of a major cultural institution as punishment for failing to abide by government demands for orthodoxy.'

Quotes on wall:
We will do everything that we can to remove funding for the Brooklyn Museum until the director comes to his senses.
– Rudolph Giuliani
I would ask people to step back and think about civilization. Civilization has been about trying to find the right place to put excrement, not on the walls of museums.
– Rudolph Giuliani
Since they seem to have no compunction about putting their hands in the taxpayers' pockets for the exhibit, I'm not going to have any compunction about putting them out of business.
– Rudolph Giuliani
This elite cries 'censorship' and falls back upon that last refuge of the modern scoundrel, the First Amendment.
– Patrick J. Buchanan
Do you want to face the voters in your district with the charge that you are wasting their hard-earned money to promote sodomy, child-pornography and attacks on Jesus Christ?
– Pat Robertson
No tax fund shall be used for garbage just because some self-appointed 'experts' have been foolish enough to call it 'art'.
– Jesse Helms
Excerpt from the First Amendment of the Constitution of the United States (known as The Bill of Rights, ratified 15 December 1791) on floor:
Article the third ... Congress shall make no law respecting an establishment of religion, or prohibiting the free exercise thereof; or abridging the freedom of speech, or of the press; or the right of the people peaceably to assemble, and to petition the government for a redress of grievances.

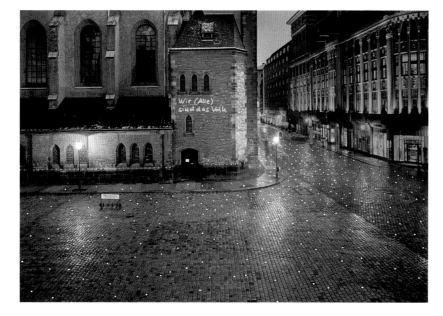

Wir (Alle) sind das Volk (We [All] Are the People)

2003

Proposal for permanent installation at Nikolaikirchhof, Leipzig

Digital simulation by the artist and Geróid Dolan, based on photograph by Peter Franke. Since 1982, led by the Reverend Christian Führer of the Leipzig Nikolaikirche, atheists and members of all faiths, have come together every Monday for 'peace prayers'. These gatherings gradually developed into massive assemblies of people carrying candles as a signal of their opposition to the repressive government of the GDR (East Germany). In the autumn of 1989 these peaceful demonstrations gained such momentum that, on 9 October, a violent confrontation between 50,000 demonstrators and the regime's police and militia was barely avoided. It was the starting point for country-wide demonstrations, accompanied by the chant 'Wir sind das Volk' (We are the people). The accent was on the 'we', a challenge to the government's claim that it represented the people. The regime of the GDR collapsed a month later and the wall that had divided Germany since 1961 came down.

Xenophobic and racist groups have since regularly tried, although unsuccessfully, to hold rallies at the Leipzig Völkerschlachtdenkmal, a monument commemorating the defeat of Napoleon in 1813. Proposal: 600 points of light 1.5 cm in diameter are embedded at irregular distances of 3 to 4 m apart from each other in the paving stones of the square around Nikolaikirche in Leipzig, Germany. Unco-ordinated, they slowly light up and gradually extinguish. The handwritten words 'Wir (Alle) sind das Volk' (We [All] are the people) are projected in blue light onto one of the church's small towers. The words gradually appear, gain in intensity and then dim. After a pause the cycle begins again. Every Monday afternoon at the time of the 'peace prayers' in the Nikolaikirche, Amnesty International and other human rights organizations set up tables in the square to promote their cause. They sell candles that can be placed among the points of light as a vigil.

critics to assert that Haacke was trivializing the Holocaust. In a strange twist of fate, the artist – usually an eloquent spokesman for the prosecution – found himself in the dock. No longer was the Mayor's violation of the constitution the issue; now it was the artist who, like others, had recognized historical parallels with the Nazi campaign against 'Degenerate Art'. As with *MOMA-Poll* (1970), Haacke became persona non grata in certain circles, both inside and outside the art world.

In the spring of 2003, Haacke submitted a surprisingly quiet entry to a competition to commemorate the Leipzig Monday Demonstrations of 1989. These nocturnal processions of protest had originated at the Nikolaikirche in Leipzig, and had been a decisive factor in the fall of the GDR. Points of light were to be installed into the paving stones around the church in memory of the candles that the demonstrators had carried. Their slogan 'Wir sind das Volk' ('We are the people'), stressed the 'we' and thus denied the regime its democratic legitimacy. The slogan had been much chanted at the time, and quickly became proverbial. Haacke took this up in his wall projection *Wir (Alle) sind das Volk* (*We [All] Are the People*) – partly in the spirit of his previous work

DER BEVÖLKERUNG, and partly to keep the memory of the rebellious slogan alive. In this way he provided another example of his dialectical treatment of monuments, maxims and memorial locations.

In 1991, the eminent French intellectual Pierre Bourdieu was not the first distinguished sociologist to acknowledge Haacke as his peer, and produced a book with him: *Libre-Échange* (*Free Exchange*).[8] As early as 1975, two American sociologists, Howard S. Becker and John Walton, had already contributed the essay 'Social Science and the Work of Hans Haacke' to the artist's book *Framing and Being Framed: 7 Works 1970–75*,[9] edited by Kasper König. Not only does Haacke enjoy a reputation among representatives of multi-national companies such as Mobil Oil or Philip Morris, he has become a multi-national artist himself. Starting from post-war abstraction in West Germany in the late 1950s, the echo of a suppressed tradition, then briefly being exposed to the French avant-garde of the early 1960s, in New York he developed a unique body of work with natural elements and physical conditions which lead him eventually to focussing on the social forces that shape how we live, his theme ever since.

This social engagement – welcomed or rejected – risks overshadowing not only his early achievements and the formal and performative innovations of his later works, but also his very special position in contemporary art.

Haacke did not simply switch to 'political art' – a label he is profoundly uncomfortable with. He

had to invent it in his own terms. Given Stalin's brutal instrumentalization of art, Social Realism had lost whatever political and artistic credit it may have had, except for artists who were closely toeing the Communist Party line. It could not serve as a model after the Second World War. The early examples of the Weimar Republic, from George Grosz to Käthe Kollwitz, were respected, but their rhetoric had since entered the museum. Above all, there was serious doubt about whether figurative painting could represent the complexity of modern reality.

More radical pictorial strategies like those of John Heartfield's 'montage' of photographic images were closer to the present. However, visual communication had developed further and substantive transformations in post-war art had muted their impact. Becoming the 'political artist' he is today, Haacke never followed a formula. He had to devise his own context-related methodology, and in fact, it was developed on the job. After questioning the auratic power of art exhibitions, he then moved to question exhibitions in the context of donors, sponsors and politics. Originally interested in the demystification of the romantic concept of art, he proceeded to demystify an art world that continues to protect old assumptions about its role that can no longer be sustained in the world we live in – if indeed they ever could. He delved into history as it affects the present and the future. The precision that gave his early works with wind and water the straightforwardness of natural science turned into a no less straightforward social science. The risk he ran in documenting dubious real estate machinations in New York turned into the risk of not being able to exhibit his works at all. And the dry wit of his early context-related installations has turned into relaxed irony. Without fetishizing the notion of the readymade, Haacke feels free to quote, satirize, imitate and redirect what he finds already made. After avoiding a signature style in his early works he now uses whatever is appropriate for the job at hand. If Haacke changed, he did so by staying the same.

Translated from the German by Michael Robinson.

1 Since 2000 a set of prints is on display in the new Museum of Contemporary Art in Siegen (Westphalia).

2 Alain Robbe-Grillet, *L'année dernière à Marienbad* (*Last Year at Marienbad*), 1961, directed by Alain Resnais; and *Dans le labyrinthe* (*In the Labyrinth*), Les Editions de Minuit, 1959.

3 Jack Burnham, *Beyond Modern Sculpture: The Effects of Science and Technology on the Sculpture of This Century*, George Braziller, New York; Allen Lane/Penguin Press, London, 1968.

4 Jack Burnham, *The Structure of Art*, George Braziller, New York, 1971

5 The complete list from 4 June 1971 is as follows: Cecile Abish, Carole Alonge, Carl Andre, Benny Andrews, Arakawa, Arman, Alice Aycock, John Baldessari, Victoria Barr, Bob Barry, Lynda Benglis, John Best, Mel Bochner, Bill Bollinger, Louise Bourgeois, Paul Brach, Daniel Buren, Donald Burgy, Scott Burton, Cynthia Carlson, James Carullo, Rosemarie Castoro, Judy Chicago, Ellen Cibula, Elizabeth Clark, Christopher Cook, John Czerkowicz, Sheila de Bretteville, Agnes Denes, Frazer Dougherty, Juan Downey, Peter Downsbrough, Tom Doyle, Jean Dupuy, Paul Earls, Doug Edge, Susan Elias, Oyvind Fahlstrom, Raphael Ferrer, Larry Fink, Richard Francisco, Bici Forbes, Marilyn Fox, Sonya Fox, Chris Gianakos, Marianne Gillies, Sarah Ginsberg, Phil Glass, Morris Golde, Leon Golub, John Goodyear, Dan Graham, Bob Guillemin, Virginia Gunter, Ira Joel Haber, Susan Hall, Tim Hamill, Lloyd Hamrol, Gerald Hayes, Mary Heilman, Al Held, Geof Hendricks, Jon Hendricks, Francis Hewitt, Dolores Holmes, Douglas Huebler, Helene Hui, Michio Ihara, Isobe, Bob Israel, Bill Jacobson, Laurace James, Neil Jenney, Poppy Johnson, Donald Judd, Craig Kauffman, David Kibby, William King, Alison Knowles, Ted Kraynik, Leslie Larkin, Diane Len, Mon Levinson, Jeffrey Lew, Robert C. Lewis, Sol LeWitt, Vinnie Longo, Irvin Mann, Brice Marden, Gordon Matta-Clark, Tom McNulty, Brenda Miller, Mary Miss, Charlotte Moorman, Robert Morris, Bob Moskowitz, Forrest Myers, Ursula Myers, Brian O'Doherty, Claes Oldenburg, Manuel Perry, Irving Petlin, Richard Pettibone, Shirley Pettibone, Bridgit Polk, Katherine Porter, David Prentice, Laurin Raiken, Anthony Ramos, Robert Rauschenberg, David Raymond, Johann Saalenraad, Alfons Schilling, Miriam Shapiro, Jackeline Skiles, Robert Smithson, Kenneth Snelson, Joan Snyder, Keith Sonnier, Nancy Spero, Frank Stella, Wolfgang Stoerchle, Amy Stromsten, Morton Subotnik, William Taggert, Paula Tavins, Jean Toche, Marvin Torffield, Wen Ying Tsai, Eugene Tulchin, Suzanne Vanlandingham, Peter van Riper, Bernar Venet, Kestutis Zapkus, Barbara Zucker.

6 See in this volume Jon Bird's Focus, pp. 84–91.

7 www.derbevoelkerung.de

8 Hans Haacke, Pierre Bourdieu, *Libre-Échange*, Le Seuil/les presses du réel, Paris, 1994. German translation: *Freier Austausch*, S. Fischer Verlag GmbH, Frankfurt am Main, 1995; Portuguese translation: *Livre-Troca*, Editora Bertrand Brasil S.A. Rio de Janeiro, 1995; English translation (American edition): *Free Exchange*, Stanford University Press, 1995; English translation (British edition): *Free Exchange*, Polity Press, London, 1995; Japanese translation: Fujiwara-Shoten, Tokyo, 1996; Chinese translation: San Lian Shu Dian, 1996; Finnish translation: *Ajatusten vapaakauppaa*, Kustannusosakeyktiö Taide, Helsinki, 1997.

9 Jack Burnham, Howard S. Becker, John Walton, *Framing and Being Framed: 7 Works 1970–75*, ed. Kasper König, The Press of the Novia Scotia College of Art and Design, Halifax; New York University Press, 1975.

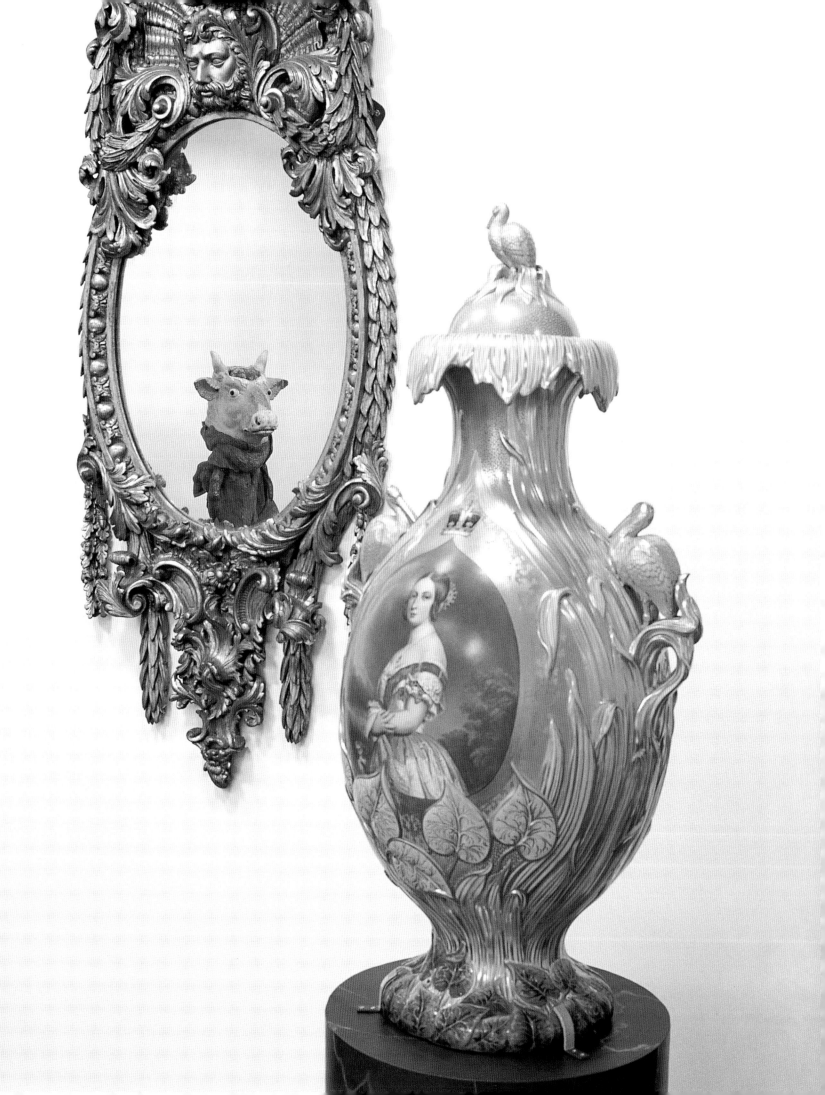

Focus

Jon Bird Unscrambling Hans Haacke's *Mixed Messages*, **page 82**.

Mixed Messages
2001
Objects from the collection of the
Victoria and Albert Museum,
London
Installation, Serpentine Gallery,
London.
left, l. to r., Marco Jindrich, *A
Souvenir of Warsaw*, 1946;
meigh vase, 1851, Britain;
mirror, *c.* 1735, British;
meigh vase, 1851, Britain;
Charles Thurston Thompson,
Venetian Mirror, 1853;
crucifix, 13th century, Tuscany;
opposite, l. to r., Richard
Billingham, *Untitled* (from the
series 'Ray's a Laugh'), 1994;
Cindy Sherman, *Untitled*, 1980;
Owen Jones, *Osler's Gallery, 45
Oxford Street*, 19th century

The opening arrangement of objects and images that formed the prelude to Hans Haacke's installation *Mixed Messages* (2001), at the Serpentine Gallery, London, presented the visitor with what appeared at first glance to be a paradigm of museum display. Facing the entrance to the South Gallery, the focal wall was adorned with an ornate eighteenth-century carved gilt mirror positioned slightly off-centre and flanked by two large painted Meigh pottery vases on pedestals, the whole ensemble cordoned off by a thick, knotted cord rope supported by brass stanchions. Haacke had used these signifiers of the division of museum space, separating the auratic object from the viewing public, in a previous work – *Oelgemaelde. Hommage à Marcel Broodthaers* (*Oil Painting: Homage to Marcel Broodthaers*, 1982), in tribute to Broodthaers, whose museum interventions and reconstructions exposed the museum as a place of boundaries and divisions. In order to reach the Meigh pottery display the visitor had first to negotiate the central space occupied by a large Victorian jardinière overflowing with an exotic palm rising almost to ceiling height, while other objects also competed for attention – a sculpture of an ox, its head opened to reveal the brain in the manner of Italian anatomical and medical wax figurines, and photographs and paintings hung slightly askew on adjacent walls. Immediately the messages of museological taxonomy and order were being mixed, a disturbance of the visual and semantic codes that spread throughout the galleries causing ripples across the surface of representation: things

were not as they seemed.

Mixed Messages was Haacke's contribution to 'Give & Take', a collaboration between London's Serpentine Gallery, the noted contemporary art space, and the Victoria and Albert Museum (V&A), a fine and decorative arts museum. This curatorial venture had fifteen contemporary artists placing their works in the galleries of the V&A alongside the existing displays, and Haacke, after a twelve-month period spent researching in the museum and its archives, selected over two hundred artefacts from the V&A collections to be reassembled in the rooms of the Serpentine. The South Gallery therefore served as Haacke's 'manifesto' - introducing the visitor to the themes that traversed the installation as a whole. Thus our first encounter with the pomp of Britain's imperial history – painted portraits of Queen Victoria, Prince Albert and images of the Crystal Palace decorated each vase – rapidly lost its celebratory aura as other juxtapositions and assemblages introduced different histories and social relations. Two photographs were hung either side of each vase, framed by sections of wall covered in a rich red damask. In one the play of mirror and reflection suggested an interior scene but on close inspection revealed the setting as landscape; the other – Marco Jindrich's *A Souvenir of Warsaw* (1946) – depicted two armed Polish soldiers in the act of being photographed, posing in front of a painted landscape backdrop. The whole scene takes place amidst the rubble and ruin of the bombed city. Taken together their contradictory associations suggested, amongst other meanings, the real as illusion and the claims of documentary photography as founded upon contingency and myth.

Other images hung in the South Gallery compounded the complexity of Haacke's messages: a studio portrait of Lady Wolverton posing as a triumphant Britannia, taken at the

Devonshire House Ball in 1897; a Richard Billingham photograph of his mother poring over an incomplete jigsaw puzzle from the series 'Ray's a Laugh' (1996) placed next to Cindy Sherman's *Untitled No. 74* (1980), both in close proximity to Owen Jones' nineteenth-century painting of the city as a market place – *Osler's Gallery, 45 Oxford Street* (19th century). Cross- historical and cultural references abound: Sherman portrays herself portraying a moment of everyday life – possibly shopping in

Manhattan – her reservoir of poses drawing upon disguise and masquerade to explore femininity and issues of sexual identity, while Billingham's depiction of his dysfunctional family was the binary opposite to Lady Wolverton's affectations, an exploration of the uncomfortable territory between public and private experience and representations of class as a documentary genre. Put to work by Haacke, these images contributed to a discourse of the body as an economy of desire, dominion, pleasure and power.

Here then we had a complex and engaging array of images and artefacts introducing themes of nationality and nationhood, gender and identity, war and masculinity, and the role of the museum in both initiating and perpetuating the ideas and values of the dominant (and collecting) culture. At the outset, Haacke's *Mixed Messages* warned viewers to be on their guard; an off-centre placing, a slightly skewed hang, an unlikely confrontation, all served to stimulate a critical viewing eye and confound the logic of the museum as a vehicle for an Enlightenment discourse of objectivity and truth.

If it has been the museums' project of modernity to become the site on which the ordinary and the extraordinary can coexist, then this has been at the expense of masking the sleight of hand (or ideology) concealing the naturalization of the procedures of classification, division, framing and display – taxonomies all, that maintain distinction and difference, hierarchy and value. Haacke's *Mixed Messages* reintroduced the sewing machine to the umbrella (quite literally, in one of the vitrines) and, in so doing, broke the museum's utopic economy – the selection of the most valued, the paradigmatic, the inevitably of progress, the dream and promise of order and totality – and in its place installed visual narratives much more akin to Michel Foucault's concept of a 'heterotopia', which 'stop(s) words in their tracks, contest(s) the very possibility of grammar at its source; they dissolve our myths and sterilize the lyricism of our sentences'.[1]

On entering the East Gallery, from one viewing position alone, Antonio Canova's indolently reclining carved marble *The Sleeping Nymph* (c. 1820) faced a Qing Dynasty Imperial robe displayed behind a French nineteenth-century wrought-iron balcony, flanked on one side by a painted chipboard cut-out of a male figure wearing the uniform of a V&A warder lasciviously contemplating the denuded nymph and, on the other, by an English medieval memorial slab of Purbeck marble incised with a line drawing of a praying male figure. A change of orientation then offered the viewing eye Auguste Rodin's bronze, *The*

Mixed Messages
2001
Objects from the collection of the
Victoria and Albert Museum,
London
Installation, Serpentine Gallery,
London.
background, l. to r., Dante Gabriel
Rosseti, *The Day Dream,* 1980;
memorial slab, incised with male
figure, c. 1320–25, England;
balcony, 18th century, France;
court robe for a woman of the
imperial household, Qing dynasty,
1770–1820, China;
V&A warder (Mr Davies), dummy
board, John Ronayne, 1977;
Gianni Versace, evening dress,
autumn/winter, 1983–84
foreground, Antonio Canova, *The
Sleeping Nymph, c.* 1820

Muse (*c.* 1911), positioned between two vitrines containing, respectively, a dummy clothed in an early twentieth-century English fishergirl's outfit and a Vivienne Westwood pair of platform heels, and a German child mannequin in a black velveteen dress, seated at a table supporting a small German sewing machine and an Issey Miyake breast-shaped leather handbag. What possible sense could a viewer make of this bricolage other than opening to the objects' competing claims on their perceptual, cognitive and unconscious responses and allowing the free association of meanings and memories to make them players in the game of *cadavre exquis*?

But despite these provocations to a kind of pleasurable uncertainty, it has always been Haacke's intention to encourage his audience to engage critically with the work – in this case with the related discourses of the museum and the discipline of art history. Thus, Haacke included three canonic works of sculpture: a cast of Michelangelo's *Dying Slave* (1513–16) placed in the Rotunda, and Canova and Rodin's already mentioned *Sleeping Nymph* and *The Muse* in the East Gallery. In the context of their adjacent objects, and depending upon the viewer's directional gaze, they worked through correspondence or disjuncture, whereas metonymically they offered a narrative of Western sculptures figuring of, and breaking from, the classical ideal of the body.

Positioned off-centre in the harmonious space of the North (Rotunda) Gallery, the *Dying Slave*'s libidinally invested gesture of religious ecstasy and languorous eroticism contrasted powerfully with a thirteenth-century carved wooden crucifix – an image of the tortured body which, in its expressive violence, signified a sacred tradition markedly different to its companion piece, an eighteenth-century Burmese Buddha, a condensation of stillness and tranquillity. Leaving the Rotunda for the East Gallery, the viewer encountered the charged sexuality of the Canova, a restaging of the antique tradition of nude female statuary, but with

a heightened realism resulting from virtuoso technique and the artist's tendency to slightly yellow the marble to intensify the flesh-like appearance. This produces, as art historian Alex Potts has argued, a surface without depth, an invitation for the eye (and, of course, the question of whose eye resonates here) to devour fetishistically the curves and contours of the body, a body no less invested than that of the *Dying Slave*, but there it is body as Gestalt that installs the erotic. The incompleteness of Michelangelo's carving technique makes surface a matter of contrast.

The situating of the Canova played narrative games with the cut-out warder, but a more art-historical association was to be made with the Rodin bronze. Again, the originating figural role of the antique provided the connection – Michelangelo's contrast of finished and rough surfaces, expressive of the vitalism of the body, re-emerged in Rodin's animated forms bearing the imprint of roughly modelled clay. Rodin's modernity lay not only in his formal experimentation – dispensing with the plinth; animating the surface; use of repetition; occupancy of space – but also in the suggestion of the body's interiority, how the modelling and fragmenting of the figure provided a metaphor for depth. Rainer Maria Rilke

described this as 'self-absorption' and this quality was evident in the works mentioned and as a presence throughout the installation as a whole.[2]

Dolls and photographs were much in evidence throughout the displays. During his preparatory research, Haacke repeatedly visited the Museum of Childhood, which is part of the V&A and is located in east London away from the main museum, and his selection, installed mostly in the various vitrines, included a nineteenth-century European doll with interchangeable body parts which could be assembled into either a white girl or black boy, an inflatable golliwog, various 'mammy' dolls, fashion dolls from many countries, two late twentieth-century dolls of Queen Victoria, Barbie dolls and teenager dolls from China and Hong Kong, 1950s portrait dolls from America of Prince Charles and Princess Anne – in fact, out of the 211 total exhibits in Haacke's exhibition, thirty-five were dolls of one type or another.

Haacke's vitrines containing dolls, toys, games and photographs, mimicked forms of display common to traditional ethnographic collections (for example, the Pitt Rivers Museum in Oxford), those representations of the collective culture of a society or group where signs of difference positioned the 'other' as a mysterious, or curious, exotic alterity. The interior of each vitrine resembled a dolls house – a spatial organization originating in the medieval crèche, a simple structure enclosing wooden or terracotta figures enacting scenes from the nativity. Toys in general, and dolls in particular, mediate between the fictional world of fantasy and the dream, and external realities – of ownership, social relations, wealth and family life – and the child's tendency to accumulate and enclose objects is an early indication of the need for boundaries between self and other. The playfulness that was a feature of *Mixed Messages* symbolized patterns of acquisition and exchange as the interplay of objects and images irrespective of their specific material and cultural histories. And other meanings were set in train: the use of toys and dolls in funerary rites, the genre of still-life and the tradition of the vanitas, the 'transitional objects' of psychoanalysis.

Haacke's vitrines and assemblages of objects from the world of childhood presented miniaturized projections of the divisions of class, sexuality, race and identity, synecdoches for the installation as a whole and unsettling reminders of how the processes of subject formation work through the private and domestic practices of everyday life as much as through social and public institutions. Traces of colonialism or class are structured into the apparent innocence of childhood reverie.

Generally, Haacke's choice of photographic image favoured social documentary rather than a celebration of the aesthetic – Paul Martin and John Thompson's late nineteenth-century photographs of labour and London street life, or the ethnographically inclined work of August Sander. In one section of the West Gallery, Carl Dammann's South African racial typologies were interrupted by a Helmut Newton colour fashion photograph: a desert shot of a white female model striding out in a tropical outfit with matching boots, hat in one hand and riding whip in the other. Following her, a couple of paces behind, a black woman in a flowing green gown and turban cradled a white baby in her arms. On an adjacent wall one of Oliviero Toscani's provocative images for Benetton posters depicted the back of a black soldier holding a large human thighbone. Seen in the context of a fashion journal or advertising hoarding, the deliberate exposure of social taboos as a marketing strategy to interpellate the viewer as a knowing and transgressive consumer would simply reinforce the visual rhetoric of the mass media and global product placement. As semiotic elements within

Mixed Messages
2001
Objects from the collection of the Victoria and Albert Museum, London
Installation, Serpentine Gallery, London.
left, top, Exchange doll (black boy/white girl), 1916–22, England
left, bottom, l. to r.,
Koryusai, *Lovers behind a Folding Screen*, 1770, Japan, woodcut;
Paul Martin, *On the sands: Yarmouth*, 1892, photograph;
nouveau jeu d'himen, 18th century, board game, France;
Dutch couple dancing, 18th century, export porcelain, China;
Black Barbie, 1970–80, Mattel Inc., The Philippines;
Dutchman teaching a lady how to smoke, 18th century, export porcelain, China;
Dutch couple, 18th century, export porcelain, China;
The Path to Matrimony, 1893, board game, England
opposite, l. to r.,
James Hayllar, *Granville Sharp, The Abolishionist, Rescuing a Slave from the Hands of his Master*, 1864, painting, English;
Charles George Lewis, *The Hunted Slaves*, 1864, engraving;
Your Country Needs You – Britain is a Multi-Racial Society, *c.* 1997–98 British Army recruiting poster;
Nadella Benjamin for Yaa Asantewaa Carnival Group, London Black Power, 2000;
Child's costume for Notting Hill Carnival, 2000;
W.D. & H.O. Wills, *Old Friend*, *c.* 1902, British, advertising poster (lithograph);
Carl Dammann, *Racial Types: Sud Afrike*, 19th century, Germany;
Helmut Newton, *Fashion Shoot*, 1971, photograph

the installation, the connotations of cannibalism and miscegenation resurfaced as the historical legacy of a more invidious typology – of the collection of cultures and peoples as an acquisitive expression of power and dominion.

As a sign of class and racial and social classification, the photographic image functioned as evidence in Haacke's general exploration of colonial representation. However, Haacke provided enough clues to warn the viewer against understanding documentary as unmediated reality or as the symbolic expression of liberal democracy. To the extent that the installation's title conveyed an intention, ambivalence and contradiction contested the field of meaning.

1 Michel Foucault, *The Order of Things: An Archeology of the Human Sciences*, Tavistock, London, 1970, Preface.

2 Alex Potts, *The Sculptural Imagination: Figurative, Modernist, Minimal*, Yale University Press, New Haven, Connecticut, and London, 2000, pp. 24–77.

Artist's Choice

Bertolt Brecht Writing the Truth: Five Difficulties (extracts), 1934/35, **page 92**.

opposite, **El Vapor de la Llana**
1995
Digitally manipulated photograph
Proposal, Barcelona.
The smokestack of El Vapor de la Llana, once an important textile factory (built 1853) in Barcelona's formerly industrial and working class neighbourhood of Poble Nou, was to serve as mast for a large black sail. It was to be rigged so that it would turn in the wind like a weather vane.
In the nineteenth and well into the twentieth century, the workday in Poble Nou lasted eleven hours or more. Workers were poorly paid, malnourished, and lived in crowded, primitive and unhealthy conditions. In 1872, textile workers formed a union. Massive and violent strikes for better working conditions were met with severe repression. Strike leaders were imprisoned, driven into exile, or executed. Several general strikes resulted in the declaration of martial law and the deployment of the army. 171 workers were killed during confrontations in 1923. With the workers rallying under the black flag of anarchism, the conflicts took on increasingly political connotations and contributed to the outbreak of the Spanish Civil War (1936–39). Even though the victorious Franco dictatorship had driven workers' organizations underground, general strikes closed down Barcelona in 1951 and 1957.
In 1967 housing developments were built close to El Vapor de la Llana, which ceased manufacturing textiles soon thereafter. In the 1990s large areas of Poble Nou, until then populated by low-income residents, were demolished to make room for the construction of upmarket residential buildings, shopping malls and corporate offices. Much of the local population has been displaced.

Nowadays, anyone who wishes to combat lies and ignorance and to write the truth must overcome at least five difficulties. He must have the *courage* to write the truth when truth is everywhere opposed; the *keenness* to recognize it, although it is everywhere concealed; the *skill* to manipulate it as a weapon; the *judgement* to select those in whose hands it will be effective; and the *cunning* to spread the truth among such persons. These are formidable problems for writers living under Fascism, but they exist also for those writers who have fled or been exiled; they exist even for writers working in countries where civil liberty prevails.

1. The Courage to Write the Truth

It seems obvious that whoever writes should write the truth in the sense that he ought not to suppress or conceal truth or write anything deliberately untrue. He ought not to cringe before the powerful, nor betray the weak. It is, of course, very hard not to cringe before the powerful, and it is highly advantageous to betray the weak. To displease the possessors means to become one of the dispossessed. To renounce payment for work may be the equivalent of giving up the work, and to decline fame when it is offered by the mighty may mean to decline it forever. This takes courage.

Times of extreme oppression are usually times when there is much talk about high and lofty matters. At such times it takes courage to write of low and ignoble matters such as food and shelter for workers; it takes courage when everyone else is ranting about the vital importance of sacrifice. When all sorts of honours are showered upon the peasants it takes courage to speak of machines and good stock feeds which would lighten their honourable labour […]

And it also takes courage to tell the truth about oneself, about one's own defeat. Many of the persecuted lose their capacity for seeing their own mistakes. It seems to them that the persecution itself is the greatest injustice. The persecutors are wicked simply because they persecute; the persecuted suffer because of their goodness. But this goodness has been beaten, defeated, suppressed; it was therefore a weak goodness, a bad, indefensible, unreliable goodness. For it will not do to grant that goodness must be weak as rain must be wet. *It takes courage to*

say that the good were defeated not because they were good, but because they were weak […]

It takes little courage to mutter a general complaint, in a part of the world where complaining is still permitted, about the wickedness of the world and the triumph of barbarism, or to cry boldly that the victory of the human spirit is assured. There are many who pretend that cannon are aimed at them when in reality they are the target merely of opera glasses. They shout their generalized demands to a world of friends and harmless persons. They insist upon a generalized justice for which they have never done anything; they ask for a generalized freedom and demand a share of the booty which they have long since enjoyed. They think that truth is only what sounds nice. If truth should prove to be something statistical, dry, or factual, something difficult to find and requiring study, they do not recognize it as truth; it does not intoxicate them. They possess only the external demeanour of truth-tellers. The trouble with them is: *they do not know the truth*.

2. The Keenness to Recognize the Truth

Since it is hard to write the truth because truth is everywhere suppressed, it seems to most people to be a question of character whether the truth is written or not written. They believe that courage alone suffices. They forget the second obstacle: the difficulty of *finding* the truth. It is impossible to assert that the truth is easily ascertained […]

For example, it is not untrue that chairs have seats and that rain falls downward. Many poets write truths of this sort. They are like a painter adorning the walls of a sinking ship with a still life. Our first difficulty does not trouble them and their consciences are clear. Those in power cannot corrupt them, but neither are they disturbed by the cries of the oppressed; they go on painting. The senselessness of their behaviour engenders in them a 'profound' pessimism which they sell at good prices; yet such pessimism would be more fitting in one who observes these masters and their sales. At the same time it is not easy to realize that their truths are truths about chairs or rain; they usually sound like truths about important things. For it is the nature of artistic creation to confer importance […]

left, **Societat civil: un parc
temàtic (Civil Society: A Theme
Park)**
1995
Lightbox (with image based on
photograph by Consuelo
Bautista), replica of pedestal and
feet of a Maillol statue, with wilted
irises, vinyl, detail of promotional
image for theme park Port
Aventura
295 × 204 × 164 cm
Installation, 'Obra Social',
Fundació Antoni Tàpies,
Barcelona.
In 1992 *Torso of Summer*
(1910–11), a bronze statue of a
female nude by Aristide Maillol,
was presented to the City of
Barcelona as a gift from the
Associació Barcelona Olímpica
1992. It was planted outside the
National Museum of Art of
Catalonia. Engraved in the marble
base are the names of ninety-three
members of the association, most
of them large corporations.
Joan A. Samaranch, President
of the International Olympic
Committee from 1980 to 2001,
was instrumental in choosing
Barcelona for the 1992 Olympics.
Beginning in 1955 and throughout
the dictatorship of Francisco
Franco, he had been an influential
Falange official of Catalonia, from
1973 to 1977 President of the
Provincial Council of Barcelona.
Ten years later he was elected
President of 'La Caixa', one of the
largest public savings banks in
Europe, the largest holding
company in Catalonia, and one
of the most politically powerful
institutions of the province. Upon
his resignation in 1999 he became
honourary chairman.
The logo of 'La Caixa' is derived
from an image by Joan Miró: a blue
star resembling a stick figure,
bouncing a red and a yellow ball –
like dropping coins. 'La Caixa' has
an art collection and an extensive
exhibition programme. It holds a
40.6% stake in Universal Studios/
Port Aventura, a theme park near
Tarragona, organized around five
exotic regions of the world. The
park's promotional material
featured a Polynesian girl.
During a visit to Barcelona in
1994, Margaret Thatcher and her
husband Denis paid a visit to
Maillol's female nude. They were
accompanied by the Mayor of
Barcelona and other dignitaries.

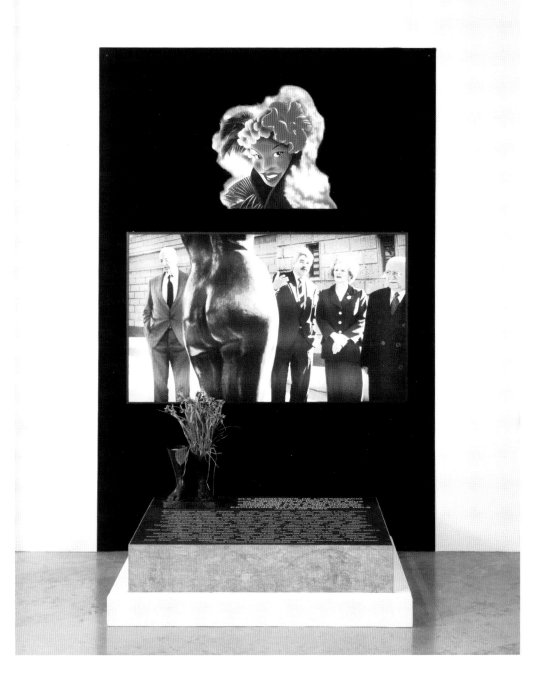

They do not discover the truths that are worth writing about. On the other hand, there are some who deal only with the most urgent tasks, who embrace poverty and do not fear rulers, and who nevertheless cannot find the truth. These lack knowledge. They are full of ancient superstitions, with notorious prejudices that in bygone days were often put into beautiful words. The world is too complicated for them; they do not know the facts; they do not perceive relationships. In addition to temperament, knowledge, which can be acquired, and methods, which can be learned, are needed [...]

3. The Skill to Manipulate the Truth as a Weapon
The truth must be spoken with a view to the results it will produce in the sphere of action [...]

The man who does not know the truth expresses himself in lofty, general, and imprecise terms. He shouts about 'the' German, he complains about Evil in general, and whoever hears him cannot make out what to do. Shall he decide not to be a German? Will hell vanish if he himself is good? [...]

Such vague descriptions point to only a few links in the chain of causes. Their obscurantism conceals the real forces making for disaster. If light be thrown on the matter it promptly appears that disasters are caused by certain men. For we live in a time when the fate of man is determined by men [...]

If one wishes successfully to write the truth about evil conditions, one must write it so that its avertible causes can be identified. If the preventable causes can be identified, the evil conditions can be fought.

4. The Judgment to Select Those in Whose Hands the Truth Will be Effective
[...] I merely want to emphasize that 'writing for someone' has been transformed into merely 'writing'. But the truth cannot merely be written; it must be written *for someone*, someone who can do something with it. The process of recognizing truth is the same for writers and readers. In order to say good things, one's hearing must be good and one must hear good things. The truth must be spoken deliberately and listened to deliberately. And for us writers it is important to whom we tell the truth and who tells it to us [...]

5. The Cunning to Spread the Truth Among the Many
Many people, proud that they possess the courage necessary for the truth, happy that they have succeeded in finding it, perhaps fatigued by the labour necessary to put it into workable form and impatient that it should be grasped by those whose interests they are espousing, consider it superfluous to apply any special cunning in spreading the truth. For this reason they often sacrifice the whole effectiveness of their work. At all times cunning has been employed to spread the truth, whenever truth was suppressed or concealed. Confucius falsified an old, patriotic historical calendar. He changed certain words. Where the calendar read, 'The ruler of Hun had the philosopher Wan killed because he said so and so,' Confucius replaced *killed* by *murdered*. If the calendar said that tyrant so and so *died by assassination*, he substituted *was executed*. In this manner Confucius opened the way for a fresh interpretation of history.

In our times anyone who says *population* in place of *people* or *race*, and *privately owned land* in place of *soil*, is by that simple act withdrawing his support from a great many lies. He is taking away from these words their rotten, mystical implications. The word *people* (*Volk*) implies a certain unity and certain common interests; it should therefore be used only when we are speaking of a number of peoples, for then alone is anything like community of interest conceivable. The population of a given territory may have a good many different and even opposed

Les must de Rembrandt
1986
Wood, black and white photograph, concrete, fabric awning, metal plaques
Front of the Boutique, 330 × 300 × 33 cm; shelter front, 370 × 370 × 180 cm; walls 300 × 800 cm
Installation, Le Consortium, Dijon, 1986.
Compagnie Financière Richmont, an offshore holding company of the South Africa-based Rembrandt Group, was formed in 1987 in Switzerland to insulate its parent from international sanctions against apartheid. Rembrandt's self-portrait serves as logo for the conglomerate, which was founded in 1940 by Anton Rupert as a vehicle for apartheid interests. The international Rembrandt empire is now managed by his son Johann. The Rupert family is the second wealthiest family in South Africa.
In South Africa, Rembrandt had major interests in engineering, investment banking, insurance, financial services, printing, petrochemical products, tobacco, food and alcohol, as well as mining (17.3% of Gold Fields, 25% of GENCOR). Because of its violent suppressions of strikes by black miners, GENCOR was called an 'enemy company' by Cyril Ramaphosa (then president of National Union of Mine Workers). Under apartheid, Total South Africa was the largest French business enterprise in South Africa. It met a vital part of South Africa's petroleum needs. Rembrandt held over 30% of Total's shares.
Through its Vendôme subsidiary, Rembrandt/Richmont has become the world's second largest luxury goods company (in revenues), controlling the jewelers Cartier and Van Clef & Arpels, Montblanc pens, Dunhill luggage, the Swiss watchmakers Piaget, Baume & Mercier and Vacheron Constantin. It also has interests in high fashion. In 1999 it divested from Rothmans (tobacco) and in 2000 from European pay-television.
In 1984, Alain-Dominique Perrin, until 2003 president of Cartier, established the Cartier Foundation for Contemporary Art in Paris. He explained that corporate sponsorship of culture 'is a tool for the seduction of public opinion'. It promotes a company's 'image', helps in 'developing new markets' and serves 'to neutralize criticism from consumer and ecological groups'. He emphasized that 'It is important to abandon the idea that sponsoring culture is a disinterested investment'.

Translation of text on plaque underneath photograph:
In September 1985 the black workers in GENCOR's gold and coal mines go on strike. The company breaks the strike with tear gas, firearms and dogs. It also evicts the strikers from their quarters and fires a great number of them. In January 1986 the black workers in GENCOR's platinum mines go on strike. Twenty-three thousand strikers are fired. Johan Fritz, the company director, states, 'We have a shield against their irresponsible actions – a large reserve of unemployed.'

interests – and this is a truth that is being suppressed. In like manner, whoever speaks of soil and describes vividly the effect of ploughed fields upon nose and eyes, stressing the smell and colour of earth, is supporting the rulers' lies. For the fertility of the soil is not the question, nor men's love for the soil, nor their industry in working it; what is of prime importance is the price of grain and the price of labour. Those who extract profits from the soil are not the same people who extract grain from it, and the earthy smell of a turned furrow is unknown on the produce exchanges. The latter have another smell entirely [...]

And a better word than *honour* is *human dignity*; the latter tends to keep the individual in mind. We all know very well what sort of scoundrels thrust themselves forward, clamouring to defend the honour of a people. And how generously they distribute honours to the starvelings who feed them. Confucius' sort of cunning is

still valid today. Thomas More in his *Utopia* described a country very different from the England in which he lived, but it resembled that England very closely, except for the conditions of life [...]

The first version of this essay was a contribution to a questionnaire in the *Pariser Tageblatt*, 12 December 1934, which bore the general title 'Dichter sollen die Wahrheit schreiben' ('Poets Are to Tell the Truth'). In it, Brecht proposed only three difficulties. The final version of the essay, here translated, had its first German publication in *Unsere Zeit*, Vol. 8, Nos. 2–3, Paris, April 1935, pp. 23–34. The translation first appeared in *Twice a Year*, New York, Tenth Anniversary Issue, 1948.

Translated by Richard Winston.

Bertolt Brecht, 'Appendix A: Writing the Truth: Five Difficulties' (1934/35), *Galileo*, Grove Press, New York, 1991.

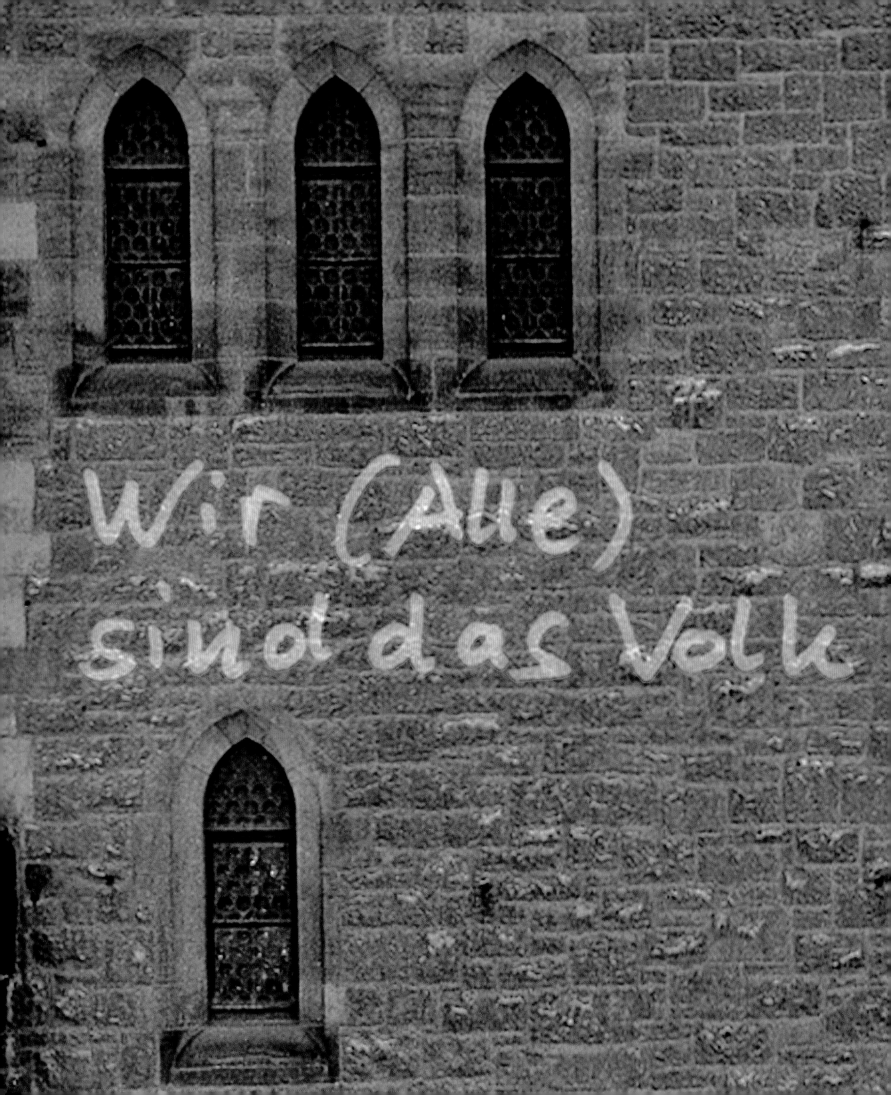

Artist's Writings

Hans Haacke Untitled Statement, 1965, **page 100**.

**Live Airborne System, November
30, 1968**
Planned 1965, executed 1968
Seagulls, bread crumbs
Coney Island, New York.

Ant Coop
1969
Live ants, acrylic container, sand
Installation, Howard Wise Gallery,
New York, 1969.

… make something which experiences, reacts to its environment, changes, is nonstable
…

… make something indeterminate, which always looks different, the shape of which
cannot be predicted precisely …

… make something which cannot 'perform' without the assistance of its environment
…

… make something which reacts to light and temperature changes, is subject to air
currents and depends, in its functioning, on the forces of gravity …

… make something which the 'spectator' handles, with which he plays, and thus
animates it …

… make something which lives in time and makes the 'spectator' experience time …

… articulate something Natural …

Exhibition announcement, Galerie Schmela, Dusseldorf, 1965. Reprinted in English in *Nul, negentienhonderd vijf en zestig* (cat.),
Stedelijk Museum, Amsterdam, 1965.

Untitled Statement 1967

left, **Cast Ice: Freezing and Melting, January 3,4,5 ... 1969**
1969
Water, freezing temperature
Installation, roof, 95 East
Houston Street, New York,
January 3,4,5 ... 1969.

opposite, **Cycle**
1969
Punctured vinyl hose, pump,
water
Installation, roof, 95 East
Houston Street, New York,
25–29 May.

The concept of 'systems' is widely used in the natural and social sciences and especially in various complex technologies. Possibly it was Jack Burnham, an artist and writer, who first suggested the term (not to be confused with 'systematic') for the visual arts. By its use, he was trying to distinguish certain three-dimensional situations which, misleadingly, have been labelled as 'sculpture'.

A system is most generally defined as a grouping of elements subject to a common plan and purpose. These elements or components interact so as to arrive at a joint goal. To separate the elements would be to destroy the system. Outside the context of the whole, the elements serve no function. Naturally these prerequisites are also true of every good painting, sculpture, building or similarly complex but static visual entity. The original use of the term in the natural sciences is valuable for understanding the behaviours of physically interdependent processes. It explained phenomena of constant change, recycling and equilibrium. Therefore, I believe there are sound reasons for reserving the term 'system' for certain non-static 'sculptures', since only in this category does a transfer of energy, material or information occur.

Painters, and sculptors of static works, are anxious to prevent their works from being influenced by time and environmental conditions. Patina is not looked for as a record of the bronzes' response to atmospheric exposure nor is the darkening and crackle of paintings desirable in order to demonstrate their reaction to environmental conditions. Although physical changes take place, the intention of these artists is to make something that alters as little as possible. Equally, the viewer hopes to see the work as it appeared immediately after its execution.

Works, however, have been produced with the explicit intention of having their components *physically* communicate with each other and the whole communicate *physically* with the environment. It is this type of work which cannot be classified as 'sculpture', whereas it can be described appropriately as a 'system'.

The physical self-sufficiency of such a system has a decisive effect on the viewer's relationship to the work, due to its hitherto unknown independence from his mental involvement. His role might be reduced to being the source of physical energy in works conceived for viewer participation. In these, his actions – pulling, pushing, turning, etc. – are part of the programme. Or his mere presence might be sufficient. However, there are systems which function properly even when the viewer is not present at all, i.e., their programme operates absolutely independently of any

contribution on the part of the viewer.

Whether the viewer's physical participation is required or not, the system's programme is not affected by his knowledge, past experience, the mechanics of perceptual psychology, his emotions or degree of involvement. In the past, a sculpture or painting had meaning only at the grace of the viewer. His projections into a piece of marble or a canvas with particular configurations provided the programme and made them significant. Without his emotional and intellectual reactions, the material remained nothing but stone and fabric. The system's programme, on the other hand, is absolutely independent of the viewer's mental participation. It remains autonomous – aloof from the viewer. As a tree's programme is not touched by the emotions of lovers in its shadow, so the system's programme is untouched by the viewer's feelings and thoughts. The viewer becomes a witness rather than a resounding instrument striving for empathy.

Naturally, also a system releases a gulf of subjective projections in the viewer. These projections, however, can be measured relative to the system's actual programme. Compared to traditional sculpture, it has become a partner of the viewer rather than being subjected to his whims. A system is not imagined; it is real.

Previously unpublished, 1967.

All the 'Art' That's Fit to Show 1974

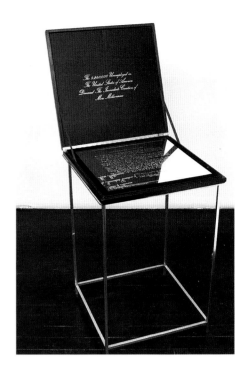

Products which are considered 'works of art' have been singled out as culturally significant objects by those who at any given time and social stratum wield the power to confer the predicate 'work of art' unto them; they cannot elevate themselves from the host of man-made objects simply on the basis of some inherent qualities.

Today museums and comparable art institutions, like the Institute of Contemporary Arts in London, belong to that group of agents in a society who have a sizable, although not an exclusive, share in this cultural power on the level of so-called 'high art'.

Irrespective of the 'avant-garde' or 'conservative', 'rightist' or 'leftist' stance a museum might take, it is, among other things, a carrier of socio-political connotations. By the very structure of its existence, it is a political institution. This is as true for museums in Moscow or Peking as for a museum in Cologne or the Guggenheim Museum. The question of private or public funding of the institution does not affect this axiom. The policies of publicly financed institutions are obviously subject to the approval of the supervising governmental agency. In turn, privately funded institutions naturally reflect the predilections and interests of their supporters. Any public museum receiving private donations may find itself in a conflict of interests. On the other hand the indirect subsidy of many private institutions through exemption from taxes and partial funding of their programmes could equally create problems. Often, however, there exists, in fact if not by design, a tolerance or even a congruence of the respective ideological persuasions.

In principle the decisions of museum officials, ideologically highly determined or receptive to deviations from the norm, follow the boundaries set by their employers. These boundaries need not be expressly stated in order to be operative. Frequently museum officials have internalized the thinking of their superiors to a degree that it becomes natural for them to make the 'right' decisions and a congenial atmosphere reigns between employee and employer. Nevertheless it would be simplistic to assume that in each case museum officials are faithfully translating the interests of their superiors into museum policy, particularly since new cultural manifestations are not always recognizable as to their suitability or opposition to the parties concerned. The potential for confusion is increased by the fact that the convictions of an 'artist' are not necessarily reflected in the objective position his/her work takes on the socio-political scale and that this position could change over the years to the point of reversal.

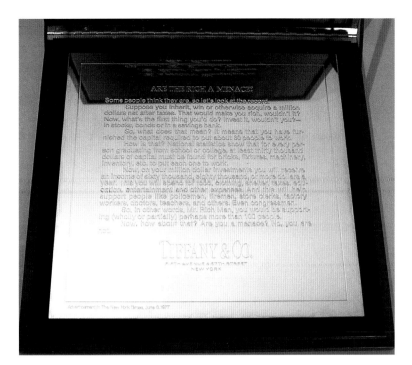

Still, in order to gain some insight into the forces that elevate certain products to the level of 'works of art' it is helpful – among other investigations – to look into the economic and political underpinnings of the institutions, individuals and groups who share in the control of cultural power.

Strategies might be developed for performing this task in ways that its manifestations are liable to be considered 'works of art' in their own right. Not surprisingly some museums do not think they have sufficient independence to exhibit such a portrait of their own structure and try to dissuade or even censor works of this nature, as has been demonstrated. Fortunately art institutions and other cultural power agents do not form a monolithic block, so that the public's access to such works might be limited but not totally prevented.

Bertolt Brecht's 1934 appraisal of the 'Writing the Truth: Five Difficulties'[1] is still valid today. They are the need for 'the *courage* to write the truth when truth is everywhere opposed; the *keenness* to recognize it, although it is everywhere concealed; the *skill* to manipulate it as a weapon; the *judgement* to select those in whose hands it will be effective; and the *cunning* to spread the truth among such persons'.

There are no 'artists', however, who are immune to being affected and influenced by the social-political value-system of the society in which they live and of which all cultural agencies are a part, no matter if they are ignorant of these constraints or not ('artist' like 'work of art' are put in quotation marks because they are predicates with evaluative connotations deriving their currency from the relative ideological frame of a given cultural power group). So-called 'avant-garde art' is at best working close to the limitations set by its cultural/political environment, but it always operates within that allowance.

'Artists' as much as their supporters and their enemies, no matter of what ideological colouration, are unwitting partners in the art-syndrome and relate to each other dialectically. They participate jointly in the maintenance and/or development of the ideological make-up of their society. They work within that frame, set the frame and are being framed.

1 Bertolt Brecht, 'Writing the Truth: Five Difficulties' (1934/35), *Galileo*, Grove Press, New York, 1991. See in this volume
 pp. 94–97.

Originally published without a title in *Art into Society – Society into Art: Seven German Artists* (cat.), Institute of Contemporary Arts, London, 1974.

The Agent 1977

Transplanted Moss Supported in
Artificial Climate
1970
Moss, spray nozzles, hose and
pipes, water
Installation, St.-Paul-de-Vence,
1970.

Commercial art galleries are powerful agents in that small segment of the consciousness industry which we know as the world of so-called high art.

It is apparent that, due to the limited resources of artists for reaching possible clients on their own, the chances for the sale of their products are considerably greater if they are promoted by a gallery. The prestige and consequently the cultural power of an established gallery not only creates a market, it also facilitates the securing of teaching jobs and grants, so that there is often a direct connection between an artist's affiliation with a commercial gallery and his/her standard of living and command over productive resources.

Today galleries obviously also hold a key position in the dissemination of the works of an artist. Exhibitions under their auspices generate articles in trade journals and other publications and furnish the grist for the gossip and shoptalk of the industry. Above all it is through such shows and the feedback they receive that an artist is invited to exhibitions in other galleries, in museums and in international art events, which in turn are often organized in collaboration with galleries. Therefore also the access to large audiences through exhibitions in prestigious show-places with the accompanying consecration, press coverage and increase in market value can be gained more easily through the mediation of a gallery than without.

Art dealers, however, are more than merchants; they are also purveyors as well as representatives of ideology and occasionally connoisseurs with emotional ties to their suppliers and clients. The difficulty in fully assessing their role derives from the ambiguous nature of the product they promote and sell.

An item deemed to be a work of art by a cultural power elite is a commodity, an ideological token, and the source for intellectual and emotional gratification, all in one. Although these constitutive qualities relate to each other, their relationships are not proportional or fixed. The evaluation of each, moreover, depends on the ever-changing beliefs, values and needs of the individual or the social set by which it happens to be judged.

Works of art, like other products of the consciousness industry, are potentially capable of shaping their consumers' view of the world and of themselves and may lead them to act upon that understanding. Since the exhibition programmes of museums and comparable institutions, with large audiences from the middle and upper middle classes which predominate in contemporary opinion and decision-making, are

influenced by commercial galleries, it is not negligible which ideologies and emotions are traded in these establishments.

Not surprisingly, institutions and galleries are often resistant to products which question generally held opinions and tastes, particularly if the positions they themselves hold are at stake. But the peculiar dialectics of consciousness, bolstered by their potential for financial speculation, and given the relative lack of uniformity of interests within the culture industry and among its consumers, nevertheless promote the surfacing of such critical works, at least in liberal societies.

With this modicum of openness, wherever suitable, the galleries' promotional resources should be used without hesitation for a critique of the dominant system of beliefs while employing the very mechanisms of that system.

'The Agent', *What do you expect?*, Paul Maenz, Cologne, 1977.

Goat Feeding in Woods
1970
Goat
'L'art Vivant aux États-Unis',
Fondation Maeght, St.-Paul-de-
Vence, July.

The Constituency 1977

Two polls, conducted respectively in 1972 and 1973, at the New York John Weber Gallery, a commercial gallery for contemporary art, showed that 70 per cent of 858 (first poll) and 74 per cent of 1,324 (second poll) gallery visitors who responded to a questionnaire during a two-and-a-half-week period each, declared that they had a 'professional interest in art'.[1]

The visitors of commercial galleries of contemporary art in New York seem to be an extremely select audience recruiting itself from the ranks of the college-educated middle and upper middle classes. The professionally uncommitted public of the gallery can hardly be suspected of representing 'the proletariat' or the mythical 'man in the street'.

Those who have a professional interest in art (artists, students, critics, the directors, curators and their assistants in museums and comparable institutions, gallery owners and their assistants, advertising and public relations executives, government and party bureaucrats in charge of the arts, art advisors of foundations, corporations and of collectors, etc.) influence, although not with an equal vote for everyone, and frequently only in a nominal capacity, which products and activities are to be considered 'art' and how much attention should be paid to each artist and the often competing art 'movements'. Many members of this diverse group are not independent agents but act rather on behalf of employers and clients whose opinions they might have internalized or cannot afford disregarding.

By no means is the art quality of a product inherent in its substance. The art certificate is conferred upon it by the culturally powerful social set in which it is to be considered art, and it is only valid there and then. The attribution of value, particularly if this value is not supported by the needs for physical survival and comfort, is determined ideologically. Unless one invokes God or the quasi-divine inspiration of a disembodied party, the setting of norms and their subtle or not so subtle enforcement, throughout history, is performed by particular individuals or groups of people and has no claim to universal acceptance. Their beliefs, emotional needs, goals and interests, no matter if the particular cultural power elite is aware of and acknowledges it, decide on the ever shifting art criteria.

Usually there is no quarrel about the existence of ideological determination if it emanates from a political or religious authority. The fact that man-made value systems and beliefs reflecting particular interests are also at work in liberal surroundings is not quite as readily admitted by the liberal culture mongers. Ideology, of course, is most

John Weber Gallery Visitors'
Profile 1
1972
21 blueprints
61 × 76 each
Installation/audience
participatory project, John Weber
Gallery, New York, 1973.
During a group exhibition of
works by Carl Andre, Hans Haacke,
Nancy Holt, Laurie James, Brenda
Miller and Maria Obering (7–24
October 1972) visitors to the John
Weber Gallery were asked to
complete a multiple-choice
questionnaire with twenty
questions. Ten questions related
to their demographic background
and ten questions to opinions on
sociopolitical issues. Intermediate
results were posted throughout
the exhibition. Over the show's
twelve days 858 visitors
participated in the poll. The
results were exhibited at the
gallery in the form of charts in 28
April–17 May 1973, while a second
poll was conducted (*John Weber
Gallery Visitors' Profile 2*, 1973).
The John Weber Gallery shared an
address with three other, at the
time prominent, galleries at 420
West Broadway in New York's SoHo
district. The public usually visited
all the exhibitions in the building.
During the period of the poll
visitors could see the following
shows: 'New Works by Artists'
(Donald Judd, Robert Morris,
Bruce Nauman, Robert
Rauschenberg, Frank Stella)
at the Castelli Gallery; Jannis
Kounellis at the Sonnabend
Gallery; and Sylvia Stone at the
Emmerich Gallery.

effective when it is not experienced as such.

Still, in the liberal environment of the John Weber Gallery, the question 'Do you think the preferences of those who financially back the art world influence the kind of works artists produce?' received a remarkable answer 30 per cent of the 1,324 respondents of the aforementioned poll answered 'Yes, a lot.' Another 37 per cent answered 'Somewhat'. The preformulated answer 'Not at all' was chosen by only 9 per cent. To fully appreciate the gallery visitors' feeling of dependence, potential conflict and, possibly, cynicism and alienation, it is worth noting that 43 per cent thought their standard of living would be affected if no more art of living artists were bought.

Apparently, a sizeable portion of the visitors of the gallery (remember, 74 per cent of them declared a professional interest in art) believed at the time that the economic power of private and institutional collectors, foundations, publishers, corporate and private contributors to art institutions and governmental funding agencies does, indeed, play a decisive role in the production and distribution of contemporary art.

The validation of certain products as contemporary high art, which, of course, guides future production while feeding on the consensus of the past, obviously is not independent of the art industry's[2] economic base. A cursory look at the art world in liberal societies might therefore lead to the conclusion that it is, in fact, as stringently controlled as the cultural life in societies where street cleaning equipment is called out to take care of deviant art, where a palette of blood and earth is used or an occasional blooming of a thousand flowers is announced with great fanfare.

It is true that the trustees and, perforce, the directors of many big museums probably agree with the declaration of one of their director-colleagues: ' … we are pursuing aesthetic and educational objectives that are self-sufficient and without ulterior motive. On those grounds the trustees have established policies that exclude active engagement toward social and political ends.'[3]

Such policies pretend to be based on the sociologically and philosophically untenable premise of a self-sufficient education and free-floating aesthetics while ignoring that a museum, by its very existence, actively engages in the promotion of social and political ends. Thus many museums which constitute some of the more powerful agents in the validation and distribution of art are closed for a whole range of contemporary work, and, if applied consistently, also to many works of the past.

Such a ban has the further effect of seriously impairing the economic viability of

JOHN WEBER GALLERY VISITORS' PROFILE 2 by Hans Haacke
A work in progress during his exhibition at the J. Weber Galler, 420 W. Broadway, NYC, April 28 — May 17, 1973.
Please answer by punching out bridge between edge and hole next to the answer of your choice.

as artist	Do you have a professional interest in art?	What do you think is the approximate proportion of Nixon sympathizers among art museum trustees?	100 %
as art/art history student			75 %
other professional interest			50 %
no professional interest			25 %
Manhattan	Where do you live?		0 %
Brooklyn			don't know
Queens		What do you think is the approximate proportion of Nixon sympathizers among visitors to contemporary art exhibitions?	100 %
Bronx			75 %
Richmond			50 %
adjoining counties			25 %
elsewhere North/Middle Atlantic States			0 %
South Atlantic States			don't know
Central and Mountain States		What was your personal income in 1972 (before taxes)?	none
Pacific States			$1 - 1999
abroad			$2000 - 4999
favor	Does your notion of art favor, tolerate, or reject works that make deliberate reference to socio-political things?		$5000 - 9999
tolerate			$10000 - 14999
reject			$15000 - 19999
don't know			$20000 - 24999
yes, 50 %	Do you think, as a matter of principal, that all group shows should include women artists?		$25000 - 29999
yes, but no specified quota			over $30000
sex should be no criterion		Sex?	male
don't know			female

Continued ▶

the incriminated works in commercial galleries, another of the major validating agents. Therefore in fact, if not by design, this posture has far-reaching consequences and leaves a politically neutral stance far behind, if such a thing exists at all.

The idealist notion of an art created out of and exclusively for 'disinterested pleasure' (Immanuel Kant), a claim contradicted by history and everyday experience, is upheld by formalist art theory as promulgated and normatively established by Clement Greenberg and his adherents. Formalist thinking, however, is not confined to his accredited followers; it reigns wherever formal qualities are viewed in isolation and their pure demonstration becomes the intended message.

This theory of cultural production and dissemination obviously overlooks the economic and ideological circumstances under which the industry and formalist theory itself operate. Questions as to the content and the audience and beneficiaries of art are heresy for a true formalist. Neither contemporary thinking in the social and political sciences nor psychoanalytic theory support such views. The pressures and lures of the world do not stop respectfully at the gate to the 'temple', Giscard d'Estaing's term for Paris' Centre Pompidou (!), or the studio door.

It is not surprising, then, that the designers of public spaces and the corporate men who dominate the boards of trustees of cultural institutions in the US[4] are so fond of these nineteenth-century concepts of 'art for art's sake'. The fact that many works done in this vein today are abstract and enjoy avant-garde status no longer poses a problem and now is often seen as an asset in the hunt for cultural prestige. The corporate state, like governments, has a natural allergy to questions such as 'what' and 'for whom'? Unwittingly or not, formalist theory provides an alibi. It induces its clients to believe that they are witnessing and participating in important historic events, as if artworks which are purportedly done for their own sake still performed the liberating role they played in the nineteenth century.

Aside from this powerful ideological allegiance and confluence of interests, the curators, critics, artists and dealers of the formalist persuasion, like the producers and promoters of any other product or system of messages, also have an economic interest in the maintenance and expansion of their position in the market. The investment of considerable funds is at stake.[5]

In spite of these constraining forces, it is demonstrably false to assume that their control over the art world in liberal societies is complete. Examples could be cited in

John Weber Gallery Visitors' Profile 2
1973
Key punch cards
29 sheets, 28 × 21.5 each
Installation/audience participation project, John Weber Gallery, New York.
During the exhibition of graphs with the results of a previous poll of the John Weber Gallery (John Weber Gallery Visitors' Profile 1, 1972) public, a second poll was conducted from 28 April–17 May 1973. As in other surveys ('Software', Jewish Museum, New York, 1970; Milwaukee Art Center, 1971; Museum Haus Lange, Krefeld, 1972; documenta 5, 1972; Kunstverein Hannover, 1973) a multiple-choice questionnaire inquired about the visitors' demographic background and opinions on sociopolitical issues. Different from the other polls, however, this questionnaire took the form of a key punch card. Intermediate results were posted throughout the exhibition. During its fourteen days a total of 1,234 visitors participated in the poll. Among the results of particular relevance to the art world were the following:
Q: 'Do you have a professional interest in art?'
A: 'As artist' = 42%,
'As art/art history student' = 14%,
'Other professional interest' = 13%.
Q: 'Do you think the preferences of those who financially back the art world influence the kind of work artists produce?'
A: 'Yes, a lot' = 30%,
'Somewhat' = 37%,
'Slightly' = 10%,
'Not at all' = 9%.
Q: 'Would your standard of living be affected, if no more art of living artists were bought?'
A: 'Yes' = 43%,
'No' = 33%,
'Don't know' = 11%,
'No answer' = 12%.
During the first half of the polling, a show of works by Robert Ryman was held in the front room of the John Weber Gallery. It was followed by a show of Steve Reich's music scores. At the time of the poll the other galleries in the same building had the following exhibitions: Hanne Darboven at Castelli Gallery; John Baldessari at Sonnabend Gallery; and Miriam Shapiro at Emmerich Gallery.

none | How much money have you spent on buying art(total)?
$1 — 1999
$2000 — 4999
$5000 — 14999
$15000 — 29999
over $30000

Do you think the preferences of those who financially back the art world influence the kind of work artists produce? — yes, a lot / somewhat / slightly / not at all / don't know

only to themselves | To whom should the trustees of art museums be accountable(more than one can be named)?
patrons of museum
museum membership
museum staff
artists' representatives
publicly elected officials
American Association of Museums
College Art Association
National Endowment for the Arts
Associated Councils of the Arts
foundation representatives
other(write in)_____
don't know

Have you ever lived or worked for more than one half year in a poverty area? — yes / no

It has been charged that the present U.S. Government is catering to business interests. Do you think this is the case? — always / often / occasionally / never / don't know

responsible | Some people say President Nixon is ultimately responsible for the Watergate scheme. Do you agree?
not responsible
don't know

Do you think the collectors who buy the kind of art you like, share your political/ideological opinions? — generally yes / generally no / don't know

poverty | How would you characterize the socio-economic status of your parents?
lower middle income
middle income
upper middle income
wealthy

How old are you? — under 18 years / 18 - 24 years / 25 - 30 years / 31 - 35 years / 36 - 45 years / 46 - 55 years / 56 - 65 years / over 65 years

Catholic | What is the religious background of your family?
Protestant
Jewish
other
mixed
none

Would your standard of living be affected, if no more art of living artists were bought? — yes / no / don't know

Do you daily read the political section of a newspaper? — yes / no

Do you think the visitors of the J. Weber Gallery who participated in the poll differed from those who did not? — very different / somewhat d. / essentially same / don't know

Thank you. Drop the card into the ballot box. Your answers will be tabulated with the answers of all other visitors. Intermediate results will be posted during the exhibition.

which certain cultural products are censored outright or discouraged from surfacing in one corner and accepted or even promoted in another corner of the same liberal environment.[6] Although in all these instances ideology or more crudely apparent financial considerations also guide the decisions, the individuals and social forces behind them do not necessarily share the same beliefs, value systems and interests.

The consciousness industry,[7] of which the art industry is an integral but minor small shop operation for a custom-made output, is such a far-flung global operation, with so many potentially conflicting elements, that absolute product control is impossible. It is this lack of total cohesion and the occasional divergence of interests that secures a modicum of 'deviant' behaviour.

The relative openness to non-conforming products – not to be equated with so-called pluralism – is further aided by the consciousness industry's built-in dialectics. For it to remain viable and profitable, it requires a pool of workers and a clientele with the judgement and the demand for ever new forms of entertainment, fresh information and sensual and intellectual stimulation. Although rarely in the foreground, it is the 'deviant' elements that provide the necessary dynamics. Without them the industry would bureaucratize and stagnate in boredom, which is, in fact, what happens in repressive environments.

Ironically, the ideological stabilization of power in the hands of a given power elite is predicated on the mobilization of the resources for its potential overthrow. If 'repressive tolerance' were as smothering as Herbert Marcuse fears, there would be no need to spend enormous amounts of money for propaganda and the public relations efforts of big corporations (Mobil Oil Corp spent $21 million alone for its 'Goodwill Umbrella' in 1976). These investments attest to the race between an ever more sophisticated public and newly developed techniques of persuasion, in which art is also increasingly used as an instrument.[8]

The millions of white-collar workers of the industry, teachers, journalists, priests, art professionals and all other producers and disseminators of mental products, are engaged in the cementing of the dominant ideological constructs as well as in dismantling them. In many ways this group reflects the ambiguous role of the petite-bourgeoisie,[9] that amorphous and steadily growing class with a middle and upper middle income and some form of higher education, oscillating between the owners of the means of production and the 'proletariat'. This embarrassing and embarrassed

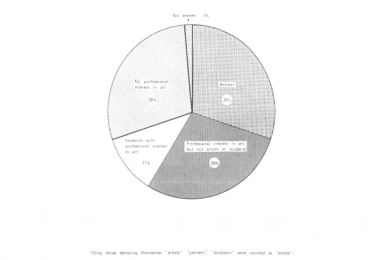

Do you have a professional interest in art (e.g. artist, dealer, critic, etc.) ?

John Weber Gallery Visitors'
Profile 2
1973
Key punch cards
29 sheets, 28 × 21.5 each
Installation/audience
participation project, John Weber
Gallery, New York.

*Only those declaring themselves "artists" "painters", "sculptors" were counted as "artists".

class, in doubt about its identity and aspirations and riddled with conflicts and guilt, is the origin of the contemporary innovators and rebels as it is the reservoir of those most actively engaged in the preservation of the status quo.

The general art public (not to be confused with the relatively small number of collectors), the public of museums and art centres, comes from the same social pool. It is a rather young audience, financially at ease but not rich, college-educated and flirting with the political left rather than with the right.[10] Thus there is a remarkable demographic resemblance between the art professionals, the art public at large, and probably the readership of this publication [*Art actuel*]. Apparently art is no longer the exclusive domain of the bourgeoisie and nobility as it was in the past.

Decades of doctrinaire interpretation of only a few aspects of the economic base have prevented us from adequately understanding the complexities of the art world and the even more complex functioning of the consciousness industry, of which the art world appears to be a microscopic model and a part. Nor have we learnt to understand the elusive character of the expanding petite-bourgeoisie in industrialized societies, which has become a considerable force in the consciousness industry and among its consumers. It seems to play a more important role in societal change than is normally recognized.

Nothing is gained by decrying the daily manipulation of our minds or by retreating into a private world supposedly untouched by it. There is no reason to leave to the corporate state and its public relations, mercenaries these satisfactions of our sensuous and mental needs or to allow, by default, the promotion of values that are not in our interest. Given the dialectic nature of the contemporary petite-bourgeois consciousness industry, its vast resources probably can be put to use against the dominant ideology. This, however, seems to be possible only with a matching dialectical approach and may very well require a cunning involvement in all the contradictions of the medium and its practitioners.

1 Complete results of *John Weber Gallery Visitors' Profile 1* and *2* are reproduced in Hans Haacke, *Framing and Being Framed: 7 Works 1970–75*, Press of the Nova Scotia College of Art and Design, Halifax and New York, 1975. Most visitors to the John Weber Gallery also view exhibits at the Castelli, Sonnabend and Emmerich Galleries, contemporary art galleries in the same building. Personal observation of the gallery public, however, suggests that the margin of error is not excessive so as to make the survey useless. For the purpose of this essay, collectors are not considered art professionals.

2 The operating budget of *non-profit* arts groups in New York State for the 1976–77 fiscal year alone is given as $410 million in a

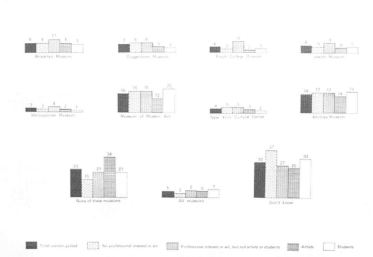

Esthetic questions aside, which of these New York museums would in your opinion exhibit works critical of the present US Government?

survey by the New York State Council on the Arts.

3 Thomas Messer, director of the Solomon R. Guggenheim Museum, in a letter to the author 19 March 1971, explaining the rejection of works dealing with New York real estate for exhibition in a scheduled one-man show at the museum. The exhibition was eventually cancelled and Edward F. Fry, the curator, dismissed.

4 Boards of Trustees of New York Museums: *Guggenheim Museum*: President, Peter O. Lawson-Johnston (mining company executive, represents Guggenheim family interests on numerous corporate boards).

 Metropolitan Museum: Chairman, C. Douglas Dillon (prominent investment banker). Vice Presidents, Daniel P. Davison (banker, Morgan Guaranty Trust Co.), J. Richardson Dilworth (investment banker, Rockefeller & Family Associates), Roswell L. Gilpatrick (corporate lawyer, partner Cravath, Swaine & Moore, prominent New York law firm).

 The Museum of Modern Art: President, Mrs John D. Rockefeller 3rd. Chairman, William S. Paley (Chairman CBS). Vice Chairman, Gardner Cowles (publisher, Chairman Cowles Communications Inc.), David Rockefeller (Chairman Chase Manhattan Bank).

 Whitney Museum of American Art: President, Flora Miller Irving (granddaughter of Gertrude Vanderbilt Whitney). Chairman, Howard Lipman (managing partner Neuberger & Berman, securities company).

5 The Andre Emmerich Gallery, a major outpost for formalist art in New York, resumed advertising in *Artforum* after a two-year pause as soon as the anti-formalist editor/publisher, John Coplans, and his executive editor, Max Kozloff, were dismissed or forced to resign by the magazine's owner, Charles Cowles (son of Vice Chairman of Board of Trustees at The Museum of Modern Art), in December 1976.

 Other prominent New York Galleries had also withheld advertising when *Artforum* editors did not abide by the tacit understanding that their galleries' artists receive ample attention and the art world's infra-structure remain a taboo subject.

6 One example from the author's own experience: in 1974 the Cologne Wallraf-Richartz-Museum banned *Manet-PROJEKT '74*, a large work, for obvious economic and political reasons. Two years later it was prominently displayed at the Kunstverein in Frankfurt. Both institutions are funded by their respective cities and both city councils, at the time, were dominated by the Social Democratic Party. Before the Frankfurt exhibition, the piece had been shown in a commercial gallery in Cologne (Paul Maenz), at the ICA, London, and the Palais des Beaux-Arts, Brussels. It also had been reproduced in its entirety or extensively covered in German, Belgian, Italian and US art magazines, and it had been purchased by a Belgian collector.

7 Title of an essay by Hans Magnus Enzensberger, in *Einzelheiten I, Bewusstseinsindustrie*, Frankfurt, 1962.

8 'Exxon's support of the arts serves the arts as a social lubricant. And if business is to continue in big cities, it needs a more lubricated environment.' Quote from Robert Kingsley, Manager of Urban Affairs, Dept. of Public Affairs, Exxon Corp., New York.

9 The contemporary petite-bourgeoisie is the subject of many relevant essays in *Kursbuch 45*, Berlin, September 1976.

10 Supported by data from polls conducted by the author at Milwaukee Art Center, 1971, Museum Haus Lange, Krefeld, 1972, documenta 5, 1972, and Kunstverein Hannover, 1973.

First published in French as 'Les adhérants' in *Art actuel: Skira annuel 77*, No. 3, Geneva, 1977. Reprinted in English (slightly modified) in *Hans Haacke: Volume. 1* (cat.), Museum of Contemporary Art, Oxford; Stedelijk Van Abbemuseum, Eindhoven, 1979.

Yve-Alain Bois, Douglas Crimp and Rosalind Krauss:
A Conversation with Hans Haacke (extract) 1984

Taking Stock (unfinished)
1983–84
Oil on canvas, gilded frame
241 × 205.5 × 18 cm
First exhibited, Tate Gallery,
London, 1984.
The sculpture of Pandora (1890)
is by Harry Bates (Tate Gallery
collection). 'MS' and 'CS', on the
broken plates, are the initials of
the brothers Maurice and Charles
Saatchi. In 1982, when Charles
Saatchi was an influential member
of the Patrons of New Art of the
Tate Gallery, the Tate gave Julian
Schnabel a solo exhibition (nine
of eleven paintings belonged to
Saatchi). He was also on the
board of London's Whitechapel
Art Gallery. After *Taking Stock
(unfinished)* was exhibited at
the Tate Gallery, Charles Saatchi
resigned from the Patrons of New
Art Committee and the
Whitechapel Art Gallery.
He began collecting art in the
early 1970s. From photo-realism
and pattern painting, his interest
shifted to Minimalism, Neo-
Expressionism and 'Neo-Geo'
works. Since the 1990s he has
focused on British art (YBA).
Throughout these years he sold
works from his collection and has
been a partner in art investment
companies.
Charles Saatchi's acquisitions
were initially financed through
Saatchi & Saatchi PLC, the
advertising agency he and his
brother started in 1970 and built
into the largest holding company
of ad agencies in the world. In
1994 shareholders ousted the
brothers because of financially
unsound expansion. In 1996 they
opened M & C Saatchi in London.
Saatchi & Saatchi ran Margaret
Thatcher's election campaigns in
1979, 1983 and 1987. After her
election, the British Airways
account was awarded to the
Saatchis, as were those of other
state-owned entities. Maurice
Saatchi credited the Tories: 'We
owe them everything … '. He
became life peer in 1996. In 2003
Michael Howard appointed him
co-chairman of the Conservative
Party. During Howard's candidacy
for the Tory leadership in 2003,
he held a news conference at the
museum Charles Saatchi had
recently opened at County Hall,
the former home of the Greater
London Council, a Labour Party
bastion.

Rosalind Krauss Since your work has, from the beginning, resisted painting, implicitly criticizing painting as incapable of supporting any serious critique of its own assumptions, what made you decide that your work for your Tate Gallery exhibition last spring would be a painting?

Hans Haacke **That wasn't the first time I did a painting.**

Douglas Crimp Right. There's the portrait of Ronald Reagan that formed part of *Oelgemaelde, Hommage à Marcel Broodthaers* (*Oil Painting: Homage to Marcel Broodthaers*, 1982), the work for documenta 7. But it is true, isn't it, that the portrait of Margaret Thatcher is the first instance in which you've used a painting by itself?

Haacke **No, there's another precedent, aside from the paintings I did before I turned to three-dimensional work in the early 1960s. For a show in Montreal in 1983, I made what I called *Alcan: Tableau pour la salle du conseil d'administration (Alcan: Painting for the Boardroom*), an industrial landscape. It is a somewhat impressionistic aerial view of the Alcan aluminium smelter in Arvida, Quebec. I painted it after a photograph that I found in an Alcan PR pamphlet. It is a cheerful, sunny picture. Into the bright sky I painted a short caption which announces, in a tone of pride, that the workers at Arvida have an opportunity to contract bone fibrosis, respiratory diseases and cancer. The painting is framed in aluminium siding. Obviously, in all three cases, I chose to paint because the medium as such has a particular meaning. It is almost synonymous with what is popularly viewed as Art – art with a capital A – with all the glory, the piety and the authority that it commands. Since politicians and businesses alike present themselves to the folks as if they were surrounded by halos, there are similarities between the medium and my subjects. When I planned the Reagan painting, I was also inspired by the thinking of Marcel Broodthaers. In the catalogue preface to his *Musée d'art moderne, Départment des aigles, Section des figures* (1972), he pointed to the parallelism between the mythic powers of the eagle, the symbol of empire and the mythic powers of art. Contrary to popular belief, eagles are really not courageous birds; they are even afraid of bicycles, as Broodthaers wrote. Their power is due to projection. The same is true for art – and political power. They need the red carpet, the gold frame, the aura of the office/museum – the paraphernalia of a seeming immortality and divine origin.**

Krauss But in the case of the Broodthaers work, the medium, we could say, is a standard iconographical emblem, rather than oil paint's being the medium.

Haacke **It is important that the Thatcher portrait is an oil painting. Acrylic paint doesn't have an aura. I was also deliberate in the choice of the Victorian frame. I had it built especially. For the design, I followed the example of frames around paintings by Frederick Leighton and Burne-Jones at the Tate. In effect, these frames elevate their contents to the status of altarpieces, endow the paintings with religious connotations. I don't have to tell you what gold represents. As with the frame, I tried to mimic, as best I could, the love for genre detail and the paint style of the Victorian era. And so all the details are Victorian, the interior with its furniture, the curtain with its tassels, the Tate Gallery's own sculpture of Pandora by Harry Bates, the typeface on the book spines, and so on. I thought I should place Margaret Thatcher into the world that she represents. As you know, she expressly promotes Victorian values, nineteenth-century conservative policies at the end of the twentieth century.**

Krauss Most of the information in the painting, as well as its title, *Taking Stock (unfinished)* (1983–84), refers to the Saatchis. Do you mean for the Saatchis to be understood as Victorian figures as well?

Haacke **Of course, in their own way, the Saatchis are also Victorians. They match the young bourgeois entrepreneurs of the nineteenth century, relatively unfettered by tradition, without roots in the aristocracy, and out to prove themselves to the world. Their conquests are the brash takeovers of advertising companies around the world. After successful forays in the UK, a few years ago they gobbled up Compton, a big Madison Avenue agency with an international network. And last year it was the turn of McCaffrey & McCall, another New York agency. By now the Saatchi empire has grown to be the eighth largest pedlar of brands and attitudes in the world. Naturally, they align themselves with the powers that promise to be most sympathetic to their own fortunes. So they ran the election campaign for Margaret Thatcher in 1979, and again last year. They also had the Tory account for the European Parliamentary elections this year. Michael Heseltine, the Tory minister, who has an interest in *Campaign*, the British advertising trade journal, has been a good friend of the Saatchis since the days when**

Maurice Saatchi worked for the journal. Everyone in London assumes that, as a reward for their services during Margaret Thatcher's first election campaign, the Saatchis got the British Airways account. Not to be outdone, the Saatchis' South African subsidiary took it upon itself to run the promotion of the constitutional change that was presented in a referendum to the white voters by the South African government's National Party. Foes of apartheid think that this change, in effect, cemented the system which reserved political power in South Africa *exclusively* for the white minority, which constitutes sixteen per cent of the population.

Crimp Both the Reagan and Thatcher paintings were also presumably intended to comment on the relationship between these people's reactionary politics and the current revival of painting in a reactionary art-world situation. The Reagan portrait appeared in a documenta exhibition that everyone knew would lend its authority to the painting revival, while the Thatcher portrait contains information about the power of the Saatchis, who are active promoters of the new painting. Why then did you choose a hyper-realist, or perhaps a late nineteenth-century academic style for these paintings, rather than a style that might more directly comment upon the Neo-Expressionism which is the dominant mode of the return to painting?

Yve-Alain Bois The iconological mode you've used is indeed quite remote from what is going on in contemporary painting.

Crimp It's true, of course, that what is going on now involves historical references, and I can see that you would want to make the connection between these political personalities and Victorian values, but that choice also reduces the work's pungency with regard to current painting.

Haacke **But if I had concentrated on the style of current painting, the political content would have been left out. I would have been dealing exclusively with an art-world affair. The art world is not *that* important. Moreover, the attitudes associated with much of the retro type of painting favoured by the Saatchis amounts to a gold-frame celebration of a romantic individualism of a bygone era, which clearly predates and differs essentially from the attitudes of the original Expressionists. Much of the current**

painting is coy naughtiness.

Krauss I'd like to explore further what you said about the kind of image politicians like Reagan and Thatcher wish to elaborate for themselves. It's true that the oil portrait, because of its aura, its air of nobility, is important for this image, yet connecting the Saatchis and Thatcher also brings into play something which involves the opposite of this aura, something which is very much of the twentieth century – the public relations selling of politicians through the media. I'm interested to think about an act which restores traditional aura to Thatcher and Reagan, who have been sold by television, who most often have their images conveyed through the medium of video.

Haacke **Margaret Thatcher's public relations advisors evidently told her that she should style herself after the Queen, including her taste in clothing. She also took voice training lessons to get rid of her shrillness. Her entire image has been transformed over the past few years to fit the media better. It pays politically to look like the Queen rather than like the nation's headmistress. I therefore thought I should paint her in a haughty, regal pose. In order to accentuate her rivalry with Queen Elizabeth and also to strengthen the period look, I seated her on a chair with the image of Queen Victoria on its back. It is a chair that I found in the collection of the Victoria and Albert Museum. Thatcher would like to rule an Imperial Britain. The Falklands War was typical of this mentality.**

Bois So that is why you used the emblematic tradition, the iconographic symbols?

Haacke **Yes. I hope everybody understood that this was done tongue-in-cheek.**

Crimp It also seems that there is a strategic aspect to this, in so far as you are using a painting style that even the most naive museum-goer can read. It's possible in this way to capture a broader audience, and interestingly enough there was a very large media response to the Tate Gallery work. By resorting to this auratic art form, you get press coverage that you probably wouldn't get if you were to use a more avant-garde kind of object. I'd like to ask you something related to the question of strategies, because I was struck by the fact that two of your most recent works are, on the one hand, a portrait

painting, which makes all kinds of concessions to being a traditional work of art, and, on the other hand, the *US Isolation Box, Grenada, 1983* (1984), which makes no pretence to being a work of art.

Bois Except that, in a way, it becomes a bad piece of minimal sculpture.

Haacke **Indeed, there, too there is a subtext. When I read about the isolation boxes in the *New York Times*, I immediately recognized their striking similarity to the standard minimal cube. As you see, one can recycle 'minimalism' and put it to a contemporary use. I admit that I have always been sympathetic to so-called Minimal art. That does not keep me from criticizing its determined aloofness, which, of course, was always one of its strengths. As to the implied incompatibility between a political statement/ information and a work of art, I don't think there are generally accepted criteria for what constitutes a work of art. At least since Duchamp and the Constructivists, this has been a moving target. On a more popular level, of course, there are strong feelings about what does or does not look like a work of art. Minimal cubes obviously don't qualify, whereas anything painted on canvas is unquestionably accepted. The argument rages only about whether or not it is a good work.**

Krauss One of the things that struck me when I saw the Philips piece (*Toch denk ik, dat U mij niet de juiste motieven toeschrijft* [*But I Think You Question My Motives*], 1978–79) was that the blown-up, rather dramatic, high chiaroscuro photographs of black youths seemed to make reference to the works of Gilbert and George from the same period. So it seems to me that there is always a component of your work that reveals certain formal moves made within the art world and the contents to which those forms can be exceedingly porous.

Haacke **I didn't think of Gilbert and George. Those are photos from a South African business magazine. They were probably supplied by the Philips PR department. But it is true that I often play on the modes of the contemporary art world; and I try to make something that is accessible to a larger public, which does not care for the histrionics of the art world. As Douglas pointed out, it helps that these pieces do not have the look of hermetic 'avant-garde' art.**

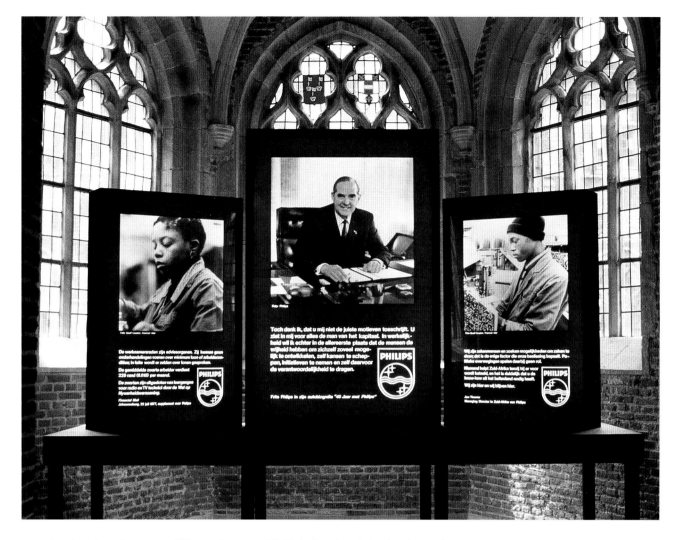

Bois But there is an important difference between this kind of work and the Thatcher and
Reagan paintings. Until now, your work has involved a minimal transformation of the
material. There was not an elaborate coding through art. I'm thinking of another Philips
piece (*De oneindige dankbaarheid* [*Everlasting Gratitude*], 1978), in which the
transformation involved only the addition of the Philips logo.

Haacke **Actually, I didn't add anything. It is a facsimile of a Philips ad that appeared in a
Teheran newspaper in 1975.**

Bois That's exactly my point. Before, the context was the signifier. Only a change of
context was required for a change of meaning to take place. But now there seems to be
a much greater mediation through art-historical codes.

Haacke **Only in part. Obviously, had I only made a photocopy of the newspaper ad, it
would have remained at the level of documentation. The shift to another material and
its inherited connotations changes it radically. Tapestry is something we know from art
history. And the panel underneath the Philips *Everlasting Gratitude* tapestry – that's the
way things are displayed in museums.**

Crimp If I understand what Yve-Alain is getting at, it is more that in the Thatcher work,
for example, you are *creating* an image as opposed to taking an advertisement and making
a facsimile of it and adding information.

Haacke **Some of the ads I invented myself, emulating contemporary corporate style.
The quotations about what's good about art for business (*On Social Grease*, 1975) I**

Translation of texts, left, *We are
businessmen and we look for
business opportunities. This is the
only factor governing our
decisions. Political considerations
don't enter into it. Nobody is going
to help South Africa unless he is
paid; and obviously, you need
know-how from abroad. We are
here to stay. – Jan Timmer,
Managing Director of Philips in
South Africa.*
middle, *But I think you question
my motives. You see me only as a
man of capital. However, above all
I really would like people to have
the freedom to develop themselves
as much as possible, to create
opportunities for themselves, to
take initiatives, and assume the
responsibility for them. – Frits
Philips, in his autobiography* 45
Years with Philips.
right, *The Employee Councils are
advisory bodies. They are precluded
from negotiating minimum wages
or conditions of employment; in
fact, wages are rarely discussed.
The average black worker earns 229
Rand a month. Blacks are excluded
from apprentice training for radio
and TV technicians by the Job
Reservations Act. – Financial Mail,
Johannesburg, 22 July 1977,
Supplement on Philips.*

De oneindige dankbaarheid
(Everlasting Gratitude)
1978
Beige wool carpet with spray paint
in midnight blue and cobalt, text
panel
2 parts, 322 × 366 cm, 39 × 203 cm
Installation, Stedelijk Van
Abbemuseum, Eindhoven, 1979.
Collection, Le Consortium, Dijon.
Philips is a multinational company
with world headquarters in
Eindhoven, The Netherlands.
It produces lighting, electronic
consumer goods, domestic
appliances, cable,
telecommunications and data
processing systems, and until
1990 also defence-related
electronics. In 1978 the company
had 387,900 employees worldwide.
Philips collaborated with the
dictatorial regime of Shah
Mohammed Riza Pahlevi of Iran.
On 2 March 1975, the Emperor
declared his country a one-party
state and decreed the National
Resurgence Party as the country's
only political party. Philips ran a
celebratory advertisement in
Keyhan, one of the major daily
newspapers of Teheran. More than
100,000 of the Shah's opponents
were jailed and tortured by his
secret service. Many hundreds were
executed. Amnesty International
declared in 1975 that 'no country
in the world has a worse record in
human rights than Iran'.
During the Shah's regime, Philips
supplied the Iranian military with
sophisticated communications
equipment, radio-altimeters and
missile guidance systems.
Leading the Iranian revolution of
1979 were segments of the liberal
intellectual elite of Iran, leftist
political groups and Muslem Shiite
fundamentalists. Eventually an
Islamic theocracy was established
under Ayatollah Ruhollah
Khomeini, which soon persecuted
its former secular allies in the
struggle against the Shah. Human
rights organizations accused the
Islamic regime, like its
predecessor, of massive political
repression, of torture and summary
executions.
Philips continued to maintain good
business relations with Iran.
Aside from Iran, Philips military
equipment was also used in the
1970s by the repressive regimes of
Argentina, Chile, Brazil and South
Africa. During the eight-year war
between Iran and Iraq in the
1980s, Philips equipment served
both belligerents.
In the 1980s, Philips began
sponsoring art programmes at the
Stedelijk Van Abbemuseum in
Eindhoven and the Rijksmuseum in
Amsterdam.

took from books and newspapers. I made commemorative plaques of them so that they look as if they would be at home in the lobby of corporate headquarters or in the boardroom. Transplanting them from that imagined context into an art gallery can be devastating. That's where the context Yve-Alain is referring to plays an important role.

Bois In a way, the Thatcher piece refers to a history of satirical portraiture, whereas when you transform a quotation from a business into an advertisement format, there is no mediation through art history. The context or the medium is immediate for the viewer because of this abrupt transformation. But in the Thatcher painting, the transformation is far more complicated.

Haacke Maybe there are more layers. Indeed, I use context as a material.

Bois Your earlier work reminds me of the strategies of the Situationists, which involved the simple robbery of codes. For example, they released films whose soundtracks had been removed and replaced with others. They made a film that was simply a porno-Kung-Fu film from Hong Kong to which they added a soundtrack that was a shouting-match between Maoists and Trotskyists. The reason they were called Situationists is because they changed strategies for each new situation, and because they invented situations, disruptive events within the apparently smooth flow of 'reality'. I have felt that your work was very much connected with that of the Situationists, because they too wanted to show the connections between investment, advertising and the culture industry. But with your paintings, there is no longer the same brilliant economy of means. What I found extraordinarily provocative in your works was their efficiency in revealing so much meaning through such slight transformation. But with a painting, you have to start from

Translation of text:
Philips of Iran expresses its everlasting gratitude to his Imperial Majesty, the Shah of Iran, who secured national unity by founding the Iranian Resurgence Party.
– advertisement in the Iranian newspaper Keyhan, 5 March 1975.

scratch and make the object.

Krauss You're talking about the economy of means in the readymade principle; but if the readymade in this case is Victorian painting, then in a way it's the same economy. Was it difficult to do?

Haacke Yes. I did a lot of painting in art school and for a while afterwards. But I never learned this kind of painting, with figures, perspective and so forth. So I listened around, looked into painting manuals, and went to museums to study how such paintings are done. I have no delusions about having produced a masterwork in the traditional sense of the craft. I hope it is good enough for a passing grade. For my purpose, this is all it needs. But it was fascinating, and I had fun doing it. Another reason for making a painting was that I had been stamped a conceptualist, a photomontagist, that sort of thing. This was a way to mess up the labels. There were, in fact, a good number of people who thought that my portrait of Reagan was a photograph, or that I'd paid somebody to paint it for me. It was therefore very important that I painted it myself. Normally, I have no qualms about paying someone to execute something I can't do, as long as I can afford it.

Crimp Again, it seems to me that it is a question of strategies, of devising a work which is appropriate to the problem at hand. That's why I was interested to ask about the differences between the Thatcher portrait and the *US Isolation Box, Grenada, 1983*. It seems to me that one of the problems of making politically engaged art today is to devise something that won't simply be assimilated because it has accepted the conventional aesthetic codes. For example, if at this moment there is a great deal of attention paid to Leon Golub's work, attention that certainly was not given to him in the past, it's because he makes figurative paintings, and figurative painting has returned as a sanctioned style.

Haacke Not exclusively.

Crimp Perhaps not exclusively. But the generalization of Golub's imagery makes it possible for the Saatchis to collect his work, or for his paintings to be seen in the

Translation of texts:
opposite, top, on marble slab,
*Declaration of human rights and of
the citizen* [of 1789]
opposite, bottom, signs on
construction fence,
Construction site
Access prohibited to the public
Hard hat area
Arabic script on green walls,
Freedom, Equality, Brotherhood
[Motto of the French Revolution,
today on French Government
buildings and stationary]
above, *Barbès-Rochechouart*
[Métro station in an immigrant
neighbourhood in the centre of
Paris]
Parisian subway poster,
At the Bon Marché [Parisian
department store]
Let's redecorate our world
*20% off on a selection of wall-to-
wall carpeting, large-size wall
covering, upholstery fabric,
curtains, wallpaper, paint and
millions of other items at
exceptional prices.*
*Until 31 August, personalized
credit arrangements*
At the Bon Marché
A call from the Left Bank

context of the Whitney Biennial, for example, and not to disturb the situation, because they fit into the predominant painting mode. So it seems that the problem one faces is to invent a style for each work which allows one to enter the art context but which is not lacking in specificity in such a way that the political thrust vanishes into the dominant aesthetic of the present.

Haacke **Concerning the Grenada piece, aside from the minimal art reference, I used Dada strategies – the readymade, challenge to cultural norms, and so on. While it looks like a dumb box and nothing else, it is, I believe, perfectly within the range of twentieth-century art theory as we know it. But you are right, it was the political specificity that caused the amazing hoopla around the piece. I thought it would take more to get the *Wall Street Journal* to foam at the mouth and commit three factual errors in one editorial.**

Crimp Do you feel that you must always make a specific aesthetic choice, that you have to invent a form that can be understood in aesthetic as well as political terms?

Haacke **It seems to work that way.**

Crimp What I mean is, do you think this is necessary in a strategic sense, something that will continue to make it possible for you to function within the art context? I'm curious about this because it seems to me that artists of your generation were able to achieve a certain degree of success in the more liberal climate of the late 1960s and early 1970s, and having achieved that success, you can, to some extent, continue to function. But for an artist beginning right now, it would be much more difficult to enter the art scene as a politicized artist. Therefore the problem for such an artist would be to devise a strategy that would result in some visibility for his or her work.

Haacke **Yes, I already had a foot in the door when I moved towards politically engaged work. It got stepped on, but I didn't lose the foot. For young artists today it may be more difficult. They will have to invent their own tricks for survival. I can't tell them what to do […]**

Yve-Alain Bois, Douglas Crimp, Rosalind Krauss, Hans Haacke, 'A Conversation with Hans Haacke', *October*, New York, Fall 1984.

Caught between Revolver and Chequebook: A Paper for 'Art and the Economy' Colloquium 1993

When I recently looked up the word 'culture' in quotation reference books, I discovered this startling phrase, 'When I hear the word culture, I reach for my revolver'.

I did not find, at first, the decidedly less militant phrase, 'When I hear the word culture, I reach for my chequebook'. I had set out to locate this quotation, because I thought it was pertinent to our topic, 'The Arts and the Economy'. After my initial disappointment, I realized that the martial quotation I had found by accident was not without relevance and, in fact, complemented the one I was looking for.

The gun-toting speaker is one of the heroes of a play that premiered in Berlin on Hitler's birthday, a short month after he had seized power in Germany in 1933.[1] The author, Hanns Johst, had earlier made himself a name as an expressionist writer and poet. With a pledge of undying loyalty, he dedicated his new play to Hitler. Two years later, Johst was put in charge of the literature section in Goebbels' propaganda ministry.

High culture, as the tone of the quotation implies, was recognized by the protagonist on the stage as much as by the playwright's new bosses as something to be watched, as something potentially threatening and, if need be, to be regulated or even suppressed. However, as Johst's personal career demonstrates, the new masters also recognized, as others had before and would do later, that the symbolic power of the arts could be put to good use.

Not least the Medici in Florence knew of the persuasive powers of the arts. But the relations between sponsors and sponsored have never been tension free. The Inquisition in Venice, for example, was suspicious enough of Veronese's treatment of the 'Last Supper' to summon him before its tribunal. As a matter of fact, they were right to be wary of him.

Mistrust, hostility, an urge to ridicule or censor the arts are not foreign to our time. Nor are we unaccustomed to seeing them used as instruments for the promotion of particular interests. We hardly remember that only forty years ago, abstract art was suspected by influential Americans as being part of a communist conspiracy, and that shortly afterwards, in an ironical twist, Abstract Expressionist paintings were sent to Europe to play a combat role in the ideological battles of the Cold War. We have fortunately been spared the degree of fundamentalist fervour that calls for the killing of artists accused of blasphemy. But we have had our share of incendiary speeches in Congress. 'Obscenity' has become a household word in Washington. The charge of supporting pornography was even hurled at George Bush and made him flinch during

Die Freiheit wird jetzt einfach gesponsert-aus der Portokasse (Freedom Is Now Simply Going to Be Sponsored – Out of Petty Cash)
1990
Watchtower in former Berlin 'deathstrip', neon, Mercedes star; bronze inscriptions; Europa-Center Installation, 'Die Endlichkeit der Freiheit', Berlin.
In 1961, the GDR (East Germany) built unscalable walls with dog runs and minefields along its borders. Over 150 people were killed trying to escape.
For this project, the windows of a watchtower in the 'deathstrip' were fitted with tinted glass, reminiscent of the Palasthotel in East Berlin. Like the windows of West German police vans, wire grills protected them against rock throwers. The searchlight on the roof was replaced by a slowly rotating Mercedes star, matching the star on the Europa Center in West Berlin.
Two inscriptions quoted from ads, in which Daimler-Benz cited famous people: 'Bereit sein ist alles' (The readiness is all), Shakespeare, echoing 'Be prepared – always prepared', a motto of the GDR's Young Pioneers; and 'Kunst bleibt Kunst' (Art will always remain art) from Goethe. A few months earlier, the City of West Berlin had sold Daimler-Benz a large tract of empty land at Potsdamer Platz for a fraction of its market value.
Daimler-Benz had vigorously promoted Hitler's rise to power. The majority of German warplanes and military vehicles in the Second World War were powered by Mercedes engines. The company relied extensively on forced labour. Its only foreign production (1980s) of passenger cars was in apartheid South Africa. In a joint venture with the Government there it also produced heavy diesel engines and supplied 6,000 military vehicles. In 1987, it broke a bitter nine-week strike by its black workers. Daimler-Benz sold Saddam Hussein's Iraq helicopters, military vehicles, missiles and flatbed trucks, which were usable as mobile missile launchers.
Daimler-Benz is a prominent sponsor of culture. It commissioned Andy Warhol to make paintings of its cars from the beginning to the present which were posthumously exhibited in 1988 at the Solomon R. Guggenheim Museum, New York. At Potsdamer Platz, it maintains its own exhibition space.

Die Freiheit wird jetzt einfach gesponsert-aus der Portokasse (Freedom Is Now Simply Going to Be Sponsored – Out of Petty Cash)
1990
Watchtower in former Berlin 'deathstrip', neon, Mercedes star; bronze inscriptions; Europa-Center Installation, 'Die Endlichkeit der Freiheit', Berlin.
left, Europa-Center
opposite, detail of 'deathstrip'

his unsuccessful re-election campaign. Most recently, Morley Safer, the Sunday painter of sudden fame, lectured the 31 million viewers of *60 Minutes* [a popular US television news programme] that contemporary art, the kind shown in museums like The Museum of Modern Art and the Whitney Museum, was nothing but a hoax.[2]

These examples, uneven as they are, and coming from varied historical periods and diverse social contexts, illustrate a truism of the sociology of culture: artworks do not represent universally accepted notions of the good, the beautiful and the true. Whether they are viewed as uplifting, destructive or nothing more than a profitable investment depends on who looks at them. In extreme situations, as the quotation that triggered these thoughts suggests, culture is silenced with guns. Contrary to Immanuel Kant's dictum of 'disinterested pleasure', the arts are not ideologically neutral. They are, in fact, one of the many arenas where conflicting ideas about who we are and what our social relations should be are pitted against each other. Encoded in cultural productions are interests, beliefs and goals. Consequently they, in turn, have an influence on interests, beliefs and goals. Artists and arts institutions – like the media and schools – are part of what has been called the consciousness industry. They participate to varying degrees in a symbolic struggle over the perception of the social world, and thereby shape society. Pierre Bourdieu, perhaps the most eminent contemporary sociologist of culture puts us on the alert: '*The most successful ideological effects*', he says, '*are those which have no need for words, and ask no more than complicitous silence. It follows … that any analysis of ideologies, in the narrow sense of "legitimating discourses", which fails to include an analysis of the corresponding institutional mechanisms is liable to be no more than a contribution to the efficacy of those ideologies.*'[3]

As our notions of the good, the beautiful and the true – the classical triad – are contingent, endlessly negotiated or fought over, so is the encoded meaning of cultural productions not something permanent, comparable to the genetic code. The context in which they appear has a signifying power of its own. As the context changes, so does the way audiences respond. One and the same artefact can elicit rather varied reactions, depending on the historical period, the cultural and social circumstances, or for that matter, its exchange value.

In addition to their symbolic value, art productions, of course, have an economic value. They are bought and sold, are subject to the mechanism of supply and demand, and they are objects of speculation, like shares in the stock market. Hype, negative

propaganda and the unstructured, gossipy talk of the town have always been part of the art market. Symbolic and economic value affect each other, but they do not necessarily go in tandem.

The phrase, 'When I hear the word culture, I reach for my chequebook', could make us think that the speaker understands that high culture is an expensive enterprise, that it needs not only moral but also financial backing, and that he is willing to chip in. It conjures up the image of the altruistic private patron who has been the proverbial mainstay of the arts in this country. However, the comment also has a cold, cynical ring. In fact, it was this ambiguity which led me to research its origin. With the help of knowledgeable friends I eventually traced it.

Like the 'revolver' quotation, this phrase is uttered by an actor. Jean-Luc Godard, in his 1963 screenplay *Le Mépris* (*Contempt*), puts it into the mouth of Jack Palance.[4] Palance plays the role of a movie producer in Godard's film. Working for this producer is Fritz Lang who plays himself as a director. In the opening sequence, Lang and the producer look at rushes from the *Ulysses* film Lang is shooting. The scene of an alluring nude siren languorously swimming underwater prompts the producer to ask Lang: 'What will go with this?' Lang answers with a recitation of a passage from Dante, whereupon the producer jumps up in a rage, tears down the projection screen, tramples on it, and screams: 'This is what I'll do with your films!' When Lang mumbles something like 'culture' or 'crime against culture', the producer cuts him off: 'When I hear the word culture, I reach for my chequebook.' In effect, he pulls out his chequebook, writes out a cheque on the back of his attractive young secretary, Francesca, and gives it to the screenwriter, who pockets it, presumably with the understanding that he will rewrite the script.[5]

The parallelism of the two quotations is probably not accidental. Fritz Lang certainly knew of the outburst on the Berlin stage. What we know about Jean-Luc Godard suggests that he had heard the phrase too, perhaps even from Fritz Lang. It is fair to assume Godard not only saw a linguistic connection, but invented this scene as a parable that allowed him to link the violence of the gun with economic violence. Lang's symbolic capital, i.e. his reputation as a film director, proves not to be a match for the economic capital of the producer, although the producer is nothing without Lang. Symbolic and economic capital constitute power. They are linked in a complex, often strained and sometimes even violent but inescapable relationship. They are rarely equal partners.

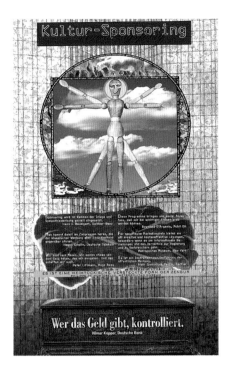
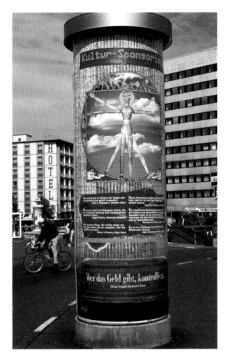

Standortkultur (Corporate Culture)
1997
Poster
350 × 175 cm
Installation, Documenta X, Kassel.
Poster kiosks of Deutsche Städte-Reklame (German agency administering outdoor advertising surfaces) in Berlin, Bonn, Bremen, Dresden, Düsseldorf, Frankfurt/Main, Hamburg, Hannover, Kassel, Leipzig, Vienna, Zürich; in Kassel also surfaces of Deutsche Bahn (German railroad).
Computer assistance: Dennis Thomas.
Translation of text:
'Sponsoring Culture/tax deductible Sponsoring is used purposefully as part of image and good-will promotion.'
– Hans J. Baumgart, Daimler-Benz
'It lends itself to reaching target groups which are resistant to traditional advertising.'
– Hagen Gmelin, Generaldirektion, Deutsche Bundespost/Telekom
'We are not patrons. We want something for the money we spend. And we are getting it.'
– Peter Littmann, President and Chief Executive Officer, Hugo Boss
'These programmes build enough acceptance to allow us to get tough on substantive issues.'
– Raymond D'Argenio, Manager Public Relations, Mobil Oil
'These can often provide a creative and cost-effective answer to a specific marketing objectives, particularly where international, governmental or consumer relations may be a fundamental concern.'
– Metropolitan Museum of Art, New York
'It is a tool for the seduction of public opinion.'
– Alain-Dominique Perrin, President and Chief Executive Officer, Cartier
'It's an inherent, insidious, hidden form of censorship.'
– Philippe de Montebello, Director, Metropolitan Museum, New York
'Whoever pays controls.'
– Hilmar Kopper, President and Chief Executive Officer, Deutsche Bank

The French Revolution was the cause for fundamental changes in the arts of Europe. Old economic dependencies and ideological allegiances were broken. An understanding and a practice for a new world, no longer governed by divine right, by princes and religious authority, had to be developed. What was to be the role of the arts, and what was to be their economic support structure in a society in which the population, at least in theory, had become the sovereign? Today, 200 years later, these issues still remain unsettled.

However, without much debate, the newly emancipated states recognized support of the arts as natural for the *res publica*, a bona fide public cause. Particularly in view of the different history in this country and the *laissez faire* arguments one hears occasionally, it is worth noting that the citizenry of Europe has maintained, since its emancipation 200 hundred years ago, that without the arts a society would be impoverished and perhaps even lose its viability as a creative, collective enterprise. Therefore all legislatures, no matter of which political bent, passed budgets in which, as unquestionable as the funding of schools and the military, a portion of the taxes was allotted to the arts. This is also the model Canada and Australia have adopted, countries which did not exist when the European consensus developed. The voters in those countries agree, still today, that the arts need and deserve their financial support, that abandoning them to market forces would subject them to the rationale which governs mass entertainment and would thus destroy them. The electorate seems to have a sense that art productions are fundamentally not merchandise, and therefore public expenditures need not be legitimized in terms of economic profitability. The number and the professional level of arts institutions supported under these circumstances, and as a corollary the comparatively high interest and participation in their activities, is truly remarkable. Sometimes figures speak. The French culture budget has been slightly raised this year to $2.3 billion.[6] In comparison, the 1994 budget of the National Endowment for the Arts stands at $166 million. It was reduced by five per cent. The cut was not so much motivated by fiscal constraints, but by the desire to punish the NEA for having, quite legitimately, funded politically unpopular artists and the institutions that exhibited them.[7]

The National Endowment for the Arts, like many of the state councils for the arts and municipal arts funding agencies, was established in the 1960s. The traditional sources of arts funding in this country, private patrons and the membership of arts

Cowboy with Cigarette
1990
Pasted paper, charcoal and ink, frame
94 × 80 × 6 cm
First exhibited, John Weber Gallery, New York.
Replica of Picasso's collage *Man with a Hat* (1912), collection The Museum of Modern Art, New York; included in Museum's 1989 exhibition 'Picasso and Braque: Pioneering Cubism', which was sponsored by Philip Morris.
In place of Picasso's clippings are facsimile excerpts from New York newspapers on arts sponsorship and the risks of smoking, and internal Philip Morris documents. Philip Morris (renamed Altria in 2003) is the largest tobacco and second largest food company (Kraft) in the world. It has headquarters in New York.
72% of its 1989 operating profits were generated by tobacco business (Marlboro, Philip Morris, Chesterfield, L & M, Parliament, Merit and Virginia Slims). The remaining 28% were from Kraft subsidiaries (Maxwell House, Jacobs, Kaffee HAG, OREO, Ritz, Milka, Suchard, Toblerone, Dairylea, Philadephia, Velveeta and Miller beer).
Quotes within clippings: Dr Louis W. Sullivan, US Secretary of Health and Human Services: 'Cigarettes are the only legal product that when used as intended cause death'. Cigarette companies are 'trading death for corporate profits' ('Smoking's Cost to Society is $52 billion a Year, Federal Study Says', *New York Times*, 21 February 1990).
Metropolitan Museum's President William Luers: 'To a large degree, we've accepted a certain principle about funding that in passing through our illustrious hall, the money is cleansed' (*NY Newsday*, 8 August 1990).
The sponsoring of an exhibition of 126 photographs by Pulitzer Prize-winning black photographer Moneta Sleet is ' … to gain further visibility in the black community and interact with constituents and public officials' and ' … interact with issues affecting Hispanics and gain access to Hispanic elected and appointed officials' (PM document, 1989).
Details of a $100,000 contribution to Jesse Helms Center at Wingate College, North Carolina, to serve as repository for Senatorial papers of Jesse Helms, a replica of his Washington office and the promotion of his 'American values' (*Corporate Contributions 1988*, PM document, 1988). The Jesse Helms Center received additional contributions in subsequent years.

institutions and their paying public, were recognized as being no longer adequate. A new sense of civic responsibility and enthusiasm for high culture, together with the discovery that the arts can create jobs and bring in tax money,[8] made public funding a politically viable proposition.

However, beginning in the Reagan administration and coming to a nasty boil during the presidency of George Bush, the NEA became a pawn in the 'culture wars' which always simmer below the surface. They broke into the open over the NEA's support for the Robert Mapplethorpe exhibition and the passage of the notorious Helms amendment in 1989, which unconstitutionally regulated eligibility for NEA grants. What has happened at the NEA during the past few years was anticipated as a possible threat in the 1960s. Interestingly, during the establishment of the agency, it was the Republicans who insisted that the NEA be insulated from political interference. This led to the creation of professional peer panels – independent juries of experts who, instead of political appointees, were to decide on grants. Twenty-five years later Republicans, with the help of conservative Democrats, demolished this safeguard against political manipulation. They severely damaged the agency and its constituency, which appears, in fact, to have been the ultimate goal of at least some of the NEA's critics.

The arts agencies were formed at a time when art audiences grew at a phenomenal rate. The arts were no longer seen as a pastime of 'effete snobs'. They became so fashionable, in fact, that marketing and corporate public relations experts discovered their potential. Without studying sociology, these wizards understood high culture's symbolic power. In exchange for their money, companies who needed to polish their

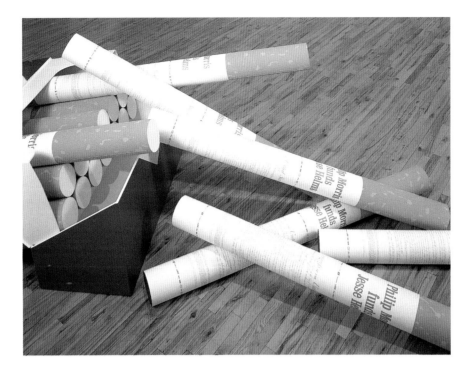

image began to attach their logo to prestigious art events. They often spent as much or more on advertising their association with the event they were sponsoring than on the event itself. Art institutions, in turn, wooed the sponsors with attractive packages and assured them, as the Metropolitan Museum did: 'The business behind art knows the art of good business.' For the CEOs who had no taste for word plays, the museum spelled out what it meant: 'Many public relations opportunities are available through the sponsorship of programmes, special exhibitions and services. These can often provide a creative and cost-effective answer to a specific marketing objective, particularly where international, governmental or consumer relations may be a fundamental concern.'[9] Of course, like the movie producer in Godard's parable, the PR operatives know that to appeal to as large a number of people as possible is essential. They also understand that not all ideas promote the interests of their client. Some are even harmful. Art professionals now use their colleagues in the development office as a 'reality check'.

Philippe de Montebello, the director of the Metropolitan Museum, is certainly a connoisseur in these matters. He has no delusions: 'It's an inherent, insidious, hidden form of censorship,' he admits.[10] But the imposition of the sponsor's agenda not only has an effect on what we get to see and hear. Mr de Montebello's president at the Met explained: 'To a large degree, we've accepted a certain principle about funding that, in passing through our illustrious hall, the money is cleansed.'[11] His suggestion that the sponsor's money is dirty came in response to a question about his Museum's collaboration with Philip Morris. The world's largest maker of carcinogenic consumer products is also the most conspicuous corporate sponsor of the arts. But not only of the arts. Philip Morris also gives hundreds of thousands of dollars to the Jesse Helms Center in North Carolina, and it sponsors the Bill of Rights. As contradictory as this may sound, it makes perfect corporate sense. Jesse Helms was instrumental in breaking down trade barriers against the import of American cigarettes in Asia, and he battles untiringly against tobacco tax increases. The Marlboro men paid the National Archives $600,000 for the permission to 'sponsor' the Bill of Rights in a two-year $60 million campaign. The campaign was designed to frame the cowboys' arguments against smoking restrictions as a civil rights issue. Support for the arts is used to build constituencies in this struggle and to keep the lines open to the movers and shakers in the media and in politics.

A PR man from Mobil once explained his company's rationale for supporting the

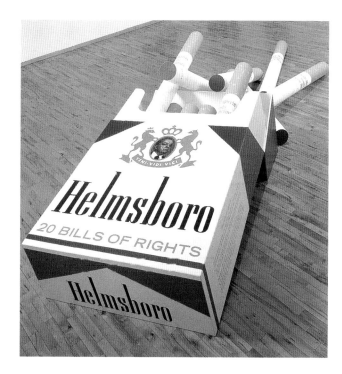

Helmsboro Country
1990
Silkscreen prints and photograph
on wood, cardboard, paper
Cigarette packet, 77 × 103 × 121
cm; cigarettes, l. 176 cm, ∅ 17 cm
each
Installation, 'Helmsboro Country',
John Weber Gallery, New York.
The Marlboro slogan before the
ban on cigarette advertising was
'Come to Marlboro Country'.
Sources of the 'Warnings':
Congressional Record, 28
September 1989; *PHILIP MORRIS
and the ARTS*, Remarks by George
Weissman. *The First Annual
Symposium*; Mayor's Commission
on the Arts and Business
Committee for the Arts, Inc.,
Denver, 5 September 1980. The
cigarettes are wrapped in
reproductions of the Bill of Rights.
Philip Morris (renamed Altria in
2003) paid National Archives
$600,000 for using the Bill of
Rights in a $60 million public
relations campaign in 1989. Free
copies were mailed in tubes
bearing Philip Morris logos.
The company regularly contributed
to election campaigns of Senator
Jesse Helms, Republican of North
Carolina. It sponsors the Senator's
'American principles' at the Jesse
Helms Center in Wingate, North
Carolina. Philip Morris: 'Senator
Helms has been extremely
supportive … and he is in a
position to be of help to us … '
Helms campaigned vigorously
against the National Endowment
for the Arts (US Government
agency for grants to artists and
institutions), leading to Congress'
passing content restrictions in
1990. Helms is hostile to AIDS
victims, homosexuals, the freedom
of women to have abortions, and
labour unions. He supported
Roberto D'Aubuisson (linked to
death squads in El Salvador),
General Augusto Pinochet (Chile),
and apartheid politicians in South
Africa. During election campaigns
he regularly exploited racist
sentiments.
In 1990, the John Weber Gallery
was threatened with legal action if
it exhibited *Helmsboro Country*. The
Gallery did not cancel the show.
When it became known that Philip
Morris sponsored Senator Helms,
ACT UP called for an international
boycott of its products. Miller Beer
sales declined that year.
In 1994, Philip Morris asked New
York arts institutions to help
defeat passage of restrictions on
smoking in public places. The ban
passed. In 2003, The Whitney
Museum celebrated its 20-year
anniversary at the exhibition space
at Altria's New York headquarters.

arts: 'These programmes build enough acceptance to allow us to get tough on substantive issues.'[12] One of the Mobil ads on the Op-Ed page of the *New York Times* put it more bluntly: 'Art for the sake of business.' Corporate support of the arts is meant to influence legislation, and, according to Alain-Dominique Perrin, the CEO of Cartier, to 'neutralize critics'. Monsieur Perrin has reason to be enthusiastic: 'Arts sponsorship is not just a tremendous tool of corporate communications,' he crows, 'it is much more than that: it is a tool for the seduction of public opinion.'

The expenses of this amourous enterprise are tax-deductible. As a consequence, the seduced foot the bill for their seduction. This strategy succeeds as long as we are convinced that we get something for nothing – and believe in 'disinterested pleasure'.

1 Hanns Johst, *Schlageter*, Albert Langen/Georg Müller, Munich, 1933, p. 26.

2 Morley Safer, 'Yes … but is it art?', *60 Minutes*, CBS television, 19 September 1993. Transcript: Burrelle's Information Services, Livingston, New Jersey.

3 Pierre Bourdieu, *Outline of a Theory of Practice*, Cambridge University Press, 1977, p. 188.

4 Jean Collet, ed. *Jean-Luc Godard*. No. 18, Collection Cinéma d'aujourd'hui, Editions Seghers, Paris, 1963. pp. 140–42.

5 ibid.

6 John Rockwell, 'Making a Mark on French Culture', *New York Times*, 8 November 1993, p. C11.

7 Karen De Witt, 'Senate Panel Gives Alexander Its Vote and a Rave Review', *New York Times*, 23 September 1993, pp. C13, 18.

8 'In New York City, art and culture alone constitute a megaindustry – more than $8 billion annually, conservatively estimated Arts and tourism combined constitute one of the largest generators of tax revenues, some $2.5 billion in direct state and federal tax receipts'. Martin E. Segal, letter to the editor, *New York Times*, 12 March 1993, p. A28.

 'In 1992, the total economic impact of the arts on the New York–New Jersey metropolitan region was $9.8 billion … Almost $3.5 billion in wages, salaries and royalties were generated … Employment, both direct and indirect, totalled 107,000.' *The Arts as an Industry: Their Economic Importance to the New York–New Jersey Metropolitan Region*. Arts Research Center, New York, 1993, p. 3.

9 *The Business Behind Art Knows the Art of Good Business*, leaflet addressed to corporations, Metropolitan Museum of Art, New York, undated (*c*. 1984).

10 'A Word from our Sponsor', *Newsweek*, New York, 25 November 1985, p. 98.

11 Amei Wallach, 'Keeping Corporate Funds, in the Name of Art', *New York Newsday*, 8 August 1990, p. II 2.

12 Raymond D'Argenio, 'Farewell to the Low Profile', address to the Eastern Annual Conference of the American Association of Advertising Agencies, New York, 18 November 1975, typewritten manuscript, p. 3.

Paper delivered at colloquium with Martin Segal, 'The Arts and the Economy', at Baruch College, New York, 18 November 1993. First published in Hans Haacke, *Obra Social*, Fundació Antoni Tàpies, Barcelona, 1995, pp. 206–11.

Free Exchange (extract) 1994

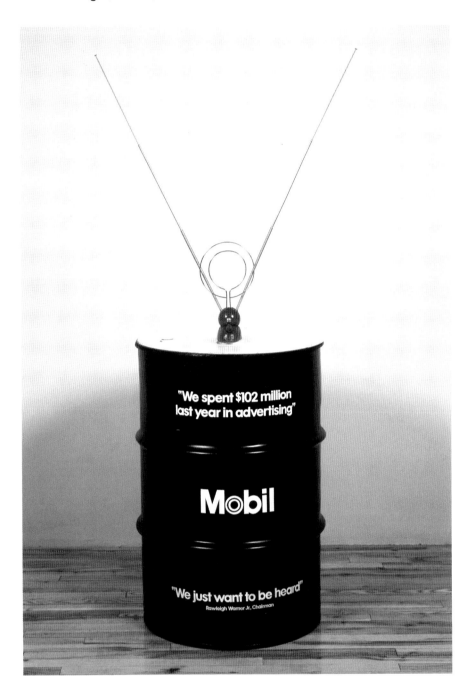

Creating Consent
1981
Oil drum, television antenna
h. 85.5 cm, ⌀ 58.5 cm
Installation, 'Upstairs at Mobil',
John Weber Gallery, New York.
Collection, FRAC, Rhône-Alpes,
Lyon.
The Public Broadcasting Service
(PBS) was set up by the US
Congress as a television network
for public interest, educational
and cultural programmes. Lacking
sufficient funding, it depends on
corporate sponsors and private
donations. While PBS does not
present commercials, sponsored
programmes are introduced and
ended by prominently crediting
the sponsor. Critics have noted
that investigative reports into
the business world are rare.
Shortly after the 1973 OPEC oil
embargo, when they were accused
of price gouging, oil companies
provided the bulk of the financial
support for PBS. It therefore
became known as the 'Petroleum
Broadcasting Service'.
Beginning in 1971, Mobil
sponsored two of the network's
series: *Mystery!* and, imported
from the BBC and ITV, *Masterpiece
Theatre*, as well as the period soap
opera *Upstairs, Downstairs* from
London Weekend Television.
Herb Schmertz, at the time
director of Mobil, Vice-president
for Public Affairs (1974–88), and
author of the book *Good-bye to
the Low Profile: The Art of Creative
Confrontation* (1986) explained:
'I am, in effect, the manager of
an ongoing political campaign ...
We're constantly out there trying
to win more votes for our
positions ... We require a visible
and articulate presence, not only
in the economic marketplace, but
also the marketplace of politics
and ideas'. Raymond d'Argenio,
then a Mobil public relations
manager, summarized the
company's rationale for cultural
sponsorship this way: 'We aimed
at the movers and shakers in many
fields, including businessmen,
city and state officials [and] the
media ... These programmes build
enough acceptance to allow us to
get tough on substantive issues.
Public broadcasting is the
keystone.'
For decades, every Thursday,
Mobil ran issue-oriented ads on
the OP-Ed page of the *New York
Times*. One of them was titled 'Art
for the Sake of Business'.

Hans Haacke [...] I think it is important to distinguish between the traditional notion of patronage and the public relations manoeuvres parading as patronage today. Invoking the name of Maecenas, corporations give themselves an aura of altruism. The American term *sponsoring* more accurately reflects that what we have here is really an exchange of capital: financial capital on the part of the sponsors and symbolic capital on the part of the sponsored. Most business people are quite open about this when they speak to their peers. Alain-Dominique Perrin, for example, says quite bluntly that he spends Cartier's money for purposes that have nothing to do with the love of art.

Pierre Bourdieu Does he say in black and white, 'it is to win over public opinion'?

Haacke Yes. In his own words: 'Patronage [*le mécénat*] is not only a great tool for communication. It does much more: it is a tool for the seduction of public opinion'.[1] It is, in fact, the taxpayers who cover what corporations save through tax deductions on their 'generous contributions'. In the end, we are the ones who wind up subsidizing the

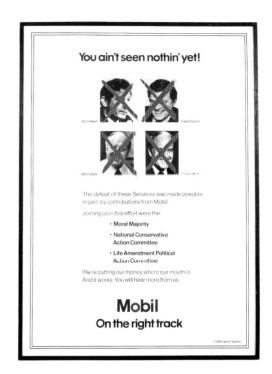

Mobil: On the Right Track
1980
3-colour silkscreen on acrylic,
photo collage
152.5 × 109 cm
First installed, 'Upstairs at Mobil',
John Weber Gallery, New York.
In the late 1970s, the four
senators depicted were the most
visible and forceful
representatives of liberal politics
in the US Congress.
The Moral Majority was a political
action group of conservative,
fundamentalist Christians.
The National Conservative Action
Committee continues as a
coalition of conservative
organizations. It conducts well-
funded campaigns to prevent the
election of liberal politicians.
The Life Amendment Political
Action Committee (now The Right
to Life Action Committee)
promotes anti-abortion
legislation and targets politicians
who support freedom of choice.
Mobil has funded campaigns for
the election of Senators and
Members of the House of
Representatives who favour the
interests of the petroleum
industry. The company's
sponsorship of PBS (Public
Broadcasting System)
programmes and cultural events,
in the words of a Mobil officer,
'build enough acceptance to allow
us to get tough on substantive
issues'.
In 1984, Mobil threatened to sue
the Tate Gallery in London and the
Stedelijk Van Abbemuseum in
Eindhoven in an attempt to
prevent them from distributing
a jointly published catalogue,
prepared for Hans Haacke solo
exhibitions. Mobil objected to
three works about its activities.
Unfamiliar with US law, on which
Mobil's claims were based, both
museums withdrew the catalogue.
A year later apprised of the
unsustainability of the charges,
the museums released the
publication.

corporate propaganda. Seduction expenses not only serve the marketing of products like watches and jewellery, as would be the case with Cartier. It is actually more important for the sponsors to create a favourable political climate for their interests, particularly when it comes to matters like taxes, labour and health regulations, ecological constraints, export rules, etc.

Bourdieu I once read an article which recalled that in businesses in the United States, this type of practice is justified by what is called the *check account theory*, the theory of the (symbolic) bank account. A foundation that makes donations accumulates the symbolic capital of recognition; then, the positive image that it is thus assured (and which is often assessed in dollar terms, under the heading of *good will*, on business account sheets) will bring indirect profits and permit it, for example, to conceal certain kinds of actions.

Haacke **To quote Monsieur Perrin: the strategic goal is to 'neutralize critics'.**

Bourdieu In the world of high fashion, it is well known that the annual presentation of the new collections assures designers the free equivalent of hundreds of pages of advertising. The same goes for literary awards. In all cases, it is a question of controlling the press and getting it to write favourably about the companies at no cost. Firms that invest in patronage make use of the press and oblige it to mention and praise them. In a very general sense, economic leverage is exerted on cultural production largely through the medium of the press, particularly through the seduction it exerts over producers – especially the most heteronomous – and through its contribution to the commercial success of works. It is also exerted through dealers in cultural goods (editors, gallery directors, among others). It is above all through journalism that commercial logic, against which all autonomous universes (artistic, literary, scientific) are constructed, imposes itself on those universes. This is fundamentally harmful, since it favours the products and producers who are most directly submissive to commercial demands, such as the 'journalist philosophers' of whom Wittgenstein speaks.

But, in fact, through your work you carry out a diversion of the processes used by wise managers. You use an analysis of the symbolic strategies of 'patrons' in order to devise a kind of action that will turn their own weapons against them.

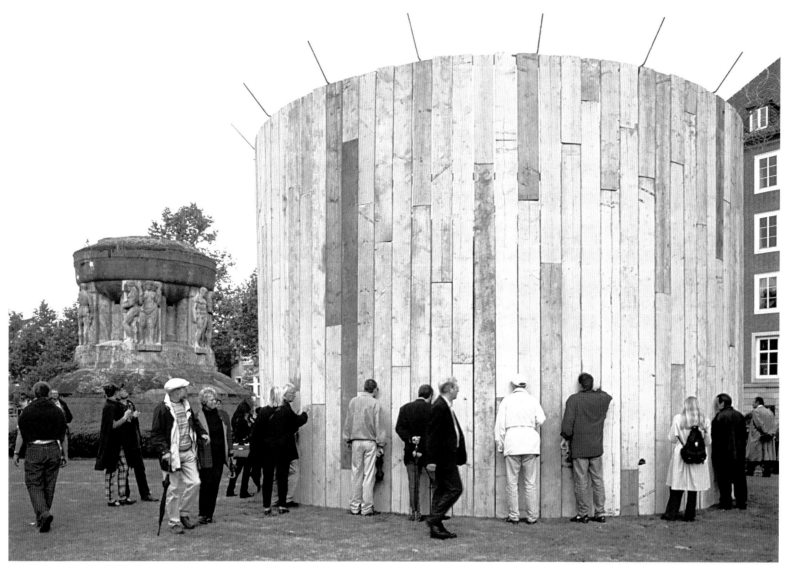

**Standort Merry-Go-Round
(German Merry-Go-Round)**
1997
Existing monument, merry-go-
round, barbed wire, wood, sound
track
h. and ⌀ approx. 6–7 m
Installation, Skulptur. Projekte
in Münster 1997.
In 1909, a memorial was
inaugurated with a nationalist
celebration at Mauritztor
[Mauritzgate], on the promenade
in Münster. Bernhard Frydag, a
local sculptor, had chiselled into
his monument the dedication:
'1864 – 1870–71 – 1866 IN
MEMORY OF WARS AND VICTORIES,
AND THE RE‑ESTABLISHMENT OF
THE REICH.'
The dates refer to the three wars
Bismarck waged against his
Prussian neighbours. In German
history books they are known as
the German–Danish War, which
led to the annexation of
Schleswig-Holstein by Prussia and
Austria; the German War between
Prussia and Austria (two years
later), and the German–French
War. In 1871, after the German
victory, the Prussian King
Wilhelm I was proclaimed Kaiser
of the newly established German
Reich in Versailles. In 1815
Münster had become part of the
Prussian province of Westphalia.
In Münster the Memorial at
Mauritztor is popularly called
Mäsentempel (monument of
asses).
During Skulptur. Projekte in
Münster 1997, next to the
monument, a cylindrical shack
was erected, made of raw
construction planks. It matched
the monument in diameter and
height (6–7 m). Barbed wire was
strung around the top. A
children's carousel with lights and
music (the German national
anthem played at high speed and
high pitch) was turning inside,
directly behind the planks. It was
possible to see the carousel only
through gaps between the planks
where they did not fit together
snugly.

I find this exemplary, because for years I have asked myself what can be done to oppose modern forms of symbolic domination. Intellectuals – but also unions and political parties – are truly unarmed; they are three or four symbolic wars behind. They have only archaic techniques of action and protest to use against corporations and their very sophisticated forms of public relations. Thanks to your artistic competence, you produce very powerful symbolic weapons which are capable of forcing journalists to speak, and to speak against the symbolic action exerted by corporations, particularly through their patronage or sponsorship. You make symbolic machines that function like snares and make the public act. For example, as in the case of Graz, you compose a work, the work's enemies destroy it, thus unleashing a whole chain of discourses that force a deployment of critical intent. These works make people talk, and, unlike those of certain conceptual artists, for example, they do not make people talk only about the artist. They also make people talk about what the artist is talking about. Through facts and actions, you prove that it is possible to invent unprecedented forms of symbolic action which will free us from our eternal petitions and will put the resources of the literary and symbolic imagination at the service of symbolic struggles against symbolic violence. I am thinking, in this connection, of a poem by Harold Pinter against the [first] Gulf War (censored by the British press and published later in *Liber*), which was also a response to the acknowledgement of the impotence of intellectuals in face of journalists' stranglehold on all forms of mass media. Not only are artists, writers and scholars excluded from public debate and public expression (those who opposed the Gulf War, for example, had to face formidable obstacles, to say nothing of the efforts of young Yugoslav intellectuals to stop the barbarity of the civil war!), but it is fashionable to say that they no longer exist! A certain number of media intellectuals collaborate with those in the media who conspire more or less consciously to discredit intellectuals, or, to speak in a more rigorous manner, who contribute to reinforcing all the mechanisms (among which are the effects of urgency) which tend, apart from all malicious intentions, to make the dissemination of complex messages difficult.

It is not a question of making journalists as a whole responsible for destroying the critical power of intellectuals. If it is through them that constraints and controls are instituted, it is also through them, or certain among them, that some areas of freedom may open. That being said, your work is so important, in my opinion, because, in part, it indicates the direction artists and scholars should look in order to give their critical

Zum Appell

Deutsche Industrie im Irak

actions a true symbolic efficacy.

Haacke Occasionally, I believe, I have succeeded in producing works which have played a catalytic role. But I think works that do not get much public attention also leave a trace. All productions of the consciousness industry, no matter whether intended or not, influence the social climate and thereby the political climate as well.

In the specific cases we are discussing, the problem is not only to say something, to take a position, but also to create a productive provocation. The sensitivity of the context into which one inserts something, or the manner in which one does it, can trigger a public debate. However, it does not work well if the press fails to play its role of amplifier and forum for debate. There has to be a sort of collaboration. The press often plays a double game without being quite aware of it or, at least not openly, showing that it does.

This ambiguous position is due in part to the enormous pressure to fill pages and the screen with ever new stimuli, extraordinary events and stuff that's different from what we have been seeing and hearing daily and that can therefore capture our attention. Lest we forget, journalism is not a monolithic enterprise: there are people who are quite willing to help us. I told you about my experience in Munich. Ruhrgas AG, one of the German companies I had named on my flags on the Königsplatz for having sold war material to Iraq, became quite irritated. When the company obtained a temporary injunction, I called the journalist of *Der Spiegel* whose article had been the source of my information. Hearing what had happened in Munich, he told me: 'This is remarkable. There was no response whatsoever from Ruhrgas to my article. But you got it. Apparently, when it happens in a public place, they react. That embarrasses, that creates a sensation.' The Munich newspapers which already had published illustrated reviews now followed them up with reports on the moves of Ruhrgas in the legal arena.[2] The upshot of their complaint was that a statement had to be inserted in the catalogue explaining that, strictly speaking, it was a wholly owned subsidiary[3] of Ruhrgas that was the supplier of Iraq, and not Ruhrgas itself. Thus the name of Ruhrgas was highlighted in the list of twenty-one companies on my flags.[4]

Bourdieu There is a kind of censorship through silence. If, when one wants to transmit a message, there is no response in journalistic circles – if it doesn't interest journalists –

AEG
Bauer-Kompressoren
Buderus
Daimler-Benz
Gildemeister
H + H Metallform
Havert
Hochtief
Karl Kolb GmbH
Klöckner
MAN
Mannesmann
MBB
Pilot Plant
Rhein-Bayern
Rheinmetall
Ruhrgas
Saarstahl
Siemens
Strabag
Thyssen

Die Fahne hoch! (Raise the Flag!)
1991
3 flags, one with photograph
silkscreen, architectural setting
2 flags, 1100 × 250 cm; 1 flag 550
× 350 cm
Temporary installation, Propyläen
Königsplatz, 'ArgusAuge (Argus-
Eye)', Munich, September.
The title quotes from the first line
of *Horst-Wessel-Lied*, a famous
Nazi song. On the central flag is
written 'Roll Call: German
Industry in Iraq', with photo of
the SS badge. The two long flags
list German companies.
Leo von Klenze designed
Königsplatz for King Ludwig I of
Bavaria (reign 1825–48) as an
ensemble of three neoclassical
buildings around a square. Two
serve as museums. A road
traverses the grass-covered
square to the third structure, the
Propylaeum, a massive triumphal
gate.
Königsplatz became a principal
site for Nazi rallies. It was paved
over and two massive buildings,
Hitler's Munich office and the
headquarters of the Nazi party,
were built on the fourth side of
the square, together with two
Ehrentempel (Temples of honour),
where the Nazis buried the dead
of their unsuccessful 1923 Munich
putsch. Every year, on the
anniversary of the putsch, they
held a commemorative ritual on
the Königsplatz, with thousands
of troops standing at attention
and the names of the dead called
as if they were a roll call.
After the Second World War, the
US Army blew up the *Ehrentempel*.
The former Nazi office buildings
are now used by the Music School
and the Art Historical Institute of
the Munich University.
Like corporations in other
countries, German companies
made major contributions to the
Iraqi arsenal, including Saddam
Hussein's nuclear and chemical
weapons programme. Many had
also provided Hitler with war
materiel.
Two days before the end of the
exhibition, Ruhrgas AG, obtained
an injunction against the display
of its name on the flags.
Eventually, a Munich court ruled
that a statement be included in
the exhibition catalogue
explaining that it was not Ruhrgas
but LOI Industrieofenanlagen
GmbH which conducted business
with Iraq. This wholly owned
subsidiary of Ruhrgas did, in fact,
supply special furnaces for the
production of cannon barrels.

then the message is not transmitted. Journalists have been the screen or filter between all intellectual action and the public. In a book entitled *Produire l'opinion*,[5] Patrick Champagne shows, *grosso modo*, that successful protests are not necessarily those that mobilize the most people, but those that interest the most journalists. Exaggerating somewhat, we could say that fifty shrewd people, capable of staging a successful *happening* that gets five minutes of television airtime, can have as great a political effect as 500,000 protesters.

This is where the specific competence of the artist is so important, because a person cannot just suddenly become a creator of surprise and disconcertion. The artist is the one who is capable of *making a sensation*, which does not mean being a sensation, like television acrobats, but rather, in the strong sense of the term, putting across on the level of sensation – that is, touching the sensibility, moving people – analyses which would leave the reader or spectator indifferent if expressed in the cold rigour of concept and demonstration.

You should be a sort of technical advisor to all subversive movements ... [...]

1 Alain-Dominique Perrin, 'Le Mécénat français: La fin d'un préjugé', interview with Sandra d'Aboville, *Galeries Magazine*, No. 15, Paris, October–November 1986, p. 74.

2 To celebrate the twentieth anniversary of its relations with Russia, in 1993, Ruhrgas sponsored an exhibition of the Shtshukin and Morosow collections, at the Folkwang Museum in Essen.

3 *Wer gehört Wem?*, Commerzbank, 1990.

4 The prohibition against exhibiting the flags with the Ruhrgas name had no practical effect, because, by the time of the ruling, the exhibition had ended.

5 *Produire l'opinion: Le nouveau jeu politique*, Éditions de Minuit, Paris, 1990.

Pierre Bourdieu's part of the dialogue was translated by Randal Johnson; Hans Haacke's were translated by himself.

Hans Haacke, Pierre Bourdieu, *Libre-Échange*, Le Seuil/les presses du réel, Paris, 1994. German translation: *Freier Austausch*, S. Fischer Verlag GmbH, Frankfurt am Main, 1995; Portuguese translation: *Livre-Troca*, Editora Bertrand Brasil S.A. Rio de Janeiro, 1995; English translation (American edition): *Free Exchange*, Stanford University Press, 1995; English translation (British edition): *Free Exchange*, Polity Press, London, 1995; Japanese translation: Fujiwara-Shoten, Tokyo, 1996; Chinese translation: San Lian Shu Dian, 1996; Finnish translation: *Ajatusten vapaakauppaa*, Kustannusosakeyktiö Taide, Helsinki, 1997.

Thoughts about the Project 1999–2000

I saw the Reichstag building for the first time on a Sunday in 1984, when I took a stroll in the Tiergarten, a large park in the centre of Berlin. Children were playing on the wide lawn in front of Wallot's maltreated colossus, while the building blocked the view of the wall in the East. Extended families were camped out in the grass and the smell of grilled lamb wafted in the air. It was idyllic.

It crossed my mind that, in 1918, Scheidemann (a prominent Social Democratic member of Parliament) had proclaimed the Republic from a window of the Reichstag – and that fifteen years later, in the same building, that Republic went up in flames.

But I got startled about something else. On the architrave of the building's portico I read in giant bronze letters the inscription DEM DEUTSCHEN VOLKE (TO THE GERMAN PEOPLE).

For many of the children playing on the lawn, as for their parents, uncles and aunts, that meant: this place is not for you! You don't belong! You stay out! The inscription sounded even more aggressive a few weeks later, when I saw it flaring up with the crackle of fireworks, in front of the forbidding scenery of the Reichstag.

In his history of the Reichstag Michael S. Cullen reports that Wilhelm II considered the architect Paul Wallot's idea to dedicate his Parliament building 'To the German People' an affront. Perhaps sensing a whiff of the French Revolution, the Kaiser knew how to prevent it from being realized. It was only in 1915, twenty-one years later, when the First World War unexpectedly was ending up not as a string of victories, that he gave his consent to the dedication. For the casting of the bronze letters the Kaiser even approved the melting down of two cannons that had been captured during the Napoleonic wars. The question whether the adjective 'deutsch' was to be spelled in upper or lower case was sidestepped by using upper case for the entire inscription (in German adjectives are normally spelled in lower case). A conflict erupted over the choice of typeface. Conservatives promoted Fraktur, because they regarded it as particularly German. Others favoured a Roman typeface as being more modern, even though that was a typeface preferred in England and France and therefore in danger of being associated with the enemy. In the end, the dedication was executed in a hybrid art nouveau typeface designed by Peter Behrens, in which he joined elements of both Fraktur and Roman type.

The fact that the Kaiser consented to the dedication under the pressures of war, the choice of captured cannons as material for the letters, and the struggle over the

Reichstag, Berlin
1884–94
Architect, Paul Wallot
Reconstructions, Paul
Baumgartner (1972), Sir Norman
Foster (1995–99)

typeface, all indicate that the inscription 'To the German People' had, in fact, right from the beginning, a nationalist charge (aside from the Kaiser's hearing a republican ring).

During the twentieth century, the adjective 'German' and the noun *Volk* have played conflict-ridden and often fateful roles in German society.

According to the encyclopedia, the term *Volk* implies a common history and cultural heritage, the sense of a common bond, as well as a distinct culture, religion, and language.

During the Third Reich, it was *Volksgenossen* (Germans as defined by the Nazis) who cheered the Führer, when he spoke to them about *Deutschtum* (Germanness), about *Volksdeutsche* (ethnic Germans of foreign nationality) and about race-hygienic *Volkstumspolitik* (policy promoting the annexation of territories with ethnic German minorities).

His speeches could be read in the *Völkischer Beobachter* (daily newspaper of the Nazi Party). Towards the end of the war the Führer drafted children and old men in the *Volkssturm* (local defence force). The ministry of *Volksaufklärung* (propaganda ministry) managed the *gesundes Volksempfinden* (healthy sense of the people). It purged the museums of un-German, degenerate art. Death sentences by the *Volksgerichtshof* (political court) imposed on *Volksschädling* (inferior and dangerous persons) were executed 'in the name of the people'. Whether a person was considered German or not was a matter of life and death. One of the sons of the bronze casters who produced the letters for the dedication 'To the German People' died in Auschwitz; the other was executed in Berlin-Plötzensee (prison). Jews and gypsies were not accepted as Germans. One-hundred and thirteen members of the Reichstag were stripped of their German citizenship. Seventy-five of them did not survive prison. Eight committed suicide.

From 1945 to 1989, the notion of *Volk* was interpreted quite differently in the territory that began immediately behind the Reichstag building. Laws were passed by a Volkskammer (GDR Parliament). The military was called *Volksarmee*. Law and order was maintained, accordingly, by the *Volkspolizei*. People worked in *Volkseigenen Betrieben* (State Enterprises). When the workers went on strike on 17 June 1953 and braved the tanks of the rulers, Bertolt Brecht proposed a solution: 'Wouldn't it be easier if the government dissolved the people and chose another one?' The government made the mistake not to employ this patent remedy. As a consequence, in 1989 it got to hear the chant 'We are the people!'

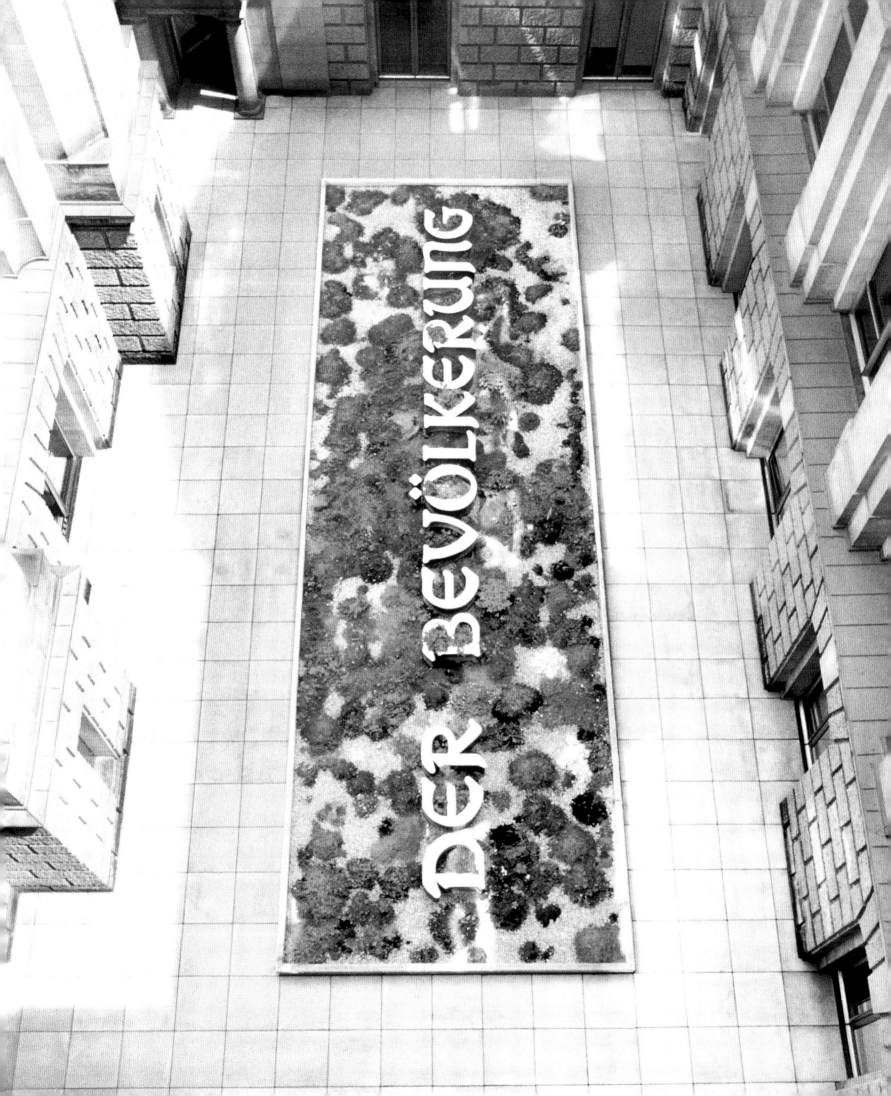

DER BEVÖLKERUNG (TO THE POPULATION)

Proposal 1999, inauguration 2000
Neon letters, frame, earth
Frame, 680 × 208 × 30 cm; neon
letters, h. 60 cm, l. 120 cm
Installed, Reichstag, Berlin, a
work in progress.
When the Bundestag (German
Parliament) moved from Bonn to
the Reichstag in Berlin, a number
of artists were asked to make
proposals for designated areas
of the building. In the autumn
of 1999, the Kunstbeirat, a
parliamentary committee, voted
nine to one for the realization of
the project DER BEVÖLKERUNG (TO
THE POPULATION).
The proposal: The words DER
BEVÖLKERUNG are spelled out in
120-cm high neon letters in an
open-air interior courtyard,
visible from the roof, where the
public is admitted. The typeface
matches that of the inscription
DEM DEUTSCHEN VOLKE (To the
German People) on the
Reichstag's facade. Members
of the Bundestag are invited to
bring half a kilo of soil from their
election districts and spread it
around the neon letters.
Spontaneous plant growth is
to remain untended.
Volker Kauder, the lone dissenter
of the Kunstbeirat, a leading
member of the conservative CDU
(Christian Democratic Union),
waged a determined campaign to
prevent the project's realization.
The German and international
media reported extensively on the
ensuing controversy, which
eventually led to an hour-long
debate in the Bundestag on 5
April 2000. Speakers from each
of the major parties spoke both
in favour and in opposition to the
project. It was approved by a vote
of 260 to 258 for the project.
On 12 September 2000 the
Speaker of the Bundestag,
Wolfgang Thierse, initiated its
participatory phase by depositing
soil from the Jewish cemetery in
his Berlin election district. By the
end of 2003 about 225 MPs had
participated.
A camera in the courtyard delivers
a daily updated view to the
project's website,
www.derbevoelkerung.de. The
website includes a chronology,
the minutes of the debate, the
names of MPs who have
contributed soil, and a
bibliography.

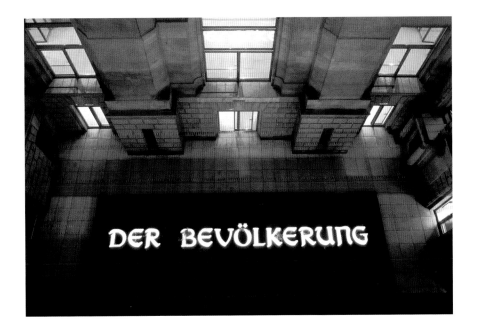

For centuries, people emigrated from the territory now occupied by the Federal Republic of Germany; they were wooed away – and they were sold by their rulers as mercenaries to fight in the wars of others. Emigration continues today. In the veins of all these people flows 'German blood'. Do they therefore all belong to the 'German people'?

And the many millions who, for centuries – and still today – have been recruited for work in Germany, who have taken refuge, stayed on in the turmoil of war, or immigrated 'normally', all these people whose names are listed in the telephone directory and whose children were born on German soil and went to German schools, are they disqualified from admission to the 'German people', because of their *Ahnenpass* (Nazi pass book to prove German ancestry)?

Resolutions of the Bundestag affect all inhabitants of the Federal Republic – no matter whether they belong to the 'German people' according to the definition of the encyclopedia or any other definition. A great number of people who are not German citizens and cannot vote in the Federal Republic nevertheless are equally subject to the decisions of the Bundestag. The exclusivity proclaimed on the portico of the Reichstag building is questionable also in view of the widening European unification and the Federal Republic's global alignments.

In his 1934/35 essay *Writing the Truth: Five Difficulties*, written in exile, Bertolt Brecht maintained: 'In these times, the one who says *Bevölkerung* (population) instead of *Volk* […] already does not support many lies.'

Members of the Bundestag do not answer to a mythical Volk but TO THE BEVÖLKERUNG. In contrast to the fiction of a German tribal unity, the territory (Lat. *terra* = earth, soil, land) of the Federal Republic is a reality, recognized and defined by international law. Its material existence is demarcated by posts driven into the ground along its borders. German citizenship laws are changing from the exclusive 'law of blood' (*ius sanguinis*) towards an ecumenically inclusive 'law of soil' (*ius soli*). Without discrimination, the land of the Federal Republic is common to all who live within its borders.

Earth plays an important role in many myths of creation. The Old Testament opens with the sentence: 'In the beginning God created the heaven and the earth.' On the third day, it continues, the Biblical God commanded: 'Let the earth bring forth grass, the herb yielding seed, and the fruit tree yielding fruit after its kind, whose seed is in itself,

DER BEVÖLKERUNG (TO THE POPULATION)
Proposal 1999, inauguration 2000
Neon letters, frame, earth
Frame, 680 × 208 × 30 cm; neon letters, h. 60 cm, l. 120 cm
Installed, Reichstag, Berlin, a work in progress.
left, MP Renate Blank with earth from her election district
opposite, parliamentary debate on artist's proposal, 5 April 2000

upon the earth.' On the sixth day he formed man 'of dust of the ground'. For the existence of man 'on the earth', as German usage indicates, the earth is tantamount to the world. In many cultures the earth is referred to as 'mother earth', giving life and periodic renewal. But she also opens herself up as the grave that takes us in, and we become one with the earth. She does not know of power and property. The earth is classless.

In countries with industrialized agriculture the soil's fertility is no longer enhanced through prayer and sacrifice. Chemical fertilizer and ecological methods replaced them. But crop failures have lost none of their horrors. They are reflected in the cost of living index, the options market and in famines – as they did thousands of years ago.

In sometimes unexpected ways, attachment to the soil survives in the concrete landscapes of our cities. On weekends, those who can afford it go to the country. For the ones left behind, vegetables home-grown on window sills or in plots on the side of train tracks serve as surrogates. Recently the smell of earth is also permeating the interior of office towers. In open spaces that are exempted from exploitation as offices, green landscapes extend all the way up to the glass roof. In New York, the sale of empty city-owned lots, on which neighbourhood residents have lovingly planted gardens, can pose incalculable political risks. In the stone deserts of our metropolitan cities, plants and their exploitation according to ecological precepts enjoy high social status.

In spite of the earth's secularization the Pope and politicians kiss the ground whenever they want to express their reverence to a country. Some people do that without cameras rolling when they return – after a long absence – to the country with which they have emotional ties. Even though these expressions of respect and love are usually played out at the foot of a landing platform, what is meant is not the tarmac but the earth underneath. If a traveller is asked to bring back a bag of soil from that faraway place where the person who makes this request was born and where he cannot go himself, it follows a similar symbolism.

The gathering and mixing of soil from all regions of the Federal Republic in the courtyard of the Reichstag building is an anti-particularist symbolic action. It affirms communality and equality. A quiet gesture, without accompanying fanfare, flag-waving and torchlight, it is matched by the unspectacular sprouting of the seeds and roots in the soil. Their growth is oblivious to photo opportunities. The entire country is represented, equally, in this ecosystem at the seat of the legislature – visible to the

visitors on the roof and to those of the website. The Members of the Bundestag express symbolically through their contribution that they take it as their task to serve the interest of the entire(!) population, and that the nationalistic motto of exclusivity on the facade of the Reichstag building needs correction.

The swearing in of new Members is an event at which they play a rather passive role. By contrast, bringing soil from their election district requires initiative and commitment. It corresponds metaphorically to the commitment to the *res publica* that is expected from everyone when they are asked to go to vote. The invitation to actively participate in the creation and continuous renewal of this art project is also an invitation to the legislators to think about the role artworks are meant to play at their place of work. So-called art in public places is usually rather static. This project, by contrast, relies on participation – as does a living democracy. It is a dynamic and collaborative work. And it is an unending process.

In a building governed by extreme security controls, this ecosystem of imported seeds in the Parliament's courtyard constitutes an enclave of unpredictable and free development. It is an unregulated place, exempt from planning anything and everything. It is dedicated TO THE POPULATION.

'To the Population', *Mia san mia* (cat.), Generali Foundation, Vienna, 2001